how to take great photographs

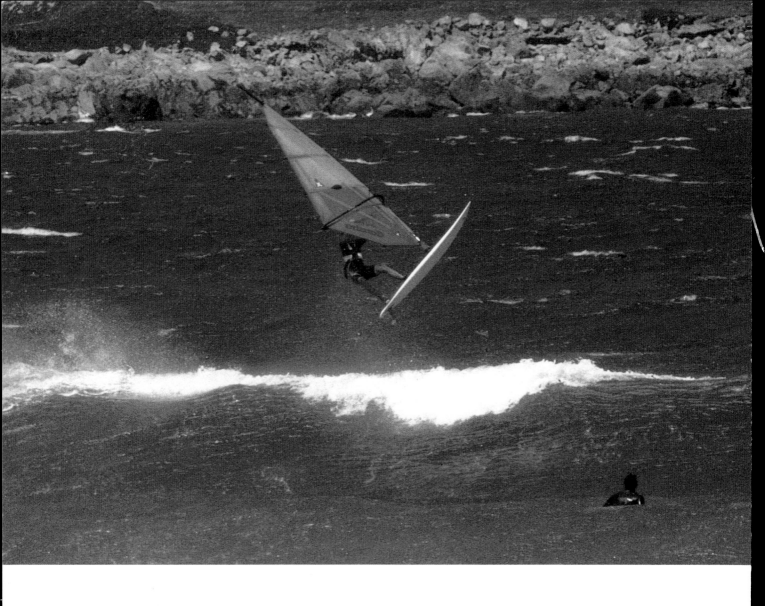

how to take great

photographs

john hedgecoe

C&B
COLLINS & BROWN

Contents

Acknowledgements

The author would like to thank John Dickens at Pentax, UK; Pentax Cameras; Ian Callow at Iford, UK; Ilford Films; Simon Childs at Agfa, UK, Agfa Films; The Tourist Offices of Austria, Guernsey and Jordan; Gorey Pottery, Jersey; Hotel Chateau de Bagnols, near Lyons, France; Snetterton Race Circuit, Norfolk; Sheringham High School, Norfolk; and Faith Chadwyck-Healey.

First published in Great Britain in 2001 by
Collins & Brown Limited
London House
Great Eastern Wharf
Parkgate Road
London SW11 4NQ

Distributed in the United States and Canada by Sterling Publishing Co., 387 Park Avenue South, New York, NY 10016, USA

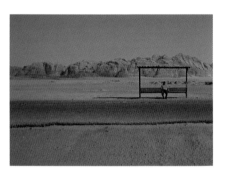

9 8 7 6 5 4 3 2 1

British Library Cataloguing-in-Publication Data:
A catalogue record for this book
is available from the British Library.

ISBN 1 85585 913 0

Contributing Editor: Chris George
Picture Coordinator: Jenny Hogg
Designer: Roger Hammond

Reproduction by Classic Scan, Singapore
Printed and bound in Singapore by Craft Print International Ltd

This book was typeset using Simoncini Garamond, RotisSerif and News Gothic.

Introduction

PHOTOGRAPHY REMAINS the most widely used creative medium today. Despite the proliferation of camcorders and computers, stills photography is the most accessible and practical medium – whether using conventional film or increasingly popular digital means.

But whilst the mechanics of photography have become increasingly electronic, simplifying the task for the modern picture-taker, the techniques and fundamentals remain much the same as those used by our grandfathers and great-grandfathers.

Whatever type of camera you use, taking a picture involves making choice. You decide where you stand, and what elements to leave in or keep out, and what part of the frame to focus on – it is these mental choices that are at the heart of composition. Lighting, meanwhile, is nothing less than integral to the picture-recording process. The way light falls on the subject can transform the results we get. Learning to read light and manipulate it to get the best pictures are essential skills that any serious photographer has to learn. Fortunately, there are some common guidelines, developed by artists over the centuries, that can be picked up to help avoid disappointing composition and lighting.

But these essential rules are not best learnt by unleashing a new photographer into the world with a camera. It is not by accident that most photographic courses – in schools, clubs and colleges – set out to develop an understanding of the fundamental skills in a studio environment.

Just as painters learn and practise by drawing bottles, fruit and flowers indoors, a photography student can learn the fundamentals in a similar way.

The beauty of still-life photography is that everything is under your control. The subject can be arranged in a variety of ways. Backgrounds and props can be changed. And because the subject is static, you can alter the composition as often as you like, without worrying about missing the moment. Even more importantly, you can experiment with different lighting set-ups. In this way, you can discover for yourself how the most mundane of subjects can be transformed into an exciting and arresting image, just by the way it is lit.

These lessons are far harder to learn outdoors. Subjects either cannot be moved, or move in a way that is out of your control. Lighting is constantly changing, and manipulating it to your advantage is much more difficult. Isolating your mistakes in the constantly changing outside world can be impossible.

With still-life photography, if you make a mistake, it is your mistake – but there is no penalty. If your pictures do not meet with your expectations, you can

ABOVE: Unlike most other photographic subjects, the still life gives you complete control – over composition, lighting and background. Shots can be repeated until you get the result that you are happy with.

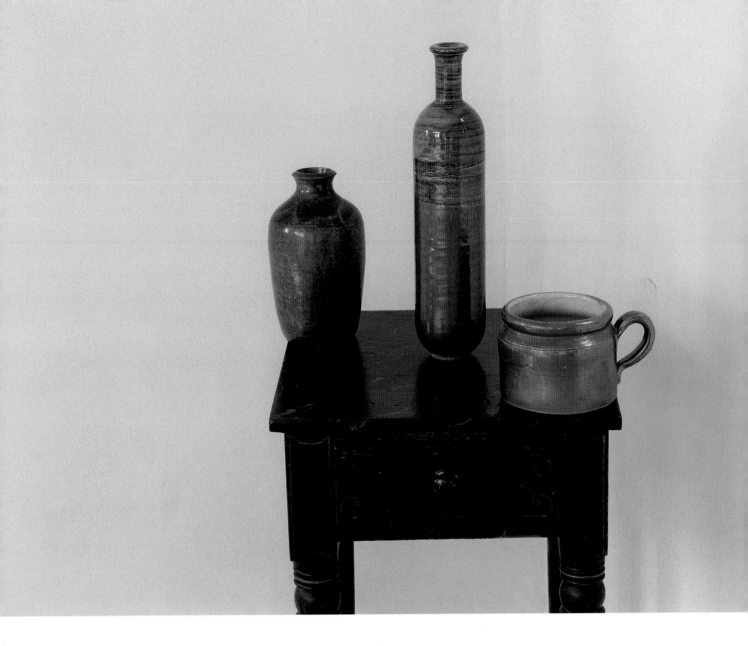

go back and repeat the shot, discovering how it can be improved, by changing each factor individually.

It is for these reasons that this book takes a different approach from many other photography manuals. The initial emphasis for the subjects and techniques that are covered in the following pages is on how these can be tackled in the studio. It is only then that we go on to show how the lessons that have been learnt in a controlled environment can be successfully applied in the city, in the countryside, with pictures of people, and so on. The first spread of a subject, therefore, shows examples that can easily be copied at home, and a secondary spread then progresses to show similar ideas being used in other situations.

You don't need to have access to a fully equipped photographic studio in order to use this book's

ABOVE: It is with still-life arrangements such as this that artists learn to draw and paint. It is also an ideal way for the photograph to master composition and lighting in the comfort of their own home.

approach to learning how to take great photographs. Still-life photography does not demand a lot of space and can be successfully tackled in your own home. Nor do you need sophisticated electronic lighting. As you will see from many of the pictures in this book, natural window light is more than suffi-cient for many subjects. And this can be altered by where you place your subject within the room, the way the window is screened, and by the use of white sheets or cardboard to reflect light into darker areas of the shot. ▷

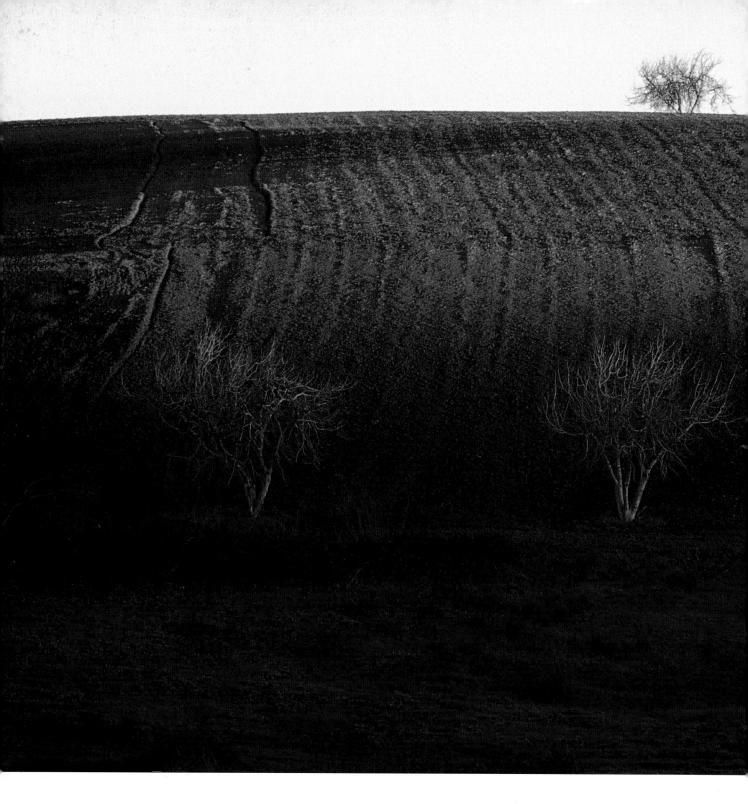

This book is broken up into three sections. In Part One we take a look at the essential elements found in all subjects, such as colour and shape, that can be exploited by the photographer. In Part Two we move on to composition, discovering some of the simple ways by which you can make pictures look more powerful, just by the way that you frame the picture, and where you place the camera. Finally, in Part Three we go over some of the more technical aspects of photography. As well as seeing how different controls and equipment are used for particular effects, we look at lighting in more detail. This section also includes a look at how computers and image manipulation software can be used to extend the creative process even further.

By the end, I hope you will have developed the skills and confidence to be well on the road to shooting your own great photographs.

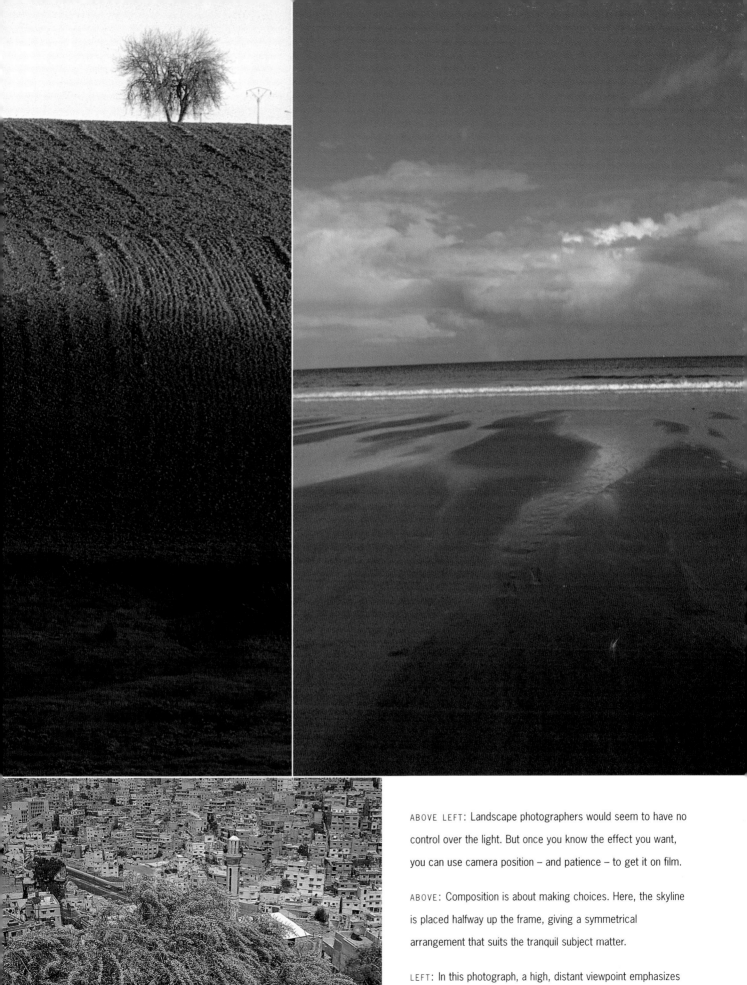

ABOVE LEFT: Landscape photographers would seem to have no control over the light. But once you know the effect you want, you can use camera position – and patience – to get it on film.

ABOVE: Composition is about making choices. Here, the skyline is placed halfway up the frame, giving a symmetrical arrangement that suits the tranquil subject matter.

LEFT: In this photograph, a high, distant viewpoint emphasizes the pattern in the houses.

PART ONE

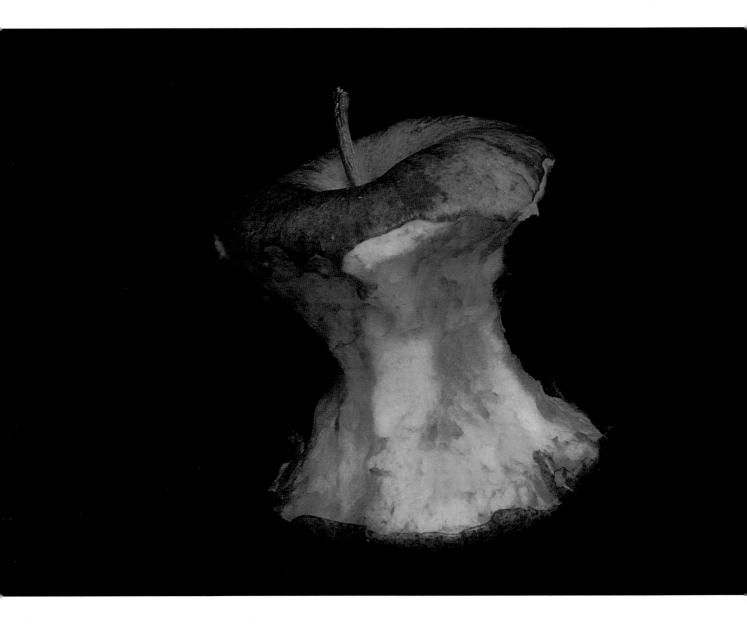

Essential elements

Touch of colour

Colour is the most powerful of the essential elements within a subject – even small patches of it in an otherwise monochrome scene will immediately attract the eye.

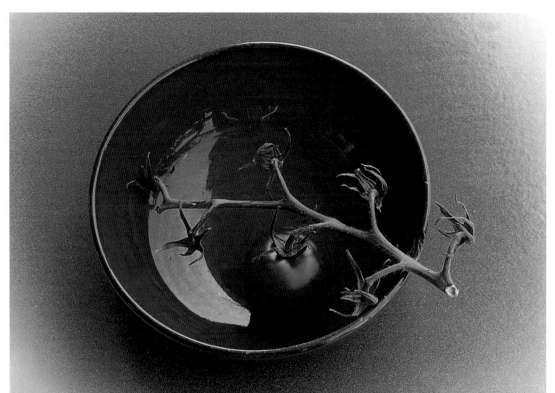

LEFT: A red bowl and a bright red tomato create a deeply saturated picture. However, the combination of reds covers so much of the picture frame, it is the green stalk that actually becomes the focus of our attention in the shot.

THE FIRST STEP in learning how to spot a potentially great photograph is having an understanding of the basic elements that make up all pictures. Shape, form and colour can be found in everything you point your camera at – from the studio still life to the athlete in the stadium. However, most frequently we can usefully accentuate just one of these elements at a time.

Of all the basic elements, it is colour that draws the greatest – and most immediate – emotional response. We all have our favourite hues and dislike certain colour combinations. In addition, however, some colours attract the eye more strongly. The primary colours, and red in particular, immediately draw us to that part of the scene. ▷

RIGHT: Even in subdued lighting, powerful colours can still be used effectively. Here, pink blooms stand out against the more 'natural' greens of the foliage and the browns of the wood and clay. By underexposing the picture slightly, the dark background is made darker, whilst the colour of the flowers is boosted.

LEFT: Odd one out. The human brain has the ability to quickly spot breaks in a pattern. Here, it is not the brightly painted faces that we come to rest our eyes on when we look at this composition, it is the white one – because it looks out of place.

PRACTICAL TASK

■ Find a red fruit – such as a tomato – and try and photograph it so that its colour dominates the image.

■ Use dark or light-coloured backdrops that show up the colour of the fruit well.

■ Arrange your set-up so that the lighting source – such as a sunlit window – is behind, or slightly to the side, of the camera.

■ Take several shots of each set-up at slightly different exposures, so as to show how the saturation of the red is affected by under- and overexposure.

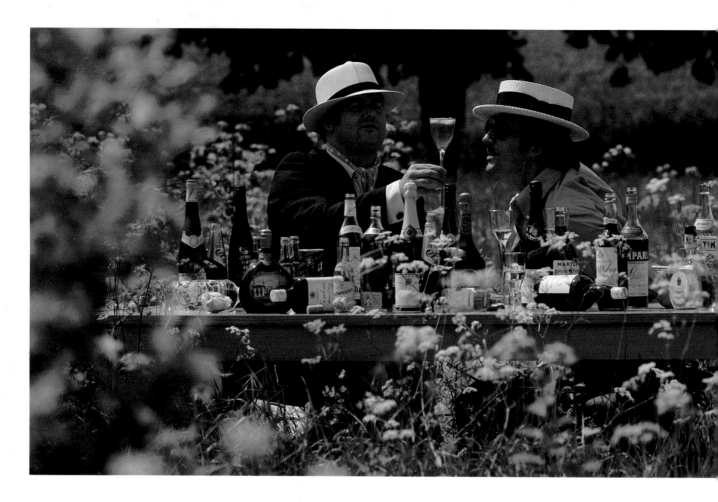

ABOVE: In this shot, the faces of the two men are obscured because they are in shadow. However, the glass becomes the main focus of attention, because the backlighting helps accentuate the redness of the wine.

See also:
→ PAGE 16
Brimming with colour – combining different bright hues to achieve a kaleido-scopic effect.
→ PAGE 134
Direction of lighting – from sidelight to rimlight, how the position of the light source in relation to the camera will affect essential elements, such as colour, form, tone and texture.

Touch of colour

This is a property that you can use to your advantage when arranging a subject in the studio. Even a small splash of red within the frame will immediately grab the viewer's attention – even if the rest of the scene is made up of less powerful hues. Like a highlighter pen on a typed page, these colours add an accent to your pictures.

When you are away from the studio, you have less choice as to the subjects you use. But hunting out strong colours – such as a poppy in a field of wheat – and then isolating them with your lens will immediately give you a powerful subject to work with.

As well as reds, bright reds and bright greens will also create similar effects – particularly if these are shown against a more neutrally coloured background. Other bright colours can also work well, especially when found on man-made materials. A purple plastic flower pot or a pink dress can dominate a picture if shot in the right way.

To help accentuate the colour, use direct lighting – with the light source (such as a window) positioned slightly to the side, or behind, the camera. This frontal lighting shows off colours better than sidelighting or backlighting (although backlight is essential when trying to show off the colour of translucent subjects). Underexposing the picture very slightly will also deepen the hues.

Sometimes, you can reverse this effect in a clever way. Imagine you are photographing a box of red apples. The scarlet skins dominate the composition, so the power of this primary is diminished. However, if you were to replace just one of these fruits with a green or yellow apple, it would be this that would immediately become the centre of attention within the composition. Here, it is the juxtaposition that makes the picture.

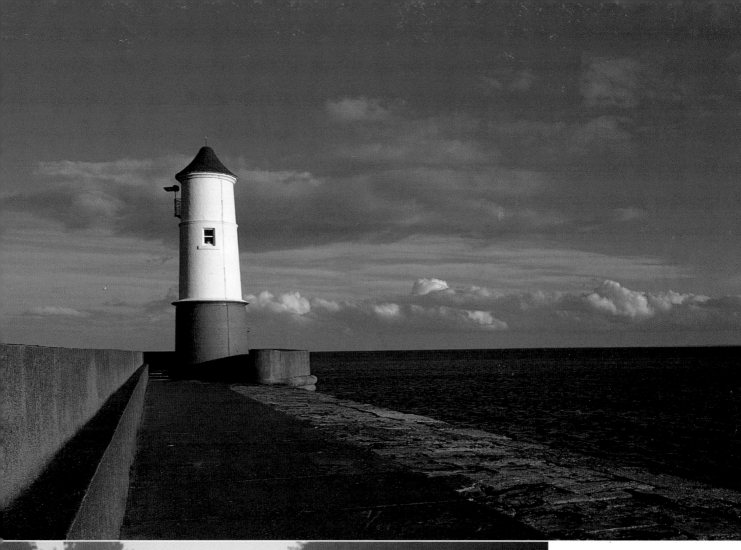

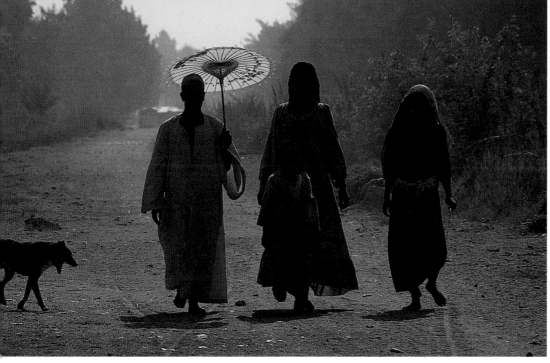

ABOVE: Red and blue can create a particular potent combination in a picture, as red tones seem to leap forward, whilst blue tones of the sky appear to recede. Brightly coloured structures, such as this red-and-white-striped lighthouse, are great photographic subjects. With the sun over my left shoulder, the paintwork shines bright, whilst still providing enough shadow to show the cylindrical form of the tower.

ABOVE: Even pale colours can create a strong focus of attention if placed against a darker, or more drab, background. Here, it is the beige tones of the parasol that grab the eye. The three figures and the dog are thrown into silhouette as the sun is in front of the camera, giving scant detail for us to look at, and precious little colour. However, the material of the umbrella glows because the light shines right through it.

Brimming with colour

Just as when decorating your living room, bright colours need to be combined with care when they are to appear together in the same photographic frame.

WHILST STRONG colours can create an immediate impact when used in isolation in your pictures, you need to take a more measured approach when combining them in the same composition.

Just as you might only wear a purple shirt with red trousers if you intended to shock or amuse people, if you unite such colours in a single frame you can't expect to get a harmonious result. Clashing colours can be used for effect, but such psychedelic results are normally to be avoided.

There are, however, strong colour combinations that will provide dramatic, vibrant results, but use with care. ▷

RIGHT: A brightly coloured painting and a natural-coloured sunflower make an unusual combination for a still life. The colours, if lit brightly, would have not blended together well. However, by using muted lighting, the colour scheme has avoided dominating the composition.

THE COLOUR WHEEL

The colour wheel can be a useful tool for helping us understand how different colours interact. Around it are the three primary colours – red, yellow and blue. In between these are the colours achieved by mixing two of these primary colours together – the so-called secondary colours of orange, green and violet. For the most striking colour contrast within a picture, a primary is juxtaposed with the colour directly opposite it on the colour wheel, known as its complementary colour. For red, the complementary colour is green, for blue it is orange, and for yellow it is violet.

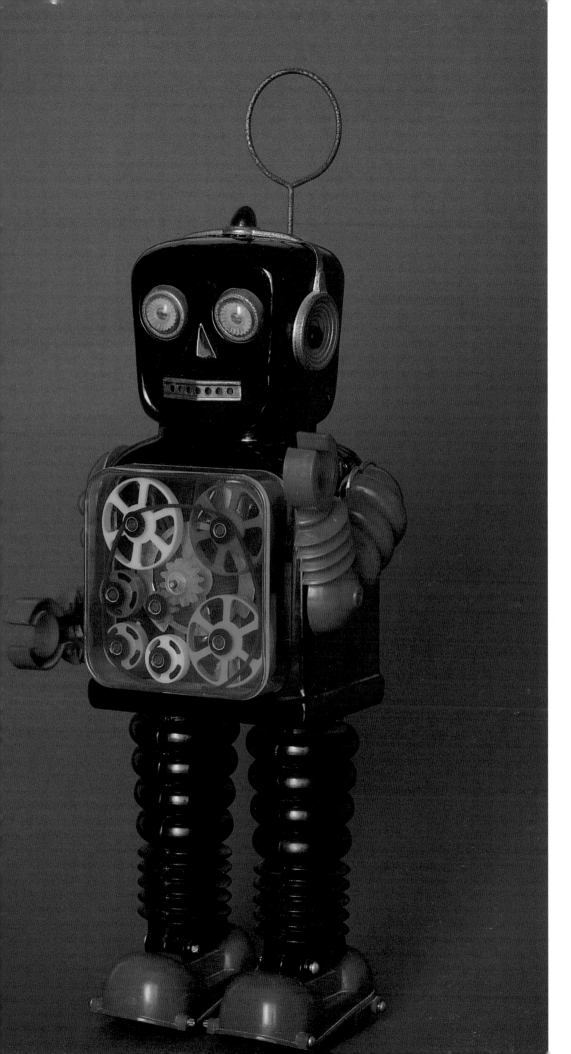

LEFT: Children's toys are often designed in a bright combination of colours which are designed to appeal to young eyes. This robot combines a full selection of primaries, with the dominant red creating a powerful partnership with the green eyes. I deliberately chose a plain, dark-coloured background for the subject so as not to add any more confusion to the colour scheme.

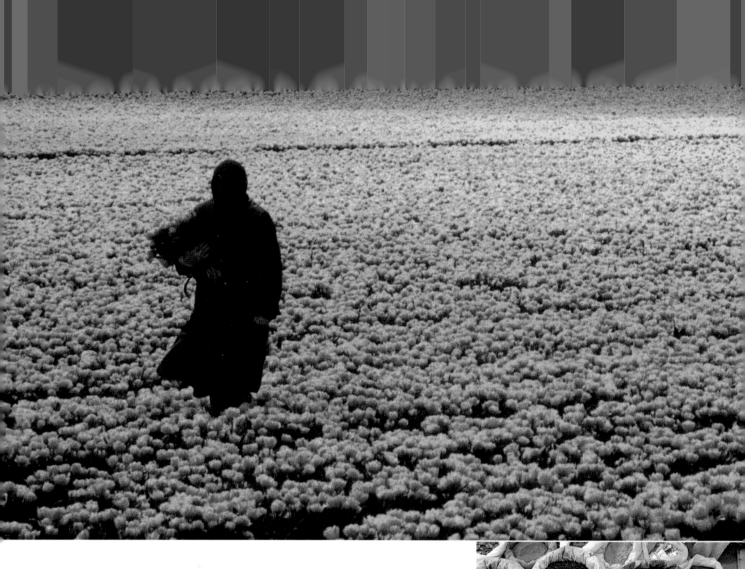

Brimming with colour

Colours that look particularly strong together
are those that are far enough away from each
other on the colour wheel so that they do not
clash. Red and green, for instance, are perfect
partners if you want to create a strong, vibrant
combination. The three primary colours of
red, blue and yellow can also be used with
great success in pairs.

Whilst you can control these combinations
in the studio, by carefully choosing still-life
subjects, props and backgrounds that work
together well, it is not always possible to do
this when you have less control of the subject.
Man-made objects, for instance, are often
decorated in a riot of colours, such as a fair-
ground ride. Often this is done to grab
people's attention, or to appeal to children.

Natural colours can also be riotous, such as
the combination of hues on a florist's stall. But
as we are accustomed to such sights, we can
take the colour cacophony far easier. We can
use such sights to present a study in colour.
Alternatively, you can subdue the effect by
making the rainbow-coloured subject just a
small part of the frame – or by using a type of
lighting that helps to restrain the bright
shades (such as waiting for the sun to go
behind the clouds, or shooting into the light).

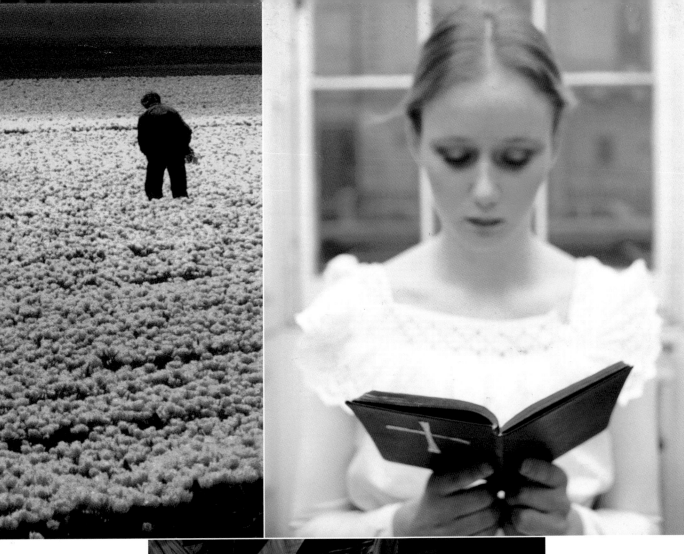

OPPOSITE: The intense colours, shapes and textures of an oriental spice stall are irresistible to the photographer. Here, the orange-yellow and red spices create an almost conflicting presence.

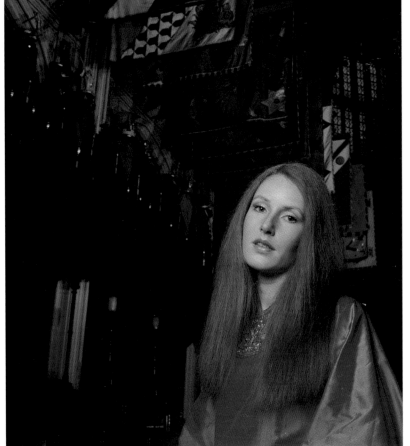

RIGHT: The intense colour of this lady's dress could have really jarred against the bright flags behind her. However, by using flash, only the foreground is lit adequately, throwing the background into relative darkness, so the cathedral decorations do not conflict.

ABOVE: The intense blue of the window here is created by using tungsten film. This gives blue results when used with daylight. However, the model is lit with tungsten bulb lighting, giving a natural colour balance. The red book, meanwhile, is framed and intensified by the white of the girl's white dress.

Harmonic colour

If you want to show the subtlety of the colours of the things around us, it is worth arranging your still lives to use a limited range of hues that blend together well.

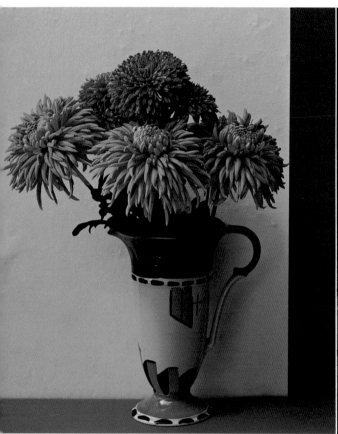

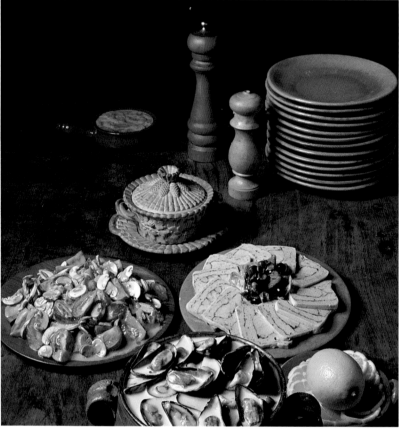

ABOVE: White is almost always a safe option for a background when setting up a still life in the home studio. Here, it isolates the colour of the flowers nicely, whilst the terracotta frame around two sides of the picture goes nicely with the yellow-orange blooms.

THE BEAUTY OF STILL-LIFE shots, as we have said, is that you are in control. The subject and lighting can be arranged in many different ways until you are happy with the results. But the starting point has to be the arrangement of items that you choose to photograph in this way.

Perhaps the simplest way to pick items for a still life is to select things where all the colours match – or at least harmonize together. You may just have one central subject, such as an avocado. But for a more interesting composition you may well add a plate and an additional prop, such as a bottle. You will also have to choose a suitable surface

ABOVE: Complex shots with lots of subjects are best arranged with a simple colour scheme. Here, I combined a brown surface with wooden and pottery props to create a common colour linking the different foods together.

OPPOSITE: Metal props, such as steel knives, pewter plates and the silver ladle used here, work well in any colour scheme. The white bull also blends in well, but its lighter colour means that it becomes the focus of attention in the shot in this predominantly brown set-up.

to put the plate on, and something else for the background. If you pick a red plate, a blue backdrop, and so on, there is a good chance that the composition won't work together. ▷

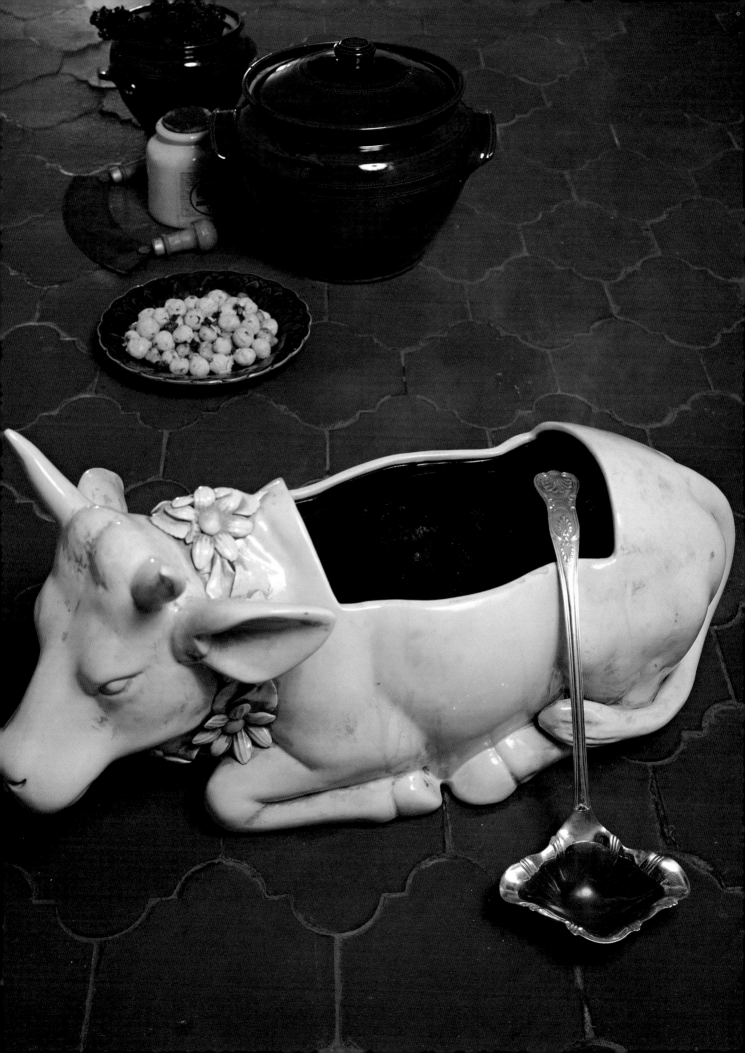

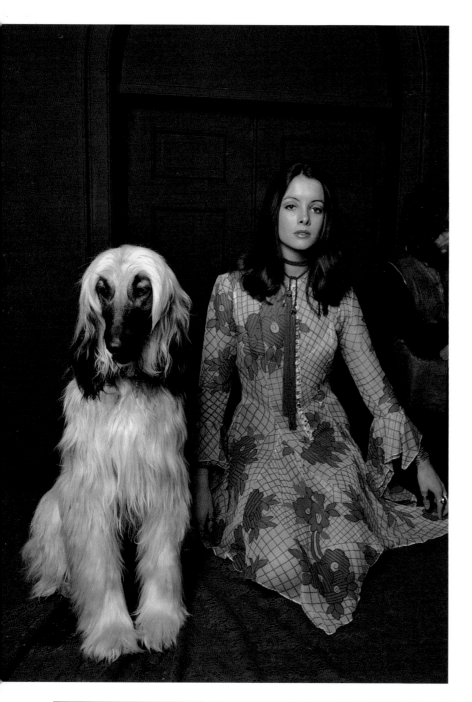

Harmonic colour

To make things easier, choose colours that harmonize, matching the colour of the subject. Other colours may be used; browns will work well, allowing you to use a wooden backdrop, for instance. Blacks work with most colours, as do whites, although these can be too bright alongside darker colour combinations.

Using one colour scheme is an even better recipe for success when shooting more complex still lives, as it will help to unite the different objects within the frame in a way that would not be possible with a more luxurious colour scheme. Such pictures rest easy on the eye, as the limited colour range can bring an immediate peace and tranquillity to the scene.

Using a restricted colour scheme will also make the task of lighting the subject that much easier. Whether you use strong, harsh lighting or soft illumination, the colours will still work together. Exposure will also be simplified, because you have avoided having excessive contrast within the frame.

LEFT: When photographing people, don't forget that you can ask them to change their clothes so as to blend in with a particular colour scheme. Here, it was the dog that suggested the palette to use. The woman volunteered to wear a brown dress, whilst I arranged a dark background to photograph these two subjects against.

COLOURS FROM THE SAME PALETTE

As well as the primary and secondary colours (as discussed on page 16), the colour wheel also includes small sections of intermediate colours, such as yellow-green, turquoise and olive. In fact, in these areas there is a myriad of slightly different shades. A good indication of the range of colours can be found in paint-mixing charts found in DIY stores, which can literally show hundreds of different shades of yellow or blue. To get colours that go together harmoniously, they should be as close to each other in the colour wheel as possible – and certainly from within the same quarter of the wheel. To these we can add the whites and blacks, which should harmonize well with any other colour palette.

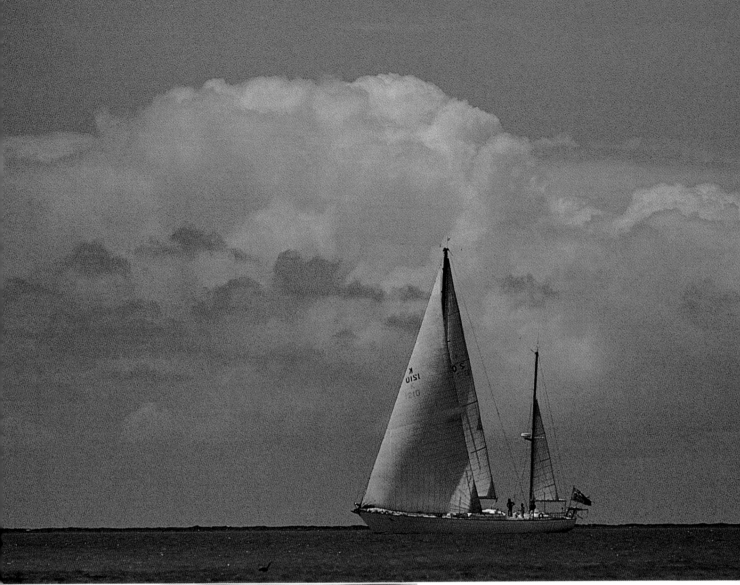

ABOVE: High ultraviolet light levels and miles of reflective sea and sky combine to make ocean shots appear rather more blue than they are in reality. However, the result can sometimes provide a more atmospheric, softer result, as in this picture of a yacht in the Caribbean.

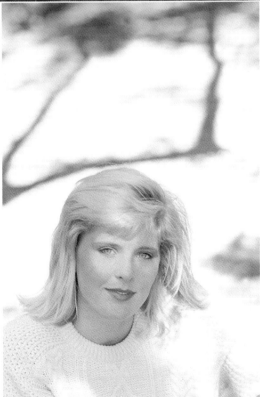

RIGHT: A classic way in which to photograph models with blond hair is to use a high-key technique. The scene is set up so the background and clothing are lighter in colour than the hair. The shot is then exposed correctly for the face alone – making the rest of the frame appear over-exposed and predomi-nantly white in colour.

See also:

← PAGE 12
Touch of colour – how a small area of bright colour can be used in an otherwise harmoniously coloured set-up to provide an immediate focal point for the picture.
→ PAGE 82
Simple backgrounds – using backdrops that match your subject, without letting them dominate the picture.
→ PAGE 94
Developing a theme – ways to unite different elements together in a still life so that they gel together.
→ PAGE 104
Colour or black and white? – if you want to avoid problems with colours without changing your props and background, there is always black-and-white film.

Emphasizing form

Shadows play a key role in photography when we want to accentuate the three-dimensional shape of the subject. The secret is to use just enough sidelighting.

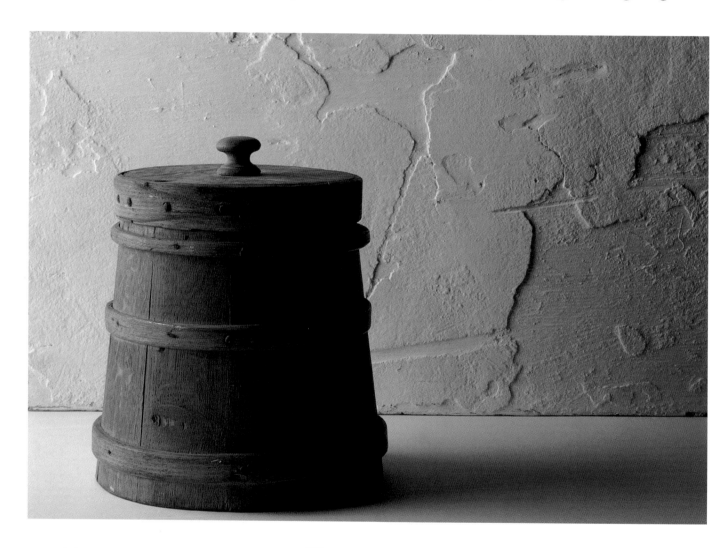

ABOVE: A simple cylindrical container is an ideal subject to practise lighting set-ups for revealing form. Here, the lighting is provided from a window to the left of the subject. The white walls and white shelf have reflected enough window light so that there is just enough detail visible on the unlit side of the object. Alternatively, a large piece of white card could have been placed just out of view on the right side of the barrel.

FORM IS THE three-dimensional shape of an object. But with a two-dimensional photograph this property is not always evident. A ball, for instance, can appear circular rather than spherical – particularly if it is lit directly from the front or from the rear.

Without the telltale pattern of shadows across the surface, the photograph gives nothing away about this vital third dimension. By using sidelighting, however, the resulting gradation of tone provides vital clues to the true form, adding the illusion of depth. ▷

OPPOSITE: I shot this set-up from above, with a diffused light to the side of me highlighting the form of the peas in the pod. The gradation of tones emphasizes their spherical shape.

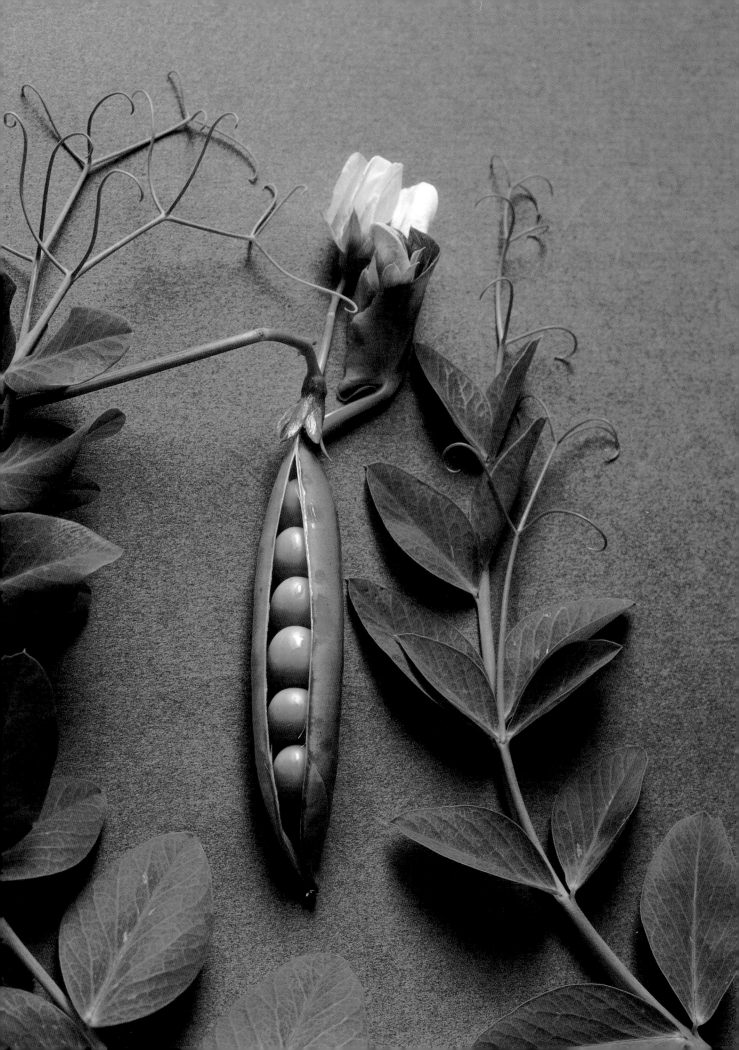

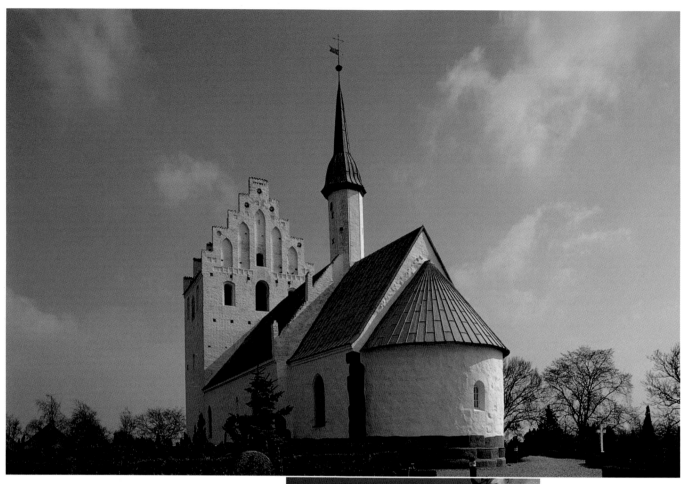

Emphasizing form

How strong this sidelighting needs to be will depend on the complexity of your subject. Direct sidelighting may be adequate for a simple object, such as a single orange. But this harsh lighting will throw much of the detail into shadow, and will not be suitable for groups of objects or complicated shapes.

Soft directional lighting gives a more detailed suggestion of form, with an increasingly gradual line between the highlights and shadows. A fill-in light or a simple reflector can then be used to add back just enough detail to the unlit side of the object.

RIGHT: The late afternoon sun produces a soft, warm-coloured light that is ideal for portraits and studies of the human form. In this sort of situation, you can angle the model to get the right degree of emphasis.

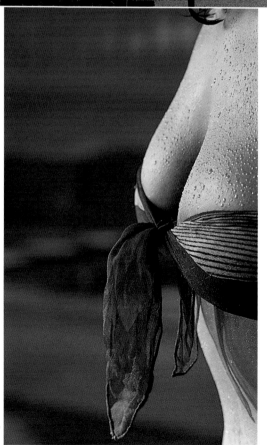

ABOVE: Some of the many surfaces of the church are caught by the sunlight coming from the side, whilst others are not. This pattern of light and shade helps to accentuate the elaborate three-dimensional structure.

OPPOSITE: Sidelighting works well with portraits, but it needs to be subtle. Here, the main light is placed at 45 degrees to the camera, and a smaller fill-in light is placed on the other side of the camera to add some detail to darker side of the face.

Emphasizing texture

If you accentuate the texture of a subject, the viewer will be able to imagine what it would be like to touch the subject. But texture can reveal a lot more information as well.

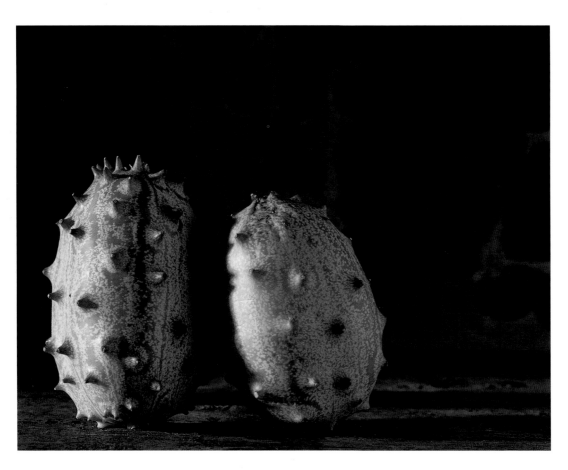

LEFT: Fruit and vegetables provide ideal subjects for revealing texture. Oranges, cauliflowers, and so on, are easy to practise with at home. Here, it was possible to reveal the prickly texture, as well as the form, of these exotic fruits by using a single sidelight to the left of the camera, with a reflector to the right of the set-up.

OPPOSITE: By getting in close, a piece of wood is turned into a pictorially pleasing image, revealing the contours of the grain. The subject was lit with a single flash unit placed so that its light raked across the surface, throwing the contours into high relief. Many otherwise mundane subjects can be transformed when they are photographed in this way.

IN MANY WAYS, TEXTURE is a sub-element of form. It describes the three-dimensional shape of an object in more detail. It tells us what the surface of a subject is like – how smooth, how rough, how hairy, how pitted. And so, it adds something that pictures can't show, it offers the viewer some idea of what it would be like to touch the surface of the object. Just like form, texture provides three-dimensional information because surfaces are very rarely flat, even if they appear smooth from a distance. If photographed from close in enough and with the right lighting, they reveal a hidden landscape of miniature craters and lines.

To accentuate texture in a photograph, you need lighting that is similar to that used for revealing form. But whilst sidelighting is useful for subjects, what you ideally need is oblique light that scours the surface of the subject, casting shadows in the hollows and creating little highlights on the mounds. The exact angle of the lighting will depend on the angle of the surface being photographed in relation to the camera.

The setting sun, for instance, will reveal the texture of a landscape, whilst the midday sun can be useful in picking out the surface detail of a limestone wall, or the engraving on a weatherbeaten gravestone. ▷

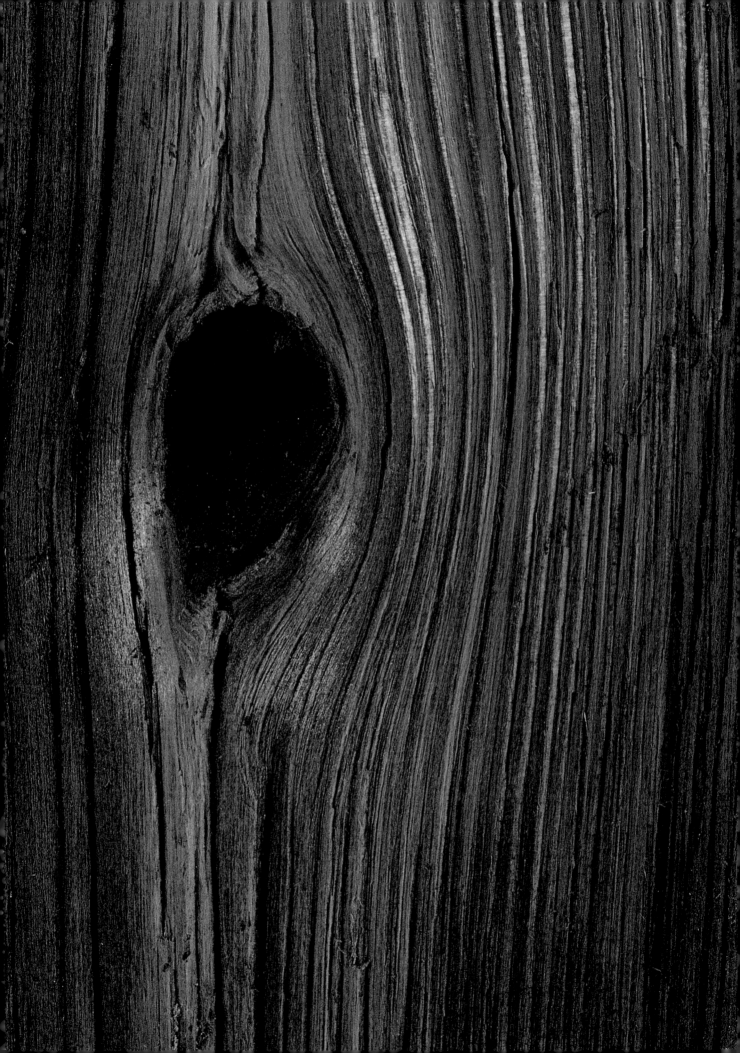

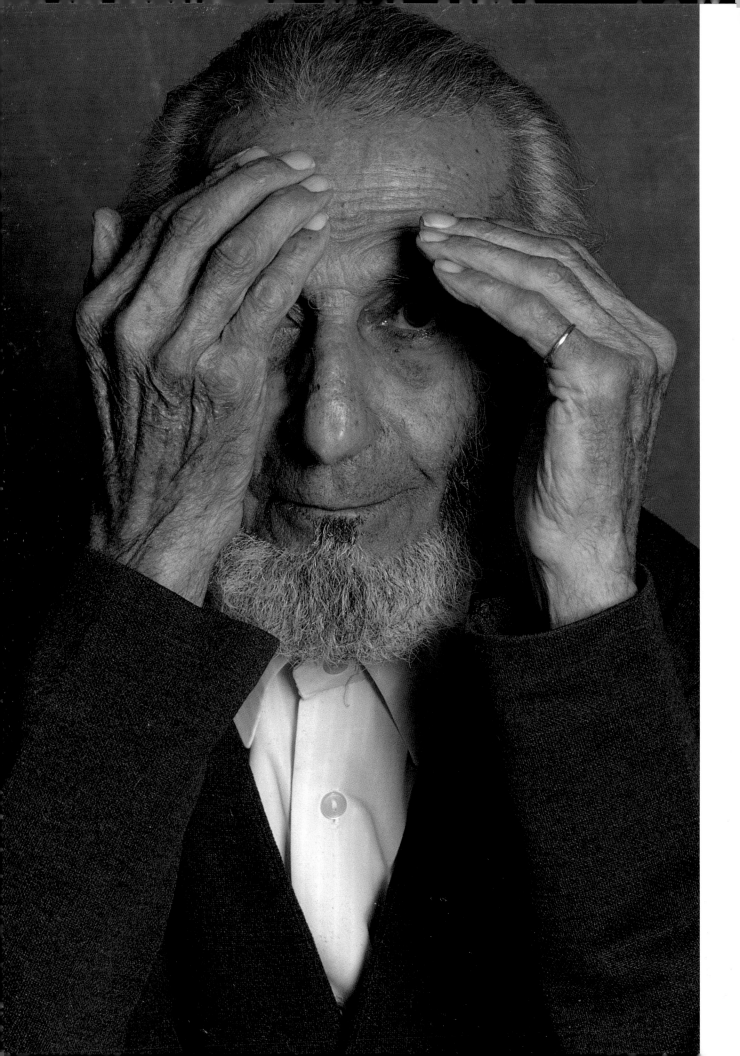

Emphasizing texture

Texture is particularly important in portraiture. It can reveal the wrinkles of an old man or the soft, smooth skin of a baby. It can emphasize the mud on the face of a rugby player, or the sweat pouring off an athlete. It also helps tell us more about the person. Perspiration on a face can suggest the temperature, the sitter's state of health, or how much exertion they are putting into what they are doing. The lines and blemishes on a person's face, or lack of them, suggest their age.

OPPOSITE: It was the quality of his skin which attracted me to photographing this old lawyer, as it not only showed his great age, but its great delicacy.

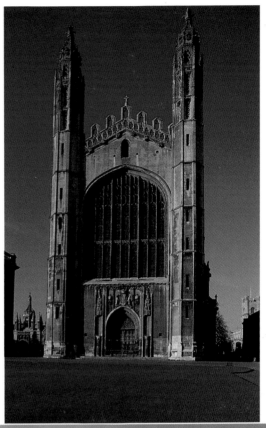

LEFT: Some sidelighting is required when shooting buildings straight-on, otherwise they can appear like cardboard cut-outs. Here, fleeting light reveals the intricate architecture of Kings College, Cambridge.

BELOW: A brief break in the clouds creates a searchlight that sweeps across the landscape. The dappled effect reveals information about the valley that cannot be seen in the shadows.

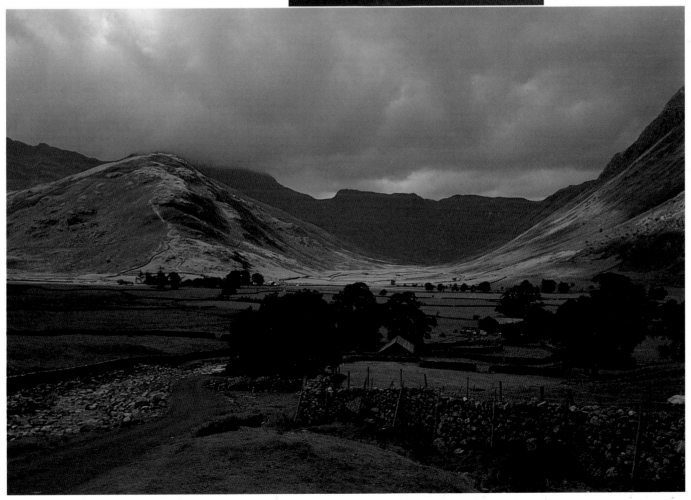

Emphasizing shape

Shape is the most economical of all the compositional elements, since we can identify most subjects from their outline alone, as in a backlit silhouette.

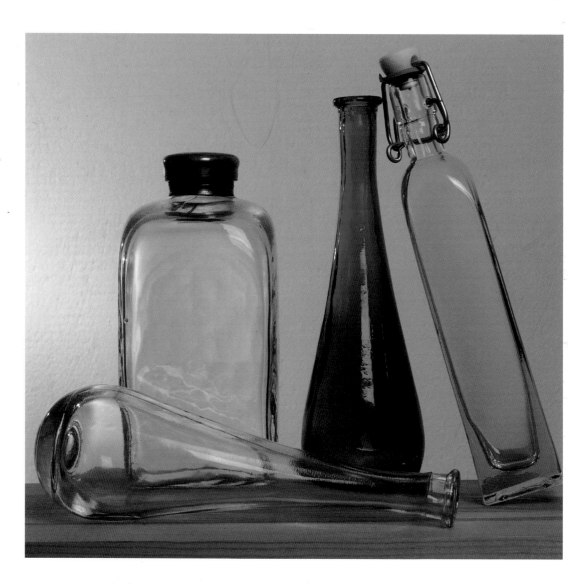

THE VICTORIANS WERE fond of silhouette portraits of themselves. Without form, colour and texture it might seem that these pictures would tell us very little about the identity of the poser. In fact, the shape or outline of a person or object are all we may need to work out its identity.

Shape can be found in every object and can be dictated by its function or design. And for the still-life photographer, hundreds of pleasing shapes can be found around the home. Bottles, kitchen gadgets, jars, ornaments, keys – all have interesting outlines which can be stressed by the way in which they are photographed.

Backlight is the simplest way to emphasize shape alone – with the subject completely covered in shadow, the viewer has no alternative but to concentrate on this one compositional aspect. ▷

BELOW: To capture the ornate shape of this jug, the arrangement was set up by a large window. It is the clear background that ensures that the outline of all the subjects are seen clearly.

ABOVE: We know glass is clear, but what we see is a complex pattern of shadows and highlights. Here, I used a dark wall and daylight from a large window (seen in the top right corner of the picture) to ensure that the overall shape stood out from the backdrop.

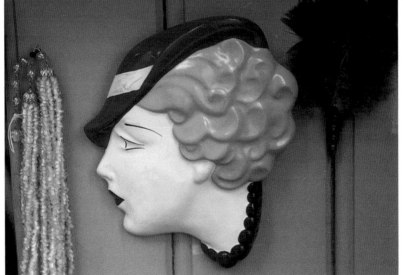

ABOVE: Ornaments, be they kitsch or beautiful, often have great shapes. I photographed this wall hanging using diffuse ambient light, so that the shape of the head shows strongly, whilst its form and its colour remain subdued.

See also:
→ PAGE 40
Creating distance –
making good use of the
foreground in the picture,
whilst still having something
interesting to show in
the background.
→ PAGE 82
Simple backgrounds –
choosing and using
backdrops that merge into
the background, rather than
becoming a dominant part of
the composition.
→ PAGE 134
Direction of lighting –
how backlighting, side-
lighting, frontal lighting and
rimlighting affect the way
your subject appears, and its
colour, shape and form
in particular.

Emphasizing shape

Strict silhouettes are useful because they simplify the composition, masking unwanted detail. But they can also challenge, by making the viewer want to see more. However, they are more useful outdoors, where larger, moving, subjects can be tackled this way. At a sporting event, you have little option but to take a shot into the sun, so shoot low down against the sunlit sky, where it creates an uncluttered backdrop against which to frame the shape of the competitor.

Shape, however, can also be emphasized in more subtle ways without losing all detail in the subject's hues, surface and depth. And this is the approach that will generally be more useful in the still-life studio.

The secret here is not only to choose a backdrop that is as plain as possible – but also to ensure that it contrasts strongly in tone or colour with the subject itself. The backdrop should also be large enough to show the subject in its entirety.

Remember that the shape of a subject changes depending on the camera position and on its orientation; many objects will be much more recognizable when from their shape alone when shot from a certain side.

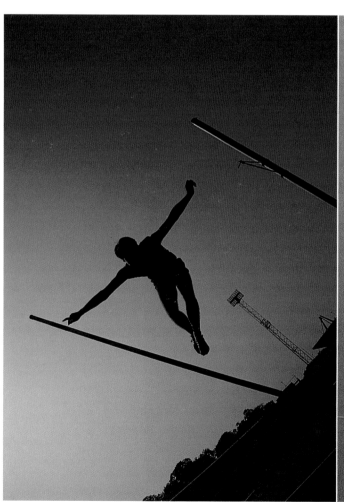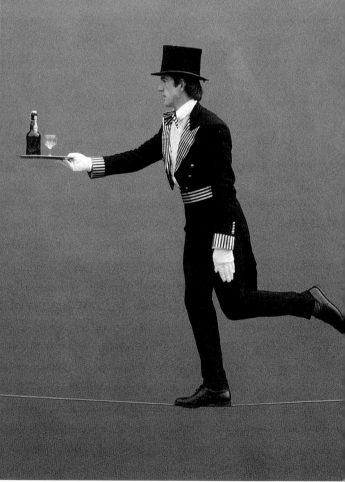

ABOVE: A classic outdoor silhouette. The figure is completely in shadow, but not only can you clearly see that it is a pole-vaulter, you also get a sense of the art and athleticism of this spectacular sport.

ABOVE: The deliberate poses of a tightrope walker are all about showing off balancing skill. To ensure that you can see exactly what is going on, a neutral-toned background is needed to show the outline of the white and black clothes.

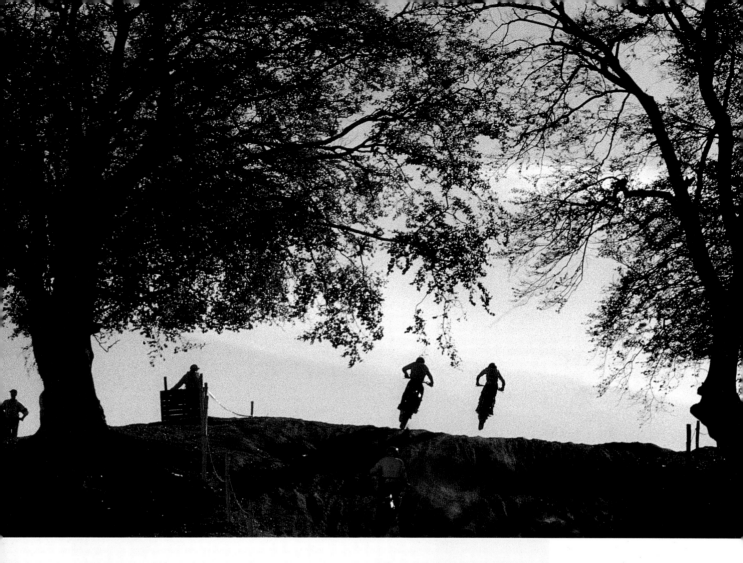

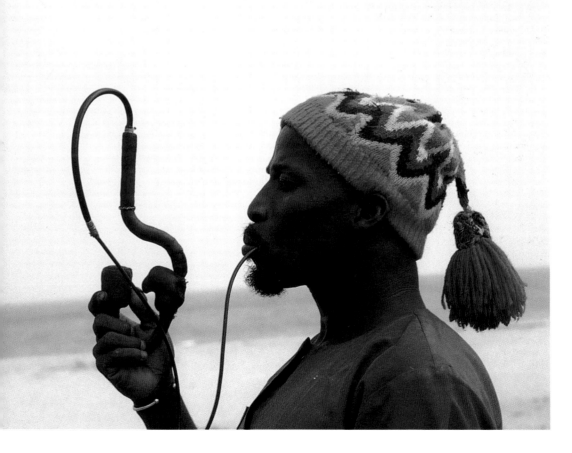

ABOVE: Quite complex scenes can be shown in silhouette – as long as the individual shapes are not overlapping. The motorcyclists and trees are immediately recognizable, despite being in silhouette. In this sort of situation, take a meter reading to expose the sky correctly.

LEFT: Although practically a silhouette, this shot was achieved by under-exposing the shot, rather than by backlighting. The result shows off the pipe and hat against the coastal backdrop.

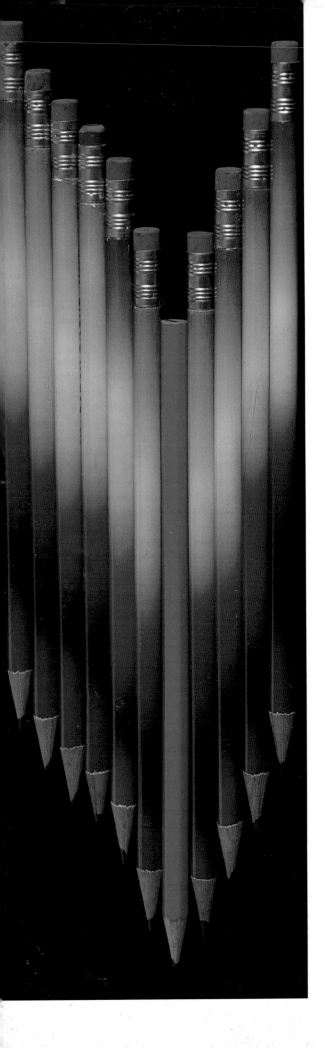

Emphasizing
pattern

Filling the frame with uniform shapes allows you to create a decorative pattern. As long as you can get hold of enough of them, almost any kind of object will work using this approach.

Patterns can be found in practically everything that you look at – the bricks in the wall, the baked beans on your plate, or the bottles on the supermarket shelf. They occur readily in nature, too, from the similarly shaped leaves on a tree to the geometric shapes on the skin of a pineapple.

Such patterns are so commonplace that we rarely think or look at them. But the camera's ability to pick out details and show them in a new light means that such images can be very rewarding for the photographer.

The way of doing this, more often than not, is to move in close with the camera, cropping out extraneous detail from view so that the pattern is plain to see. Sometimes, this will mean using close-up and macro equipment, so that you can get in near enough. Or you may need to zoom in from a distance with a long telephoto lens. However, there are so many of these patterns around us, indoors and out, that specialist equipment is not essential. ▷

OPPOSITE: By placing home-grown carrots together, you begin to notice the slight differences in their shape, as well as the similarities. I shot them from above, lying on a piece of weathered stone, using slight sidelighting to help to emphasize their form, as well as their rich colour.

LEFT: All manner of household items can be used to create interesting and colourful patterns. Here, rainbow-coloured pencils were arranged to create an interesting display. The blue pencil becomes the centre of attention because it is the odd one out. For shots like this, use black velvet as a background to place the subject on – it is non-reflective, so will look black on film.

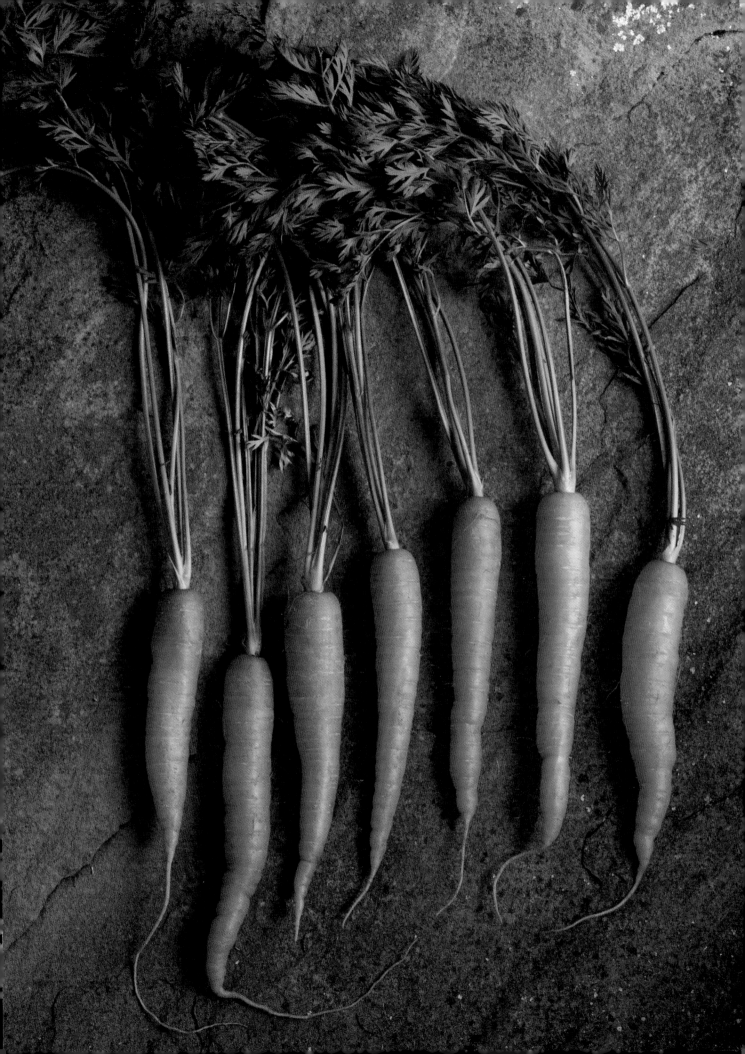

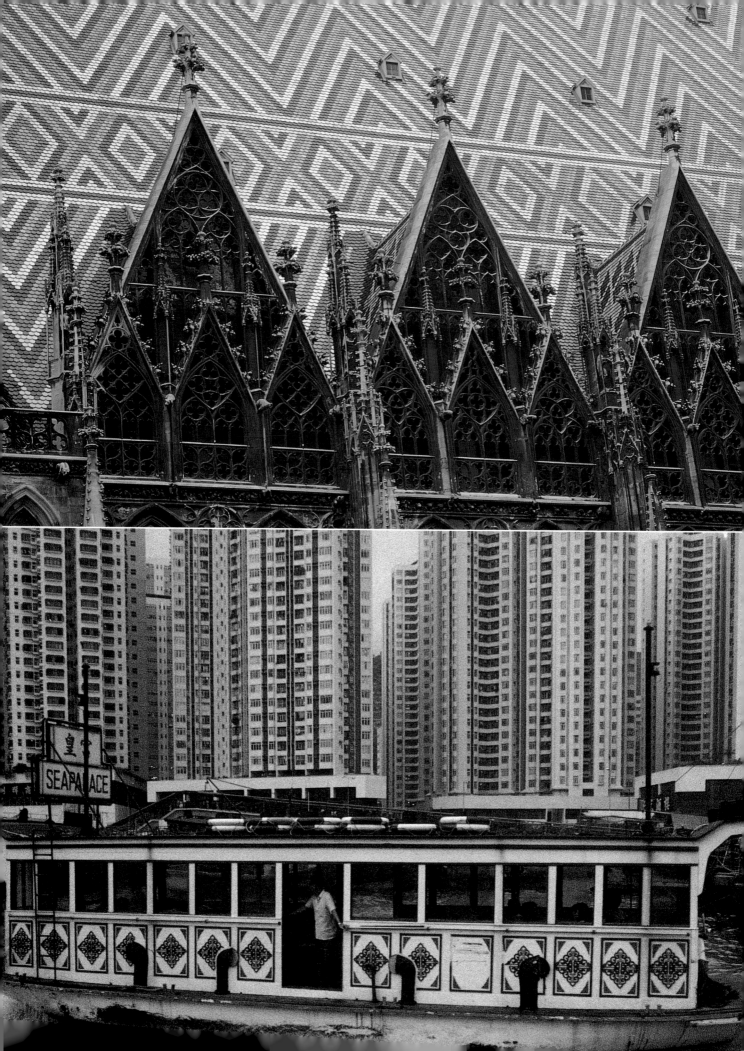

OPPOSITE ABOVE: Architecture is full of pattern. This famous roof of Vienna cathedral uses a zig-zag mosaic of tiles mimicked by the intricate stonework below.

RIGHT: Light and shadows frequently create shapes which are interesting to photograph. Here, the arch-shaped shadows overplay a detailed background, to create an overall pattern.

OPPOSITE BELOW: The box-like structures of high-rise buildings in Hong Kong harbour create a highly repeated pattern. Rather than cropping in close, I framed the shot to include the similar, but larger, pattern of the boat in the foreground.

Emphasizing pattern

In the home it is easy to create your own patterns by grouping together all manner of objects that are found in quantity around the house. Choose something with interesting shapes, such as dried pasta or wood screws. Alternatively, go for something with good colour, such as a tray of apples, plastic-covered paper clips or a pack of felt-tip pens.

Spreading these out as evenly as possible stresses the pattern, whilst a straight-on camera position ensures that they appear the same size on film. The important thing is to make sure that you have enough of them so that they fill the frame without any extraneous background showing through; lay the objects on a sheet of black velvet, particularly with smaller objects.

The lighting that you use will depend on the subject. If it is the uniform form you want to stress, then go for sidelighting. If you want to make the most of the colour of the objects, a more frontal lighting position is called for. But whatever the direction of the lighting, it is best if it is not too harsh; soft directional lighting will provide a certain amount of modelling or colour saturation, without the study being ruined by a mass of shadows.

Out of the studio, you need to train your eye to spot the patterns that are already around you, rather then constructing them for the camera. If you make a conscious effort to go out and just take shots of pattern, you will soon find that they are everywhere.

Don't be afraid to get in close or use a longer lens setting to help stress the pattern. By removing the pattern from its surroundings, you will often end up with a more teasing, abstract picture.

See also:
→ PAGE 66
Frames within a frame – examples of still-life photographs using apples to create a mosaic-like pattern.
→ PAGE 132
Specialist lenses – choosing and using macro lenses to photograph miniature subjects up close.

Creating distance

Although photographs are always two-dimensional, there are a variety of ways that you can add depth to your pictures to make up for that missing third dimension.

IN THIS CHAPTER, WE have already looked at how shadows can be used to create the impression of three-dimensional form on a two-dimensional photograph. But there are other ways to suggest depth.

In fact, adding depth to a photograph is one of the skills that the photographer has to continually work hard at, so that images convey more than a cardboard cut-out.

Two of the main tricks are composition and depth of field. Various techniques can be used to structure the elements of the picture that lead the eye through the scene, suggesting that some things are further away than others. Perspective is useful here, because although we have a good idea of the size of a fully grown tree, say, we know that it will appear smaller the further away it is from us.

Depth of field, meanwhile, can be used in different ways. In some shots, where there is a substantial distance from the foreground to the background, it is essential that we keep as much of the image sharp as possible. At other times, we can suggest depth by throwing the background out of focus.

For the still-life photographer, having subjects at markedly different distances from the camera creates particular problems. Even using every method, depth of field can only be stretched so far with most cameras, so it may be impossible to keep both background and foreground sharp. ▷

PRACTICAL TASK

■ Pick a fine, still day.

■ Make a picnic using colourful and photogenic foods that make interesting props.

■ Find a scenic spot overlooking an attractive landscape or building. Arrange the picnic as a still life.

■ Use your camera to check that you can isolate the still life from the background, and that you can surround the picnic with an area of uniform colour or pattern.

■ Use a tripod so that you can use the smallest aperture available with the lens that you are using, to guarantee that as much of the scene as possible is in focus.

■ Wait for the light to evenly illuminate the foreground.

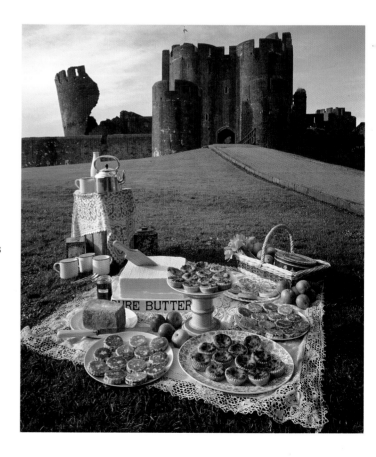

RIGHT: In this shot, the grass forms a double purpose. It creates an immediate uniform canvas on which to lay out the food, and its border, with the drive on the right, makes a strong diagonal line which draws the eye from the foreground to the impressive castle in the distance.

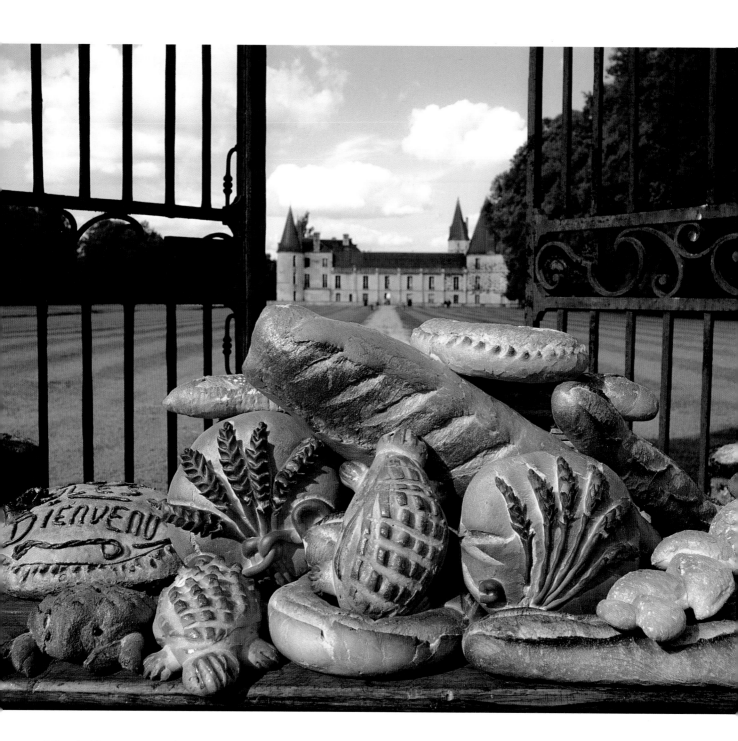

ABOVE: A French château creates a subtle backdrop for this display of ornate bread. I partially closed the gates to create a frame for this arrangement, and positioned them so that the castle does not overlap the still life in the foreground. The drive, converged nicely by the wide-angle lens, leads the eye between the two subjects.

See also:

→ PAGE 74

Low-angle approach – varying the height of the camera can help to emphasize the foreground in your pictures.

→ PAGE 118

Depth of field – three main factors control how much of a picture is sharp: the aperture, the focal length and the focused distance.

→ PAGE 128

Wide-angle lenses – short-focal-length lenses are not just useful for 'squeezing' panoramas and big buildings into a single frame – they also provide great depth of field. But you have to work hard not to leave large areas of the foreground blank.

Creating distance

The other problem is that even when using the smallest aperture and a wide-angle lens to keep everything in focus, the different elements start merging with each other. The solution is often one of camera height. If we raise the camera high enough, the different elements may not overlap, allowing us to have, say, a fruit bowl in the foreground and a garden statue in the background.

The one advantage that the still life photographer has is that subjects do not move – so that the shutter speed used is rarely important. This means that the smallest aperture on a lens can always be used – as long as the camera is firmly fixed on a tripod. With other subjects, depth is more readily suggested by the context – but still you need to work at it to ensure that the picture works.

Wide-angle lenses, for instance, are good for creating immediate depth – but the disadvantage is that they can create an empty foreground. You inevitably need to search out good ways to fill this featureless area, without detracting from the rest of the image. In landscape shots, for example, you can often move your camera position, and crouch down low, so that an interesting boulder or flower fills the otherwise bland expanse of grass. In street scenes, you can wait for an interesting vehicle to pass, to fill the black expanse of road in the foreground.

OPPOSITE TOP: Gondolas made an obvious choice for filling the foreground in this shot of Venice. However, to get them to appear large enough in the frame, I had to wait until they were near enough to me. They also help to suggest depth, because although we know they are the same size, the one further away from us looks smaller.

BELOW: By moving a table in front of where I was standing, I filled what could have been a large expanse of carpet, as well as adding complementary detail. An aperture of f/22 and a tripod kept everything sharp.

ABOVE: With action subjects, the need for long telephoto lenses and fast shutter speeds usually precludes using small apertures. However, in this shot, the fact that only one of the motorcyclists is critically sharp means that the eye is more readily drawn to the crash, whilst the out-of-focus rider helps to suggest depth.

OPPOSITE BELOW LEFT: Here, I could have used a more telephoto lens setting and still retained enough of the waterfall to convey the scene. However, by using a 35mm wide-angle lens and crouching down, I was able to fill the foreground with the beautiful lichen-covered boulder. This approach added more depth to the shot.

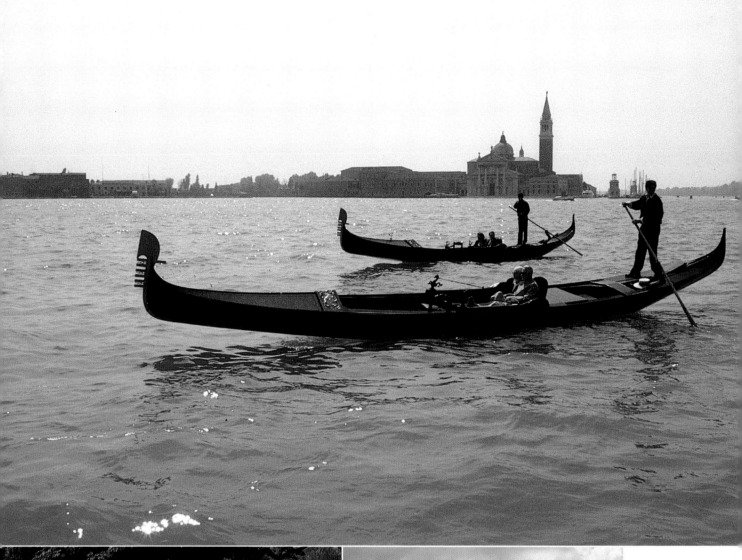

ABOVE: A wide-angle lens is not the obvious choice for a portrait, but here it allowed me to include the sweeping lines of the cornfield and cloudy sky. I got close enough to the model to ensure that she fills the bottom of the frame.

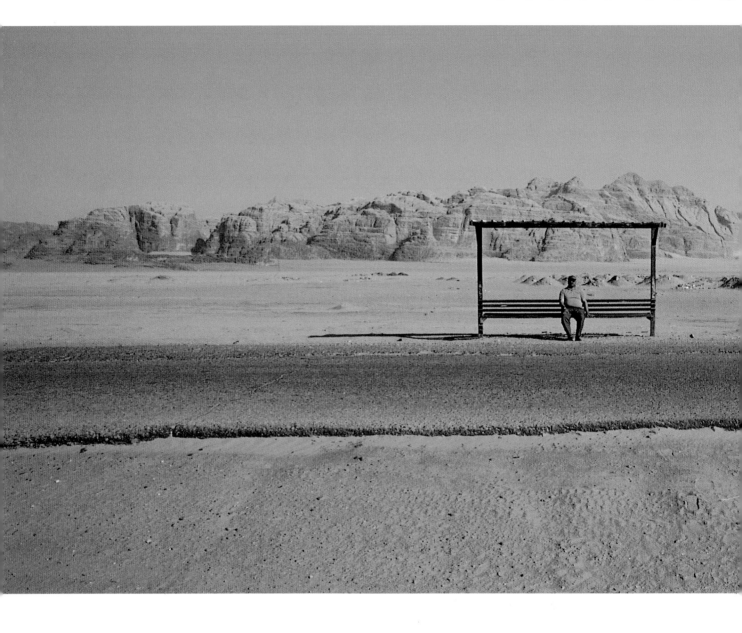

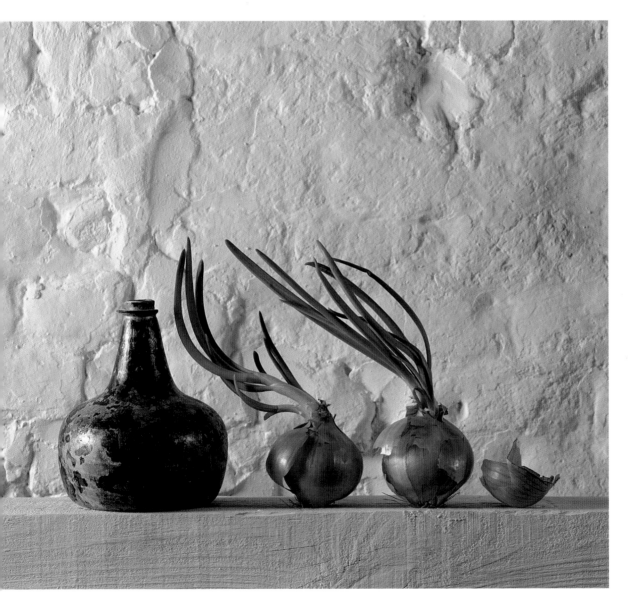

Composition

Simplifying the image

Photographic composition is not so much about what you decide to include in the frame, but what you deliberately leave out. To avoid having too much distracting detail, therefore, it is often best to keep the composition as simple as possible.

THERE IS A BELIEF that picture composition in photography is the same as for other art forms. Whilst many of the guidelines commonly used by photographers have inevitably been passed down by painters, there is a fundamental difference between the disciplines. The artist starts off with a blank canvas, and adds detail until it is judged complete. The photographer, for much of the time, has to do the opposite.

The camera cannot select what gets recorded on the film – once you press the shutter, everything in view becomes part of the image. So the photographer has to decide what to exclude and what to include before the picture is taken. He or she holds up an empty frame, as it were, and places it around an existing subject.

Where this frame is placed is all-important, as the smallest change can make all the difference – whether by moving round the subject, lowering or raising the camera, moving closer or further away, or by changing the focal length of the lens being used. ▷

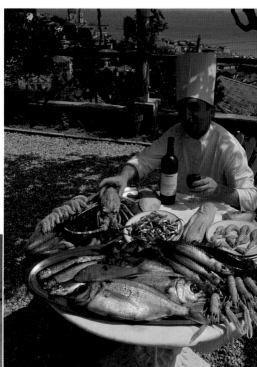

BELOW: Too much – the cluttered background and the addition of the chef mean that you don't know where to look first.

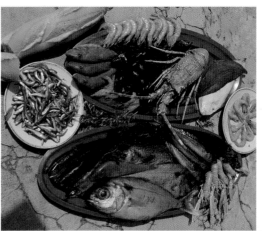

BELOW: This version of the still life tells us more about the location. The addition of the doorway has not been allowed to distract too much, as the use of a wide-angle lens ensures that the plates of seafood in the foreground still dominate the composition.

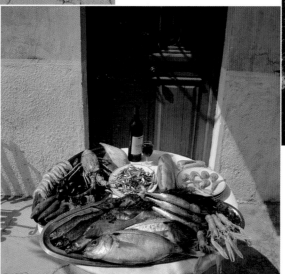

ABOVE: The simple approach – a spread of seafood makes a complex subject on its own. There is a lot to be said for keeping the background as simple as possible – here, a marble tabletop, shot from above, does the trick.

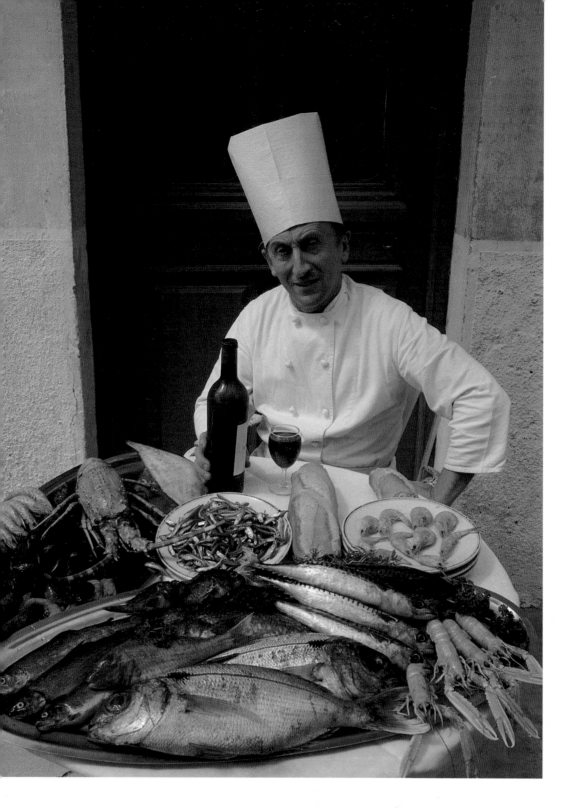

LEFT: The final solution – here, the doorway, chef and platter are successfully united in the frame. The use of the wide-angle lens close up to the table ensures that the seafood dominates the shot. The dark doorway creates a perfect frame for the chef in his white clothes and hat. Neither of the two main elements in the picture distracts from the other. Creating such a composition may require a lot of time, patience and experimentation.

PRACTICAL TASK

■ Take an apple, pear or orange from the fruit bowl and cut it in half. Arrange the pieces into an interesting composition.

■ Take a simple shot first – with the pieces of fruit arranged against a contrasting backdrop, such as a piece of wood or a small white plate.

■ Gradually add more props, arranging the composition from scratch each time. Add more fruit, a knife and so on.

■ Try a more elaborate background, such as a coloured tablecloth.

■ Make sure you take a picture at each stage.

■ Finally, when you have a satisfying composition, transfer it so that you can incorporate your kitchen, garden or house in the background.

ABOVE: How you compose a picture will depend on its purpose. If you were trying to sell the chair and cushions, then the above shot might be useful for a catalogue. But as a portrait, the face of the woman gets lost in the surrounding detail.

Simplifying the image

Unlike paintings, the proportions and frame are not infinitely variable, even though some cameras offer more than one format. You have to make the most of the space available.

As the camera is indiscriminate as to what it records in this frame, one of the key rules of composition, therefore, is to try and keep things as simple as possible. A good picture has a harmony that makes it appealing to the human eye. If you are not selective about what is shown, the composition can jar.

In the studio, you have far more control. With still-life subjects, you can add and remove subjects easily, and change props and backgrounds. The secret is to try and avoid over-complicating the scene. With other types of photography, there is less freedom – you

can't move mountains to suit your pictures. Avoiding distracting and unnecessary detail, is therefore more difficult. However, by altering viewpoint – by moving the camera, or changing the lens – it is still possible to create unfussy images.

Picture composition is like writing a sentence. It can be short and simple, or long and complex. The goal is to avoid the sentence being jumbled; the simpler and shorter the sentence, the easier this is to do.

ABOVE: An easy way to simplify a composition is to move in, or zoom in, as close as possible to the subject. By taking a step forward, to cut out more of the foreground and background, this shot becomes a more successful portrait than the one opposite.

See also:
→ PAGE 102
Different formats – film not only comes in different sizes; the proportions of its sides can also vary depending on the camera you use. Some models even offer two or more formats.
→ PAGE 108
Cropping for impact – if you do your own digital or darkroom printing, or if you frame or cut your results, you can re-compose your photographs after they have been taken.
→ PAGE 114
Digital retouching – the advent of digital imaging and computer manipulation means that you no longer have to get the result perfect first time. Distracting details and unwanted subjects can be surgically removed from your images without leaving a trace.

Design approach

There is no right way to go about composing your shots, but by relating different elements in terms of size, tone and colour you can ensure they look instinctively 'right'.

THERE ARE NO MAGIC solutions for assembling a group of subjects in a frame so that they are recorded as a great photograph. Just as people disagree as to what is good architecture or good flower arranging, picture composition can be a matter of taste. However, it is certain that some have a better eye for what looks 'right' for most people. Some intuitively have this artistic skill, whilst others have to learn it through their mistakes.

Whilst arranging a single object within the frame presents few real problems, it is when there is more than one subject in the frame that things become more tricky. Designing the frame so that all the elements work together involves some artistic skill.

One of the ways to think about it is by trying to see beyond the subjects themselves, and instead looking at the way that they relate to each other. In this way their differences and similarities can be stressed, or can be placed so as to create some sort of balance. ▷

PRACTICAL TASK

■ Collect three children's toys (or ornaments).
■ See how many different ways you can arrange them artistically in the frame, using a simple, plain backdrop.
■ Use a basic lighting set-up with sidelighting from a window, or flash, with a reflector to provide fill-in.
■ Take a picture every time that you think that you have an interesting composition. Aim to get half a dozen decent shots.
■ Now try the same exercise with five subjects.

ABOVE: The pudding and plate have a natural connection in shape. But to break the symmetry, the sauce-jug is also placed in the frame. Its lighter tone acts as a counterpoint to the darker pudding. Lit by bouncing flash off the ceiling.

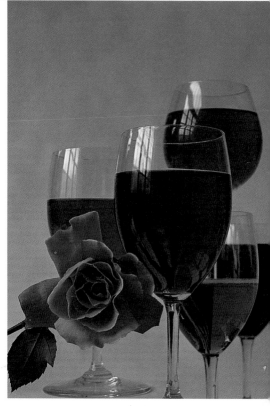

RIGHT: The arrangement of wine glasses leads the eye through the image in a curved line, whilst their different heights ensure that each is seen clearly. Lit with side window light, with fill-in from a reflector.

OPPOSITE: Here, it is not only the smallest subjects that have been placed in the foreground to increase their relative size – these are also the brightest-coloured objects, which tend to attract our eye. The peel in the foreground then leads the eye in a curved, S-shaped, line through the other elements in the still-life arrangement.

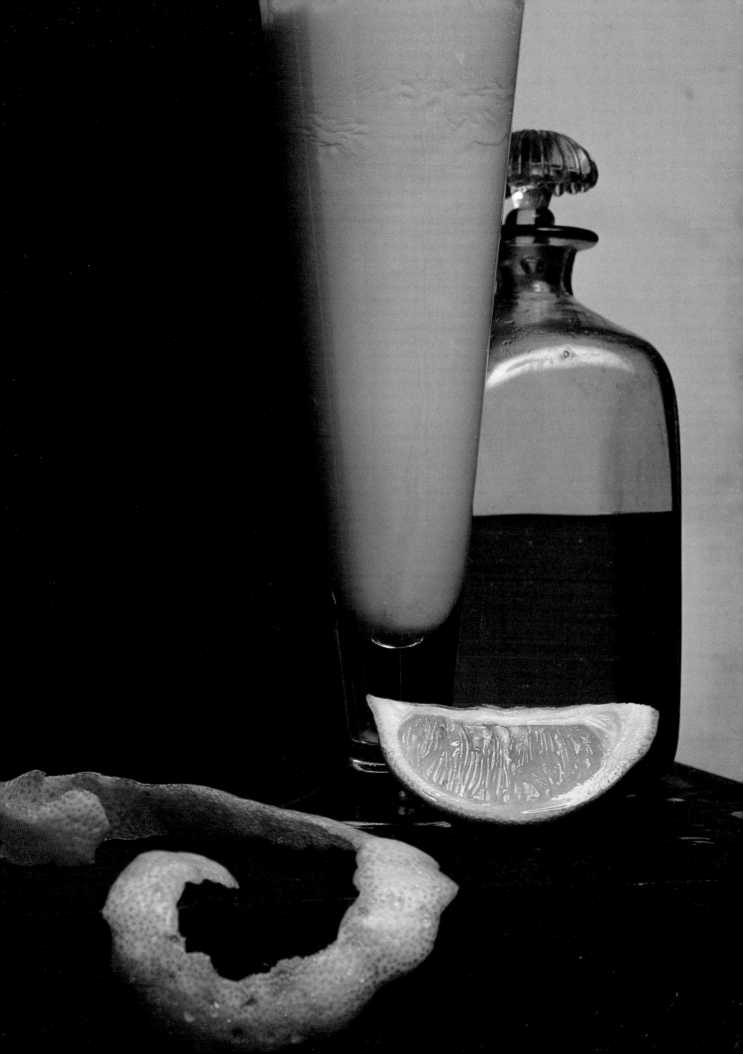

RIGHT: Our eyes are frequently first attracted by the lighter tones in a picture – particularly if they are surrounded by darker shades. Here, it is the glass on the table and the woman's face that grab our attention, leading our eye through the picture in a diagonal line towards the clock. The strong sidelighting was provided by a single flash unit, which was bounced of a white wall to the left of camera.

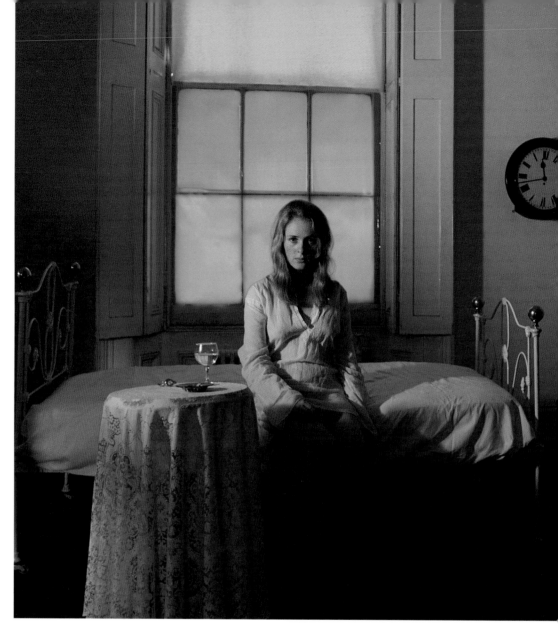

Design approach

The different tones of your subjects, for instance, can be a powerful tool. Lighter tones attract the eye more powerfully than darker ones – just as some colours do. A large, dark subject, therefore, can be used to balance a small, light object in a picture.

The emphasis and size of particular subjects can also be altered by where they are put in the frame. Smaller objects disappear if put at the back of a picture, but can be made to seem larger if they are much closer to the camera than other, larger, subjects.

It is also worth thinking about the way people look at pictures. They don't look at them with eyes fixed. Our eyes scan pictures,

quickly moving the focus of attention from one subject, or one element, to the next, and then back again. We hold the gaze at each point for a fraction of a second, with some points keeping our attention for longer, and being revisited more often, than others.

The invisible lines between your subjects, which the viewer's eyes will follow, are also an important part of the design process. A group of subjects can be arranged in a row, like people standing for a bus queue. But this arrangement will be dull and unexciting for the eyes to follow. If the path between them is an L-shape, a zigzag, curve or diagonal – or creates a shape such as a circle, triangle or oval – the composition is bound to appear more interesting. The result will have a natural balance and rhythm.

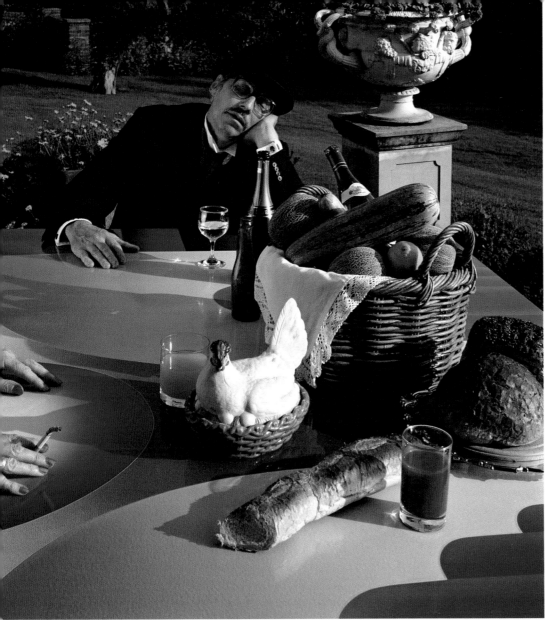

See also:
← PAGE 12
Touch of colour – a small area of a strong colour can attract the eye, balancing a larger less vibrant subject elsewhere in the shot.
→ PAGE 54
Triangles and diagonals – how diagonal lines provide a strong way to lead the eye through a picture.
→ PAGE 62
Balance and proportion – where to place your subject in the frame to gain the maximum effect.
→ PAGE 90
Strengthening the image – choosing and using props to improve the composition of your photographs.

ABOVE: In any picture which includes people, it is the faces, and the eyes in particular, that our gaze is immediately attracted to. Here, however, we are intrigued by the anonymous hands on the left, and these lead our eyes around the picture in a curved line back to the man at the head of the table, and round to the still-life composition in the foreground. This managed scene was shot in the garden with direct sunlight.

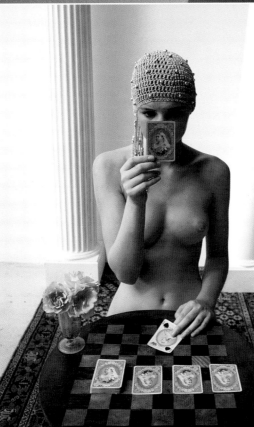

LEFT: In portraits, arms and legs can be used to lead the viewer through the image. Here one arm leans on the card-table, pointing the way to the cards in the foreground. The other arm teasingly leads us to the card that the model is looking at but we cannot see. This scene was lit with a diffused flash unit hidden in the alcove to the left of the model. The white walls provided reasonable fill-in, but this was augmented by a large reflector to the right.

Triangles and diagonals

Slanting lines create immediate drama in your pictures, and can be manufactured just through your viewpoint, or by looking for natural, or inferred, triangles.

Even the simplest changes to a composition can have dramatic results. And one of the most powerful tools to help you turn ordinary-looking pictures into dynamic ones is with diagonal lines.

It is easy to fall into the trap of having all the horizontal and vertical lines in a picture running parallel to one of the sides of the frame. But whilst this might seem natural, the results can often look staid and boring. Putting things on a slant creates immediate drama – and it doesn't mean that your subjects have to look as if they are leaning to one side. The diagonals can be naturally engineered just by the viewpoint that you use.

The reason why diagonals work so well is through the way that they interact with the rectangular frame that the camera puts around them. As they do not run parallel to the sides, they create tension in the picture; they add a degree of instability that is exciting to the eye.

Converging diagonal lines, of course, are the basic currency of perspective, and these can be exaggerated through viewpoint. ▷

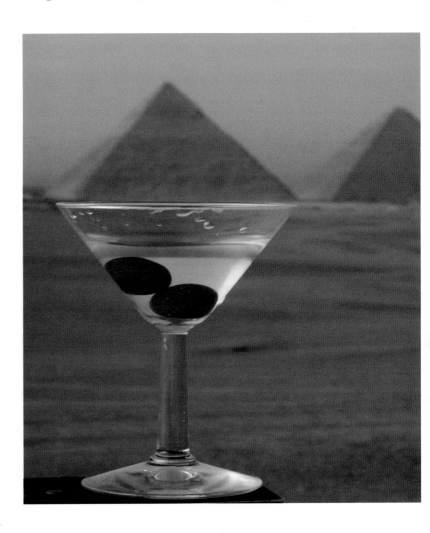

ABOVE: The triangular shape of the ancient pyramids of Egypt make for exciting pictures – however, most views have been seen a thousand times before. Here, I have gone for a visual pun. In the foreground is a still life of a cocktail glass – itself shaped like an upturned pyramid. By experimenting with the camera distance, I was able to shoot the scene so that one of the pyramids appears to be sitting on top of the glass.

PRACTICAL TASK

■ Take pictures of books neatly arranged in a bookcase.

■ If you shoot them straight on, the lines of the books and the shelves will run parallel or perpendicular to the edge of the viewfinder. Your task, however, is to shoot them so as to create strong diagonal lines.

■ Stand at an angle to the bookcase, and shoot with a short telephoto lens setting, angling the camera slightly so the shelves tilt across the frame. Now lean some of the books over so they form different diagonals.

■ Next, move in closer to one end of the bookcase, so you are looking along the shelves. Using a wide-angle lens, the horizontal lines will converge. Lie or kneel down to get a low-angle shot to increase the effect.

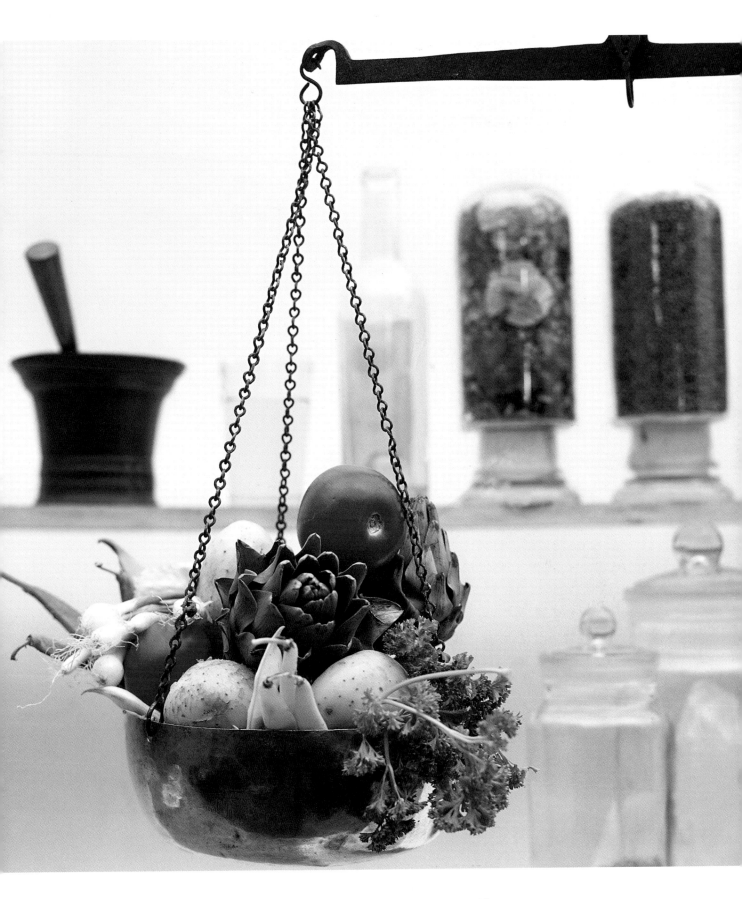

ABOVE: A set of scales makes an interesting receptacle in which to arrange a still life. The chains supporting the pan create strong diagonal lines, which lead the eye to the main subject of the picture. Other diagonal lines, at different angles, are created by the pestle and mortar and the runner beans.

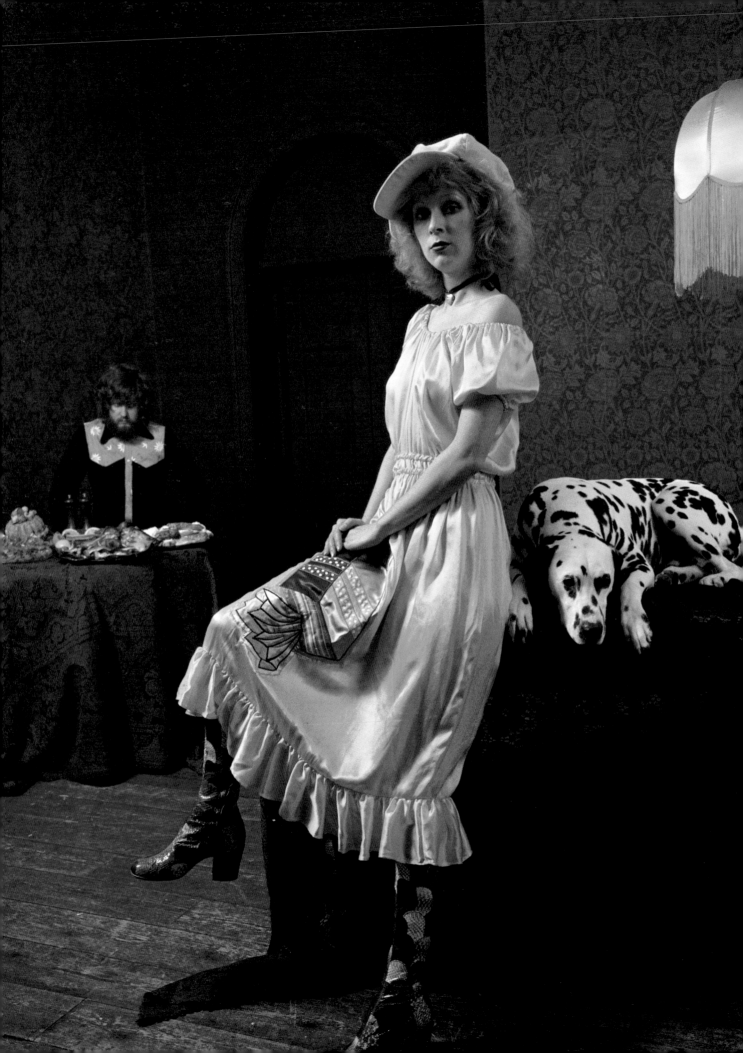

Triangles and diagonals

The closer you get to the subject, and the wider the lens that you use, the more dramatically the lines will converge.

Other diagonals can be discovered in the scene – a path cutting across a landscape, or the edge of a table. These can be incorporated so they are made a strong feature of the picture. A single diagonal creates maximum impact when at 45 degrees to the frame.

Triangles, which provide at least two diagonals running at an angle to the frame, are also powerful devices in picture composition. These can be real or merely implied by the relationship between the main elements of the picture. When there may be more than one diagonal, the maximum drama is created when the angles they create with the sides of the frame are as great as possible, without being equal to each other.

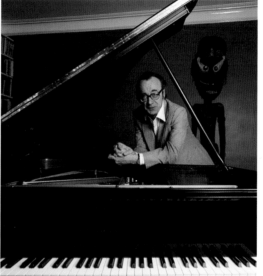

BELOW: In this romantic shot, triangles are created in two ways. First there is the overall shape made by the couple. Then there is the implied triangle – the one that is made as your eyes dart between the two people and the third main subject, the white horse in the background.

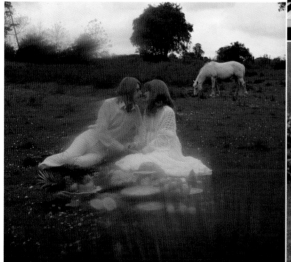

LEFT: The lid of a grand piano not only creates a perfect frame in which to photograph a celebrated musician, it also provides two strong diagonal lines to add drama to the portrait.

OPPOSITE: Strong diagonal lines are created simply in this shot by the legs of the model, which break the horizontal and vertical lines in the composition.

RIGHT: To photograph this prize-winning gardener, I arranged the fruits of his labour – his giant vegetables and immaculate flowers – so that they created a triangle, bordered by his arms, which lead the viewer's eye up to his face at the top of the frame.

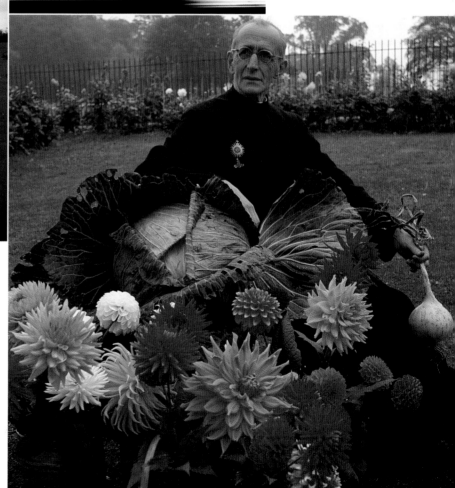

Circles and curves

Circles are the most visibly-pleasing of shapes to incorporate into your pictures – grabbing the eye's attention, and adding harmony with their absolute symmetry.

A S WITH TRIANGLES, CIRCLES are an extremely powerful shape to use within a composition – but for different reasons. Instead of adding drama and tension, their curved lines suggest harmony. It is not difficult to see why circles work so well. Their shape has a fundamental mathematical and aesthetic beauty; but it is the way that it works within the frame that makes it so useful to the photographer. As it has no corners, it acts as a perfect foil to the angular shape of the frame itself. ▷

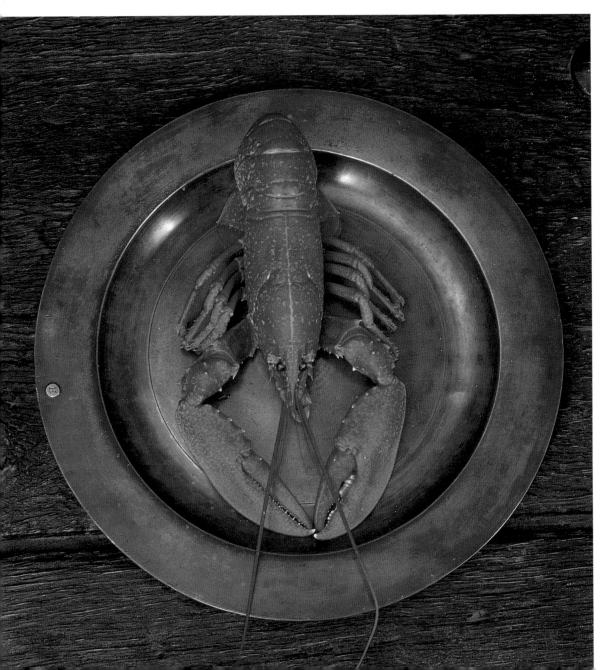

LEFT: A circle fits perfectly within a square – making a symmetrical arrangement that suggests perfect harmony. Whilst square pictures can be shot with some medium-format cameras, others can crop their pictures to this shape in the darkroom or on the computer. Here, the perfect symmetry has been challenged with the incorporation of the menacing-looking lobster.

OPPOSITE: The theme for this still life was suggested by the old black-and-white print of a relative. The props all honour his memory – the medal, the glasses, the jug of beer and his favourite food. The large, light-toned pie immediately grabs the attention against the dark background.

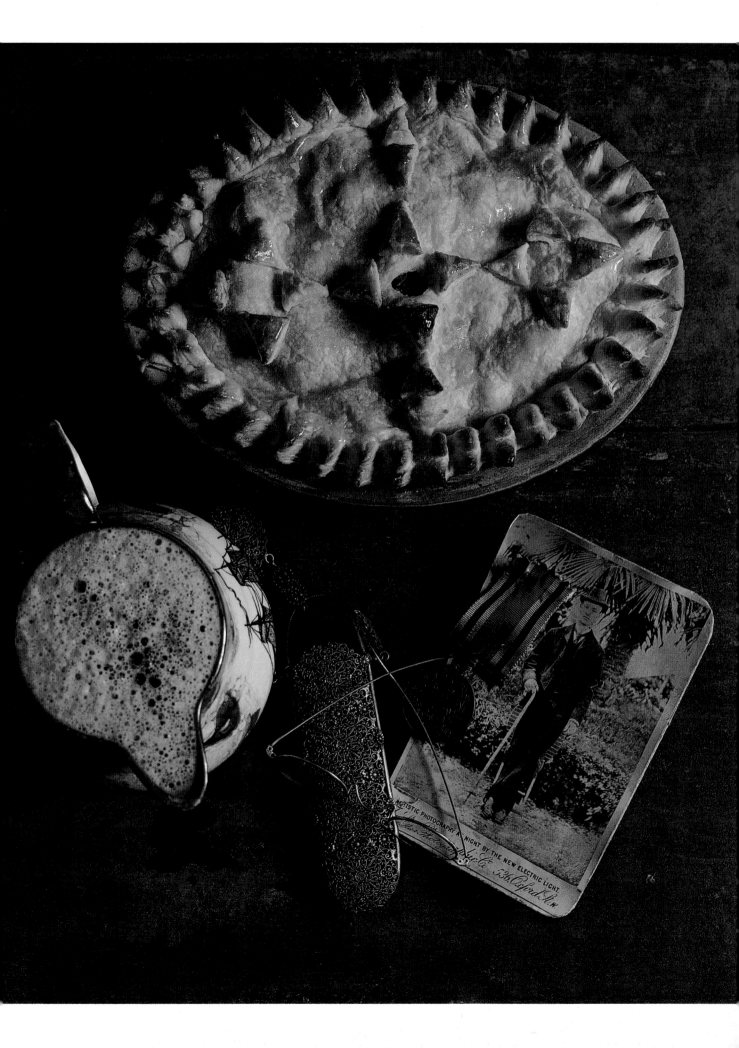

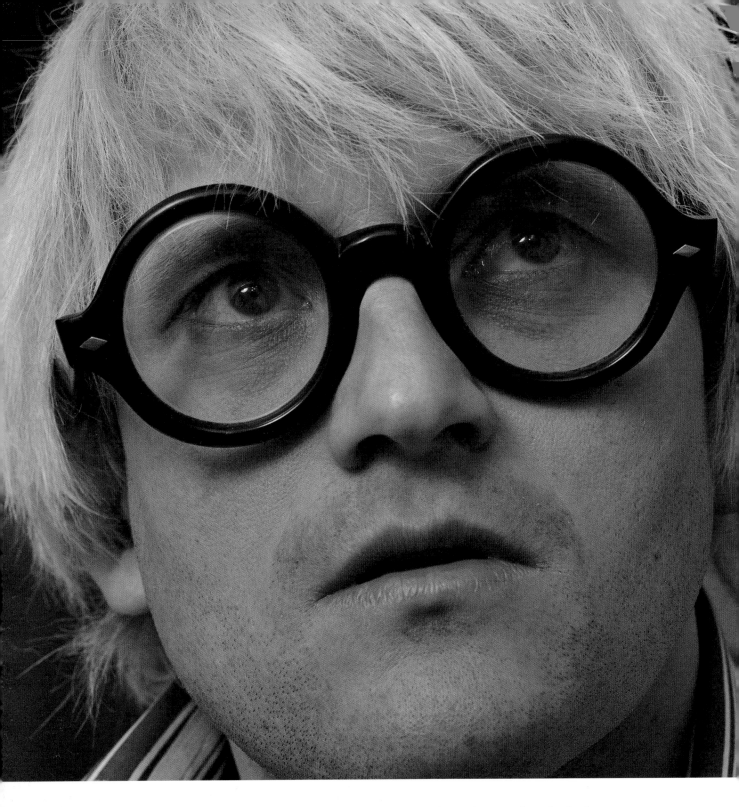

Circles and curves

Circles are found readily in the world around us. From cars to jars, they dominate both man-made design and the natural world. Their shape is not just pleasing to the eye – like all curves, it is relaxing and sensuous.

Stressing the shape of a circle means choosing the camera angle carefully. Unless the object is spherical, it will only look perfectly circular when photographed straight on – so that the back of the camera runs parallel with the shape.

The symmetry of circles and curves can be stressed by placing the shape in the centre of the frame, or the composition can be made more dynamic by placing the circle towards one of the sides or the corners of the viewfinder.

ABOVE AND OPPOSITE: Circular glasses create an extremely strong shape for portraits. Thick round frames are synonymous with the artist David Hockney, whilst the monocle of the designer Erté was angled carefully to reflect the light.

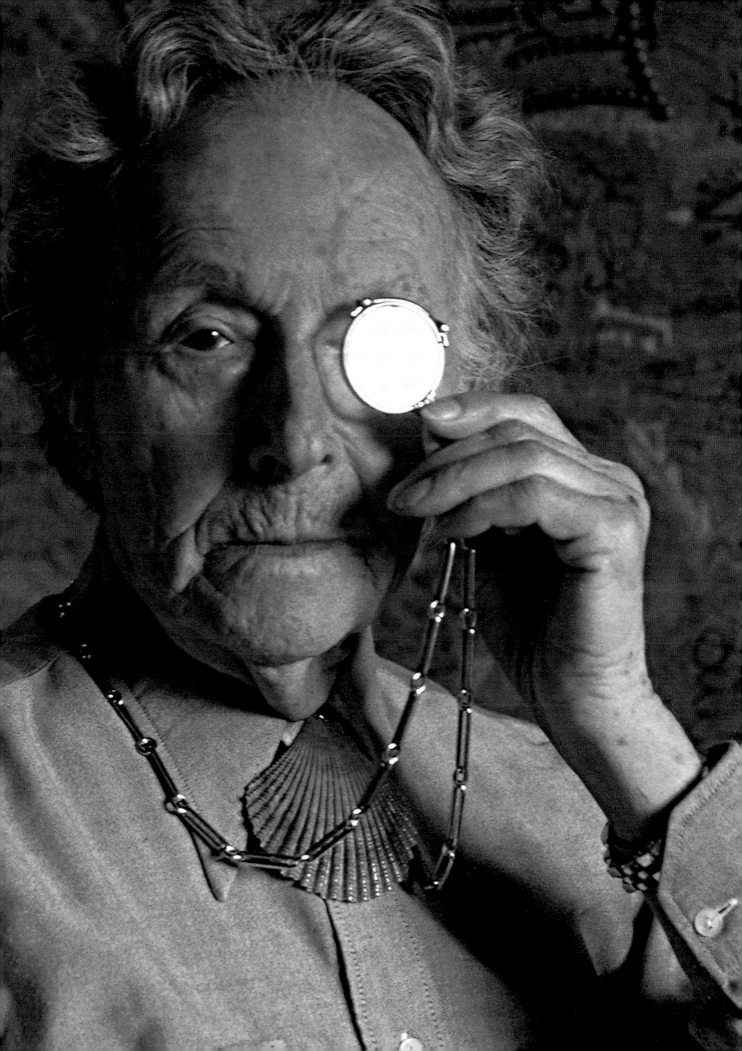

Balance and proportion

Avoid placing the main elements of your picture dead centre of the frame – the composition will look more alive if the subject is placed slightly nearer an edge.

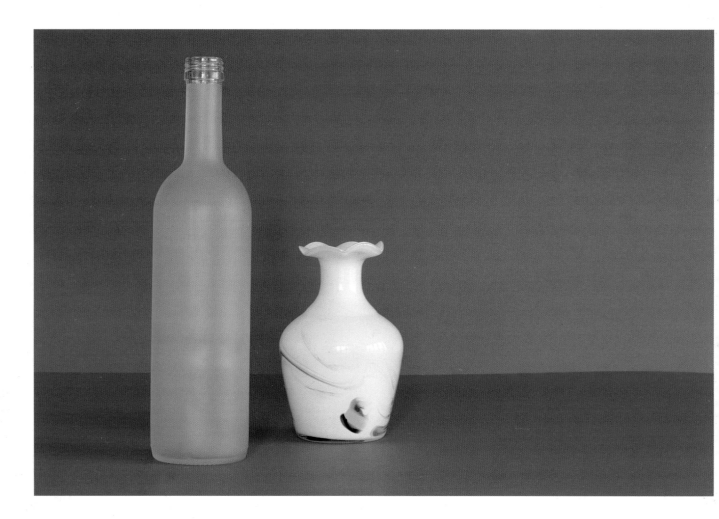

AS WELL AS DECIDING what to include in the picture, and what to leave out, the composition process also involves considering where the main elements of your picture are going to be placed within the frame

A central position may seem the obvious choice for the main subject – but the resulting image can often look too balanced, and this is usually only used when stressing the natural harmony or symmetry of the subject.

A more successful approach is to place the main focus of the picture significantly away from the centre. This creates a more dynamic balance, and therefore creates a shot that is more interesting to look at.

Watch out for strong vertical and horizontal lines within the picture – even if they are not the main subject. The horizon, for instance, is usually best placed so it crosses the image a third of the way down the frame. ▷

The rule of thirds

One useful guide to placing your subject within the frame is the 'rule of thirds'. Mentally divide the frame into nine equal segments, using imaginary vertical and horizontal lines. Then place your subject on one of the intersections made by these lines.

ABOVE: More space is left to one side of the two subjects than the other, creating a balanced composition from a simple studio set-up.

OPPOSITE: For a dynamic shot, the bottle is placed off-centre, whilst the line created between bench and backdrop is placed low down in the frame.

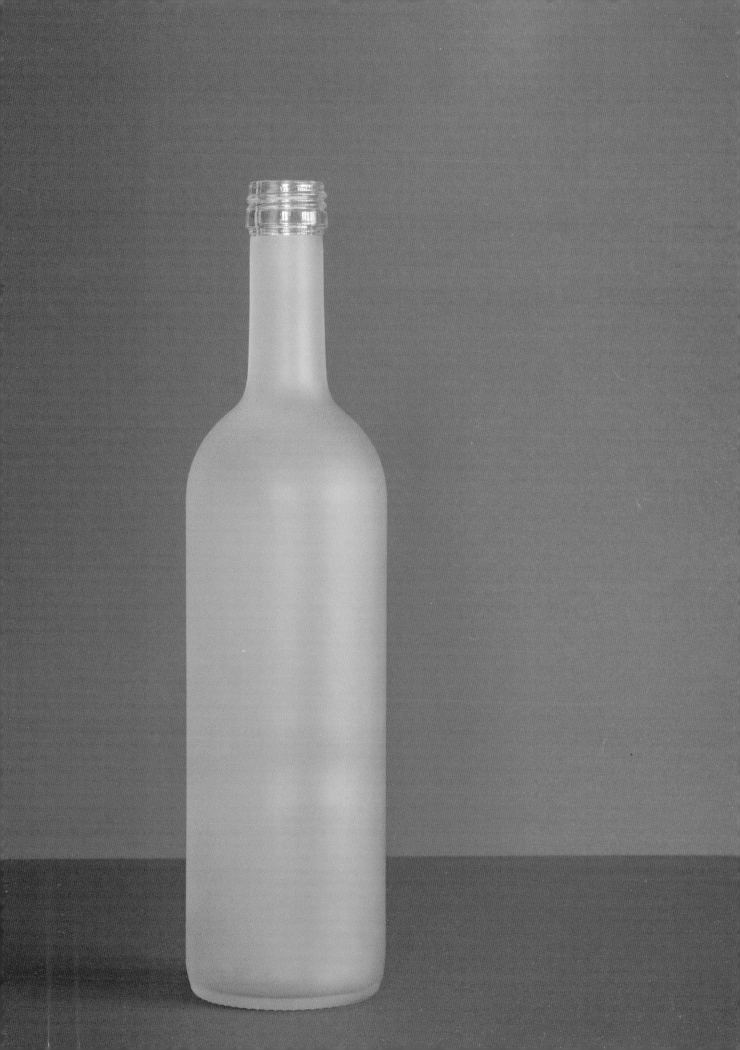

Balance and proportion

Occasionally you may want more sky than foreground, so place the horizon a third of the way up from the bottom of the frame. With complex compositions you have two or more subjects vying for attention in the frame. Here, avoid arranging them in a horizontal line. Instead, arrange them, or pick a vantage point, where imaginary diagonal paths are created between the main elements. It is these lines that the eye will follow, as the viewer scans from one point of interest to the next. The effect will also make the shot appear more three-dimensional.

OPPOSITE ABOVE: When you have two subjects of similar size within the frame, it is worth taking a viewpoint that makes one appear smaller than the other. This helps to create a stronger three-dimensional effect.

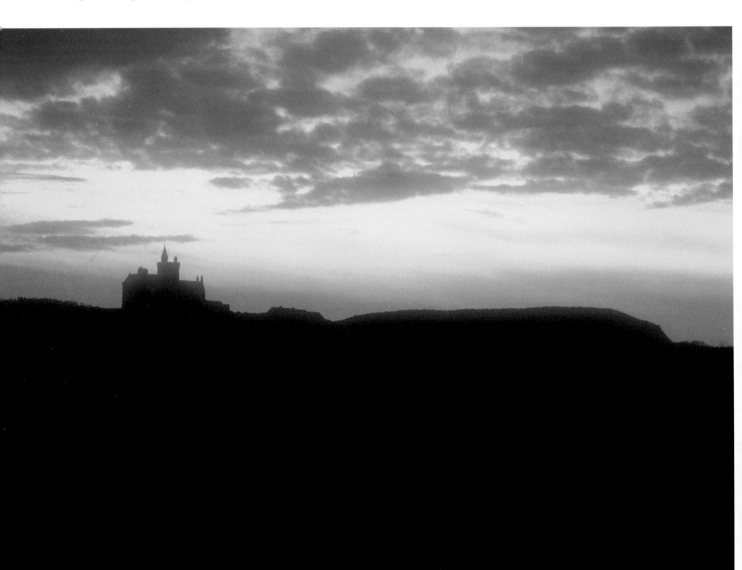

ABOVE: Placing the horizon halfway down the frame suits the calm sunset scene, although the symmetry is made less obvious by the undulating landscape. However, the castle creates a strong focus for the shot, which is deliberately placed well off-centre.

OPPOSITE BELOW: Three subjects compete for our attention, but the composition ensures that none are lost. The dominant form of the house creates a strong diagonal which leads the eye to the white cliffs in the distance, whilst the figure provides a link between the two, as well as being the main focal point.

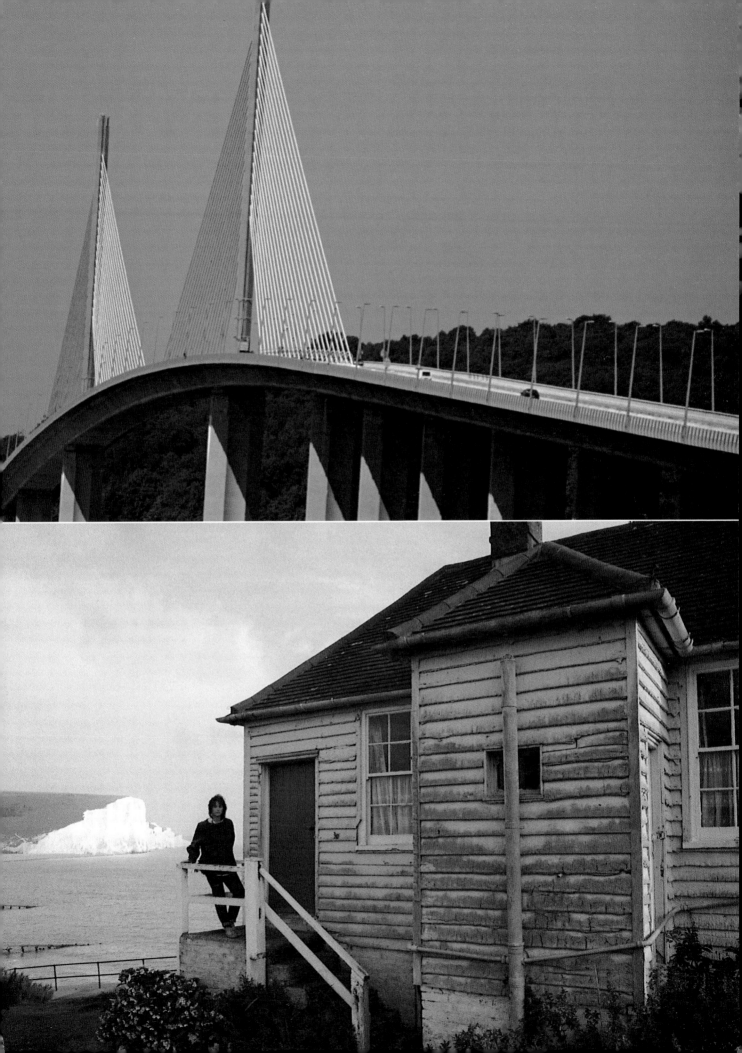

Frames within a frame

The borders around the edge of the picture are not the only way to frame a composition. 'Natural frames' can be used to alter the format of the shot, to add an interesting shape to the photograph, and to add depth to the scene.

ONE WAY TO HIGHLIGHT a particular part of a composition is by using 'natural frames'. Here, elements within the scene are used to mask off a particular area, creating emphasis for another, and altering the format of the shot. A simple example of this approach is when shooting a picture of a castle. By taking the shot from within the entrance archway, you can compose the shot so that the archway becomes a secondary frame for the building beyond.

Such frames are found readily in the outside world, with doorways and windows being regularly used in this way. Not only do they impose a new shape on the picture, which can add interest to the shot, but this approach has other benefits. It emphasizes depth from frame to subject and can allow you to mask unwanted detail in the shot. In the example of the castle, for example, the archway can be positioned so as to obscure a group of tourists which would otherwise be in the frame. ▷

OPPOSITE: Here, the shape of the decorative plate is highlighted against the darker tone formed by the patterned arrangement of wrinkled home-grown apples.

PRACTICAL TASK
■ Take a plain white plate and place it on a dark background. How many interesting objects can you photograph within this circular frame? Look for suitable candidates in your garden, on your shelves and in your refrigerator.
■ Take a trip around the block. How many different shots can you take using natural frames? Each time you take one of these pictures, ask yourself whether the approach is adding shape or depth to the picture, or both? Also see if you can find scenes where you can use the technique to mask unwanted or uninteresting detail.

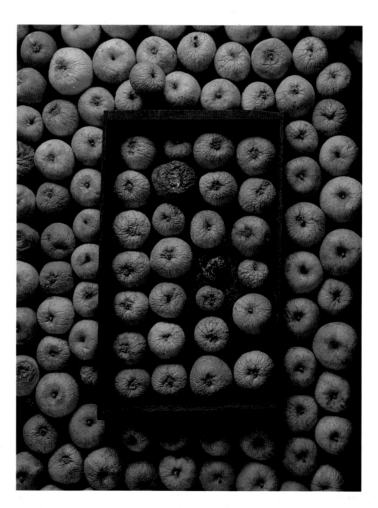

LEFT: The uniform arrangement of apples stresses their round shape, whilst the oblong tray mirrors the shape of the frame, adding further symmetry to the shot.

See also:
← PAGE 36
Emphasizing pattern – looking for and highlighting the repeated shapes and forms of everyday life.
← PAGE 40
Creating distance – tricks for adding back the missing third dimension to your photographs.
→ PAGE 102
Different formats – using different cameras to create alternatively-shaped frames.

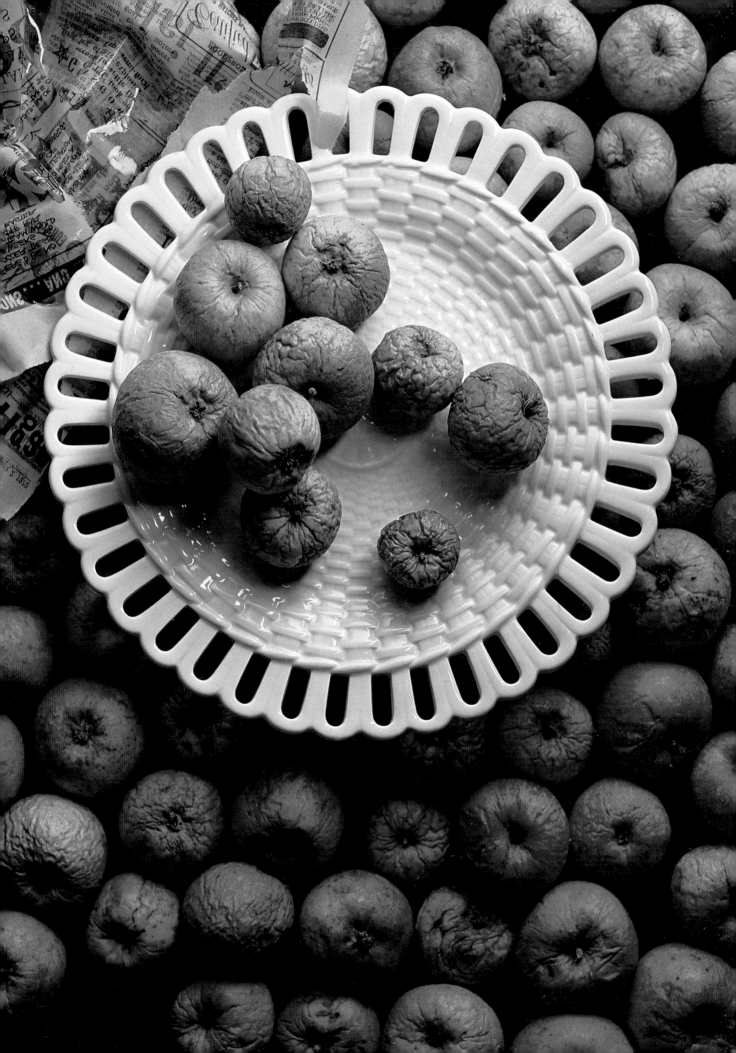

RIGHT: A mirror creates an intriguing double image of the woman in the foreground, but our eye is drawn to the central figure in the distance, framed in the archway on the other side of the room.

BELOW: The elaborate shape of the headboard frames the figure of the woman, whilst creating a much-needed visual break from the elaborate patterns of the wallpaper and the bedspread.

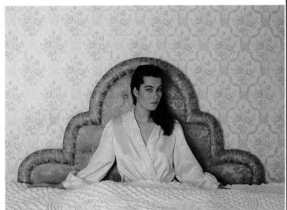

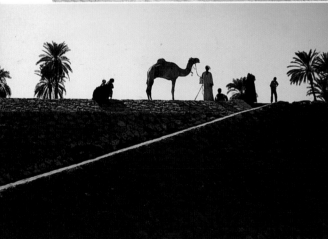

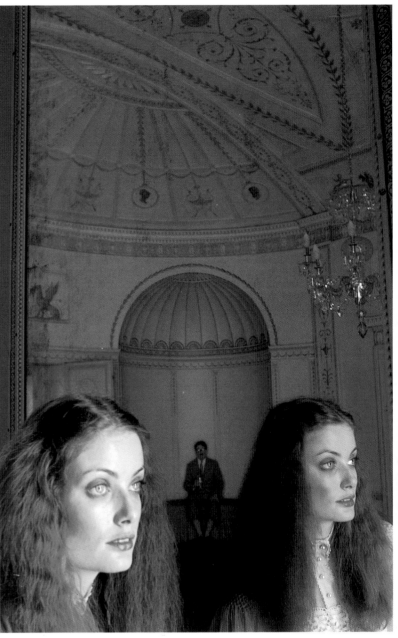

ABOVE: In this silhouetted shot, it is the sky that creates an irregularly-shaped natural frame for the figures in the distance. The dark foreground is empty space, but the strong diagonal line draws the eye through to the main part of the picture.

Frames within a frame

This technique is also a good way to add depth to a scene, suggesting the third dimension that is missing in photographs. Not only will the frame, of a doorway, obviously appear to be at a different distance from the main subject beyond, but the viewer also gets a feeling of 'looking through' the opening, further reinforcing the sense of depth.

In the studio, frames are of more limited use for still-life arrangement, as distracting detail can be removed, and depth is harder to suggest on a small scale. However, the approach can be used to emphasize a particular subject, and to add an interesting overall shape to the arrangement.

A classic example would be with food photography, where a plate can be used to frame and draw the eye to the main dish, away from the surrounding props. This works particularly well if the tone or colour of the plate contrasts with that of the background.

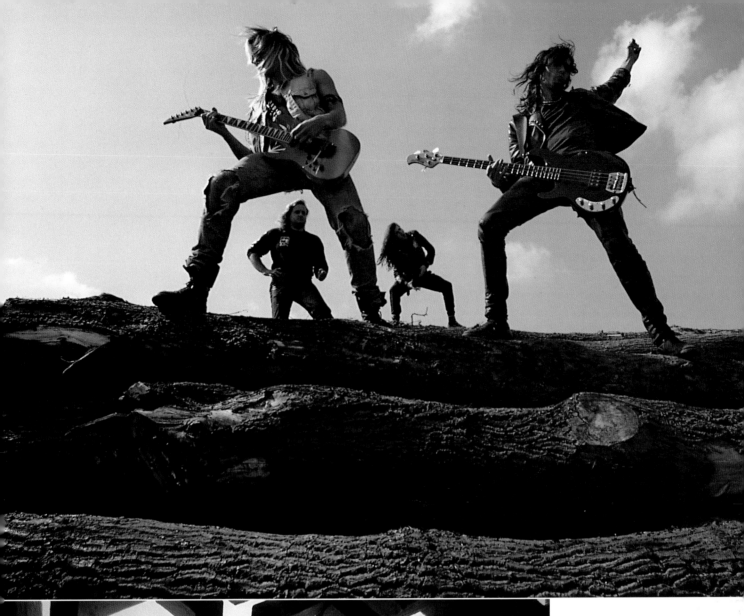

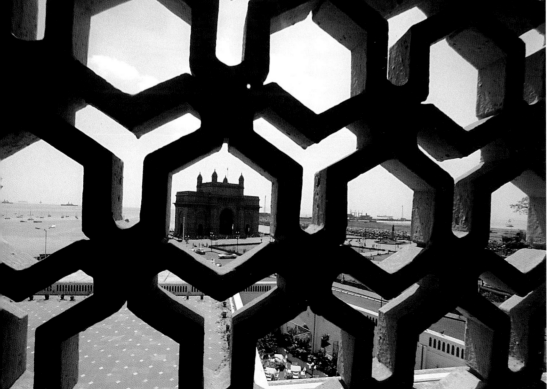

ABOVE: In this group portrait, the legs of the guitarist create a frame for the figure beyond. The composition would seem contrived with some subjects, but suits the larger-than-life antics of a heavy rock band.

LEFT: Geometric trellis-work creates an interesting pattern, neatly framing the building beyond, and it also does a good job of obscuring what otherwise would have been a dull foreground to the shot.

View from above

For a refreshingly-different way of looking at your subject, get up high and take a birds' eye view – shooting down on the arrangement from up above.

ECAUSE OF THE WAY we are used to seeing things, it is easy to fall into the trap of taking all our pictures from one height. But although we view the world, most of the time, from eye level, the photographer should try to be more adventurous. High and low viewpoints will often be more interesting than those shot from head, or chest, height.

From a high viewpoint you point your camera downwards to frame the subject. This bird's-eye view shows the relative positions of different objects in a way that is not so apparent from other angles. By looking downwards, the height of subjects is compressed, which can be useful in still lifes, allowing different-sized objects to be combined. ▷

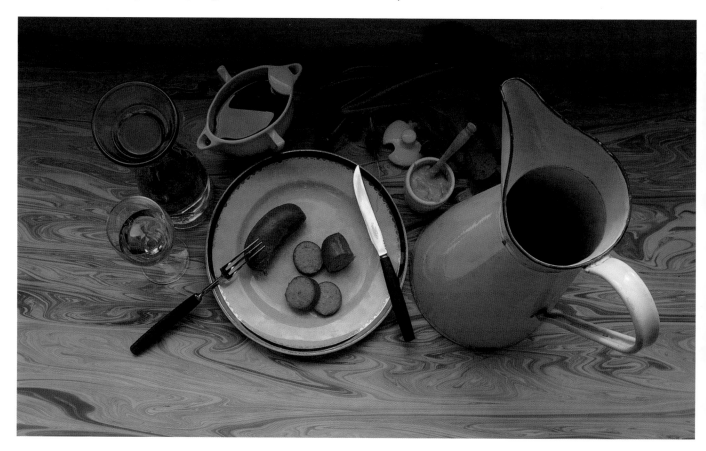

ABOVE: This is what a meal looks like when we sit down to eat. This arrangement was shot with a single flash unit bounced from the white ceiling above.

OPPOSITE: This visual puzzle challenges our view of the way we expect things to appear. The glasses seem to be defying gravity – but the bottles, in fact, are lying on their side. A plank of wood, resting to look like a shelf, and a picture frame on the 'wall', help to create the illusion.

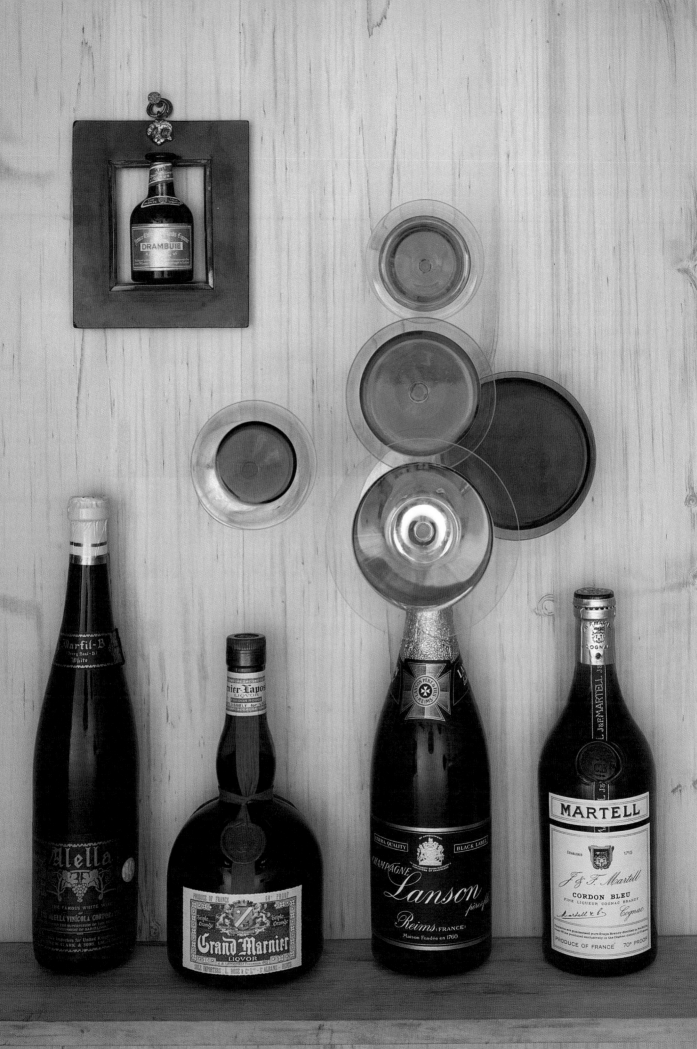

View from above

Outside, an elevated view will mean hunting out a suitable vantage point – from a hill, from a top-floor window.

With portraiture, a bird's-eye view should be used with care. The camera angle makes people look shorter – which itself is often unflattering – but the view also tends to suggest that you are looking down on the person, metaphorically as well as physically. If you want to show someone's vulnerability, the pose is valid, of course – or if you want to give a standard adult's view of a child.

In architectural photography, finding an overlooking observation point will allow you to include features of a building which are often not visible to passers-by at street level, such as the design of the roof.

In landscape photography, meanwhile, the tilted camera angle means that you will be able to avoid including the sky, or the horizon, in the shot. This not only provides an unconventional view of the countryside, but can avoid the problems with exposure that an over-bright sky can sometimes cause.

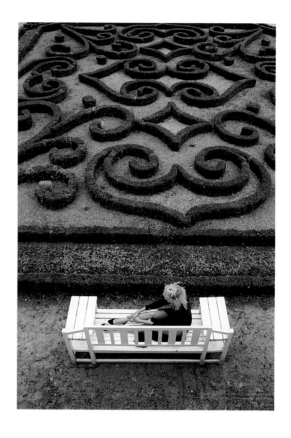

BELOW LEFT: A kneeling position gives a high viewpoint for these fungi, emphasising their shape and colour.

BELOW RIGHT: High-angle portraits often make subjects look weak and submissive. As the woman is lying down in this shot, however, the view is naturally more intimate.

LEFT: An elevated camera position is essential when showing the elaborate patterns created by the hedges in a formal garden. The seated figure creates visual interest, as well as a sense of scale.

See also:
← PAGE 46
Simplifying the image – the basic tools and techniques of photographic picture composition.
← PAGE 66
Frames within a frame – examples of still-life pictures taken from a high angle.
→ PAGE 74
Low-angle approach – when to get down on the ground and shoot a worm's-eye view of the world.
→ PAGE 122
Open aperture – using shallow depth of field to eliminate the identity of the background.

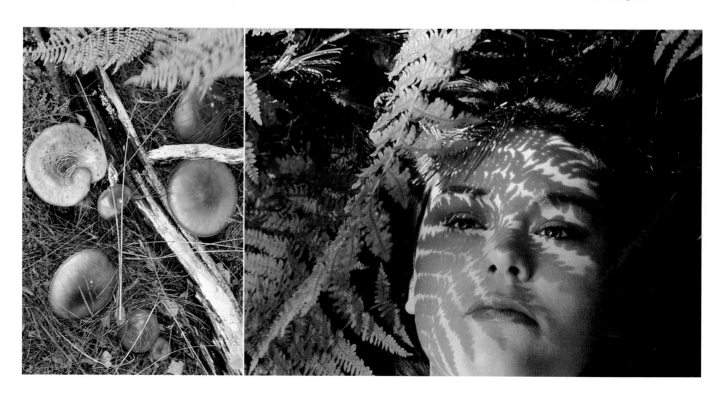

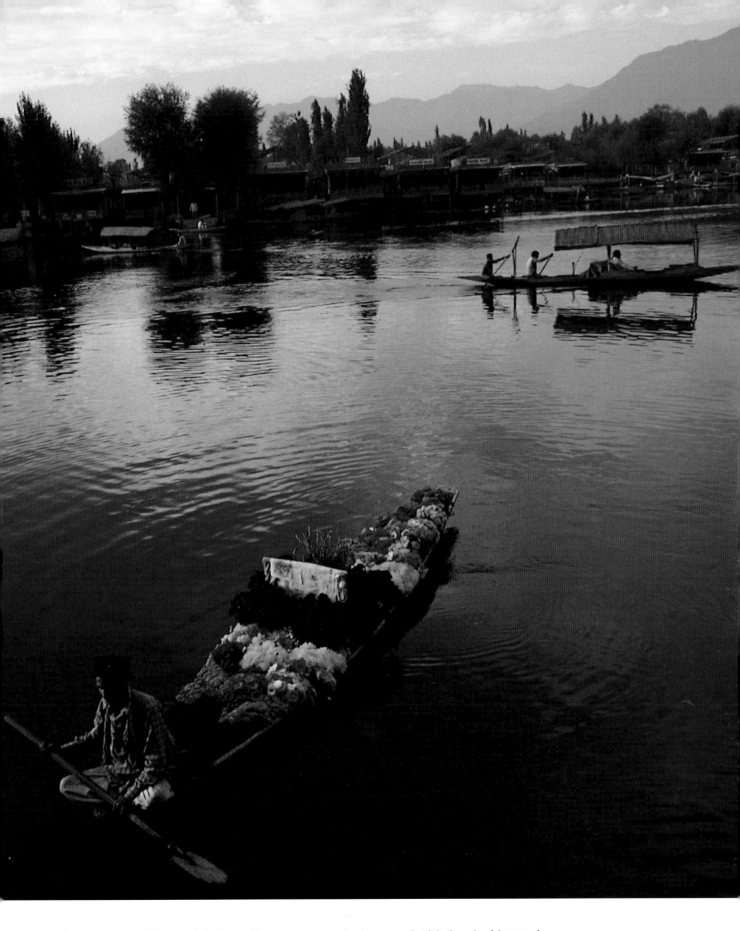

ABOVE: An elevated camera position meant that I was able to show all the activity on the water, as well as the photogenic reflections, without having too include too much of the relatively-brighter sky in the composition. The camera angle also means that it is the colourful cargo of the boat in the foreground that is emphasized, rather than the man at its helm. It is this splash of colour, therefore, that becomes the main drawing point of the picture.

Low-angle approach

Don't be afraid to get down on your knees, or throw yourself to the floor, in the search for the perfect picture – a worm's-eye view has lots of good uses.

LEFT: Because I was using the floor as a background, I had to lie down near the subject so as to make the most of the natural sidelight, which beautifully reveals the form of the fruit.

See also:

← PAGE 46

Simplifying the image – the basic tools and techniques of photographic picture composition.

→ PAGE 128

Wide-angle lenses – filling the foreground when using focal lengths with a wide angle of view.

→ PAGE 132

Specialist lenses – using shift lenses to correct perspective when tilting your camera to fit tall buildings into the viewfinder.

FOR MOST SUBJECTS, getting a low-angle view is far easier than finding a high camera angle. You don't need the aid of furniture or tall buildings – all you have to do is to bend your body so that you are lower than the subject. Depending on the height of what you are shooting, you just kneel, sit or lie down, on the ground.

The advantage of a low angle is that it exaggerates the height of your subject, making it stand tall in the picture. This is particularly useful in the studio, because the subjects that are usually photographed in still-life set-ups are small to begin with. And making them appear that bit bigger in your pictures allows you to emphasize form more easily. In the studio, of course, you do not need to get your clothes dirty to get a worm's-eye view. Subjects can simply be arranged on a surface at table height, so that a low angle can still be achieved with a tripod.

A low camera angle will also help to make objects in the foreground appear large, even when framed against a much wider backdrop. This is particularly useful when you want to set-up a still life with a building or landscape in the distance. The miniature foreground can be exaggerated with a wide-angle lens, which will also provide sufficient depth of field to keep the background in focus. ▷

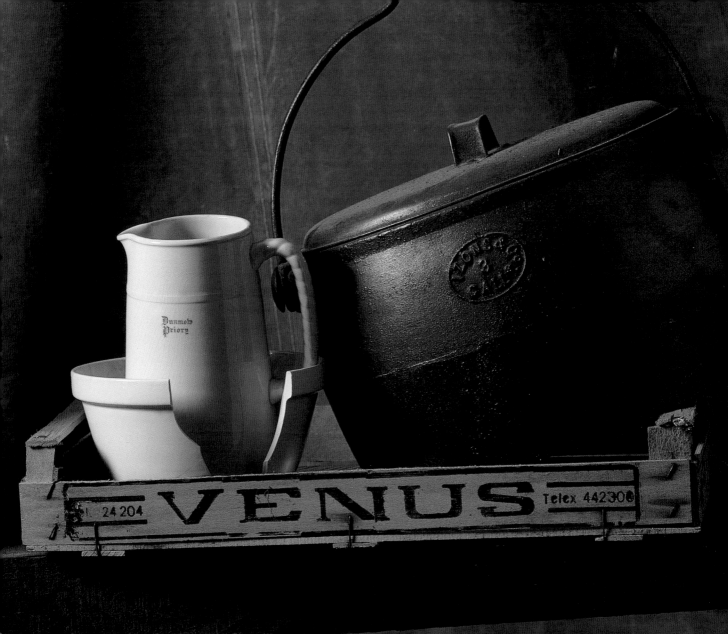

ABOVE: Some studio subjects are easier to set up on the floor, rather than on a table. But to shoot them, you then need to lie on the floor yourself. Note that if you set up shots in this way, the light source also needs to be positioned low.

RIGHT: A low camera angle helps ensure that the apples are not lost against the large-scale outdoor backdrop.

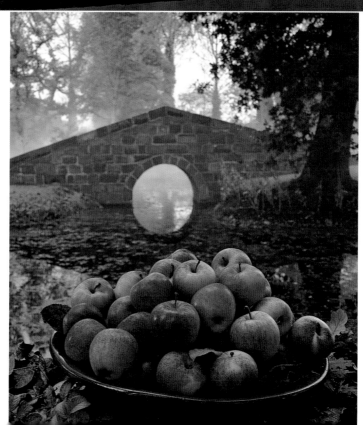

Low-angle approach

The same technique is often used by landscape photographers. By crouching down rather than shooting from head height, small features in the foreground, such as a flower or interesting rock can be made prominent in the composition – thus helpfully filling what would have been an uninteresting area of the photograph.

We normally see buildings from a low angle, and have to tilt the camera upwards so as to fit the top of the buildings into the shot. But the higher the building the more we have to rotate the camera, and this can have an effect on perspective. The parallel lines of a skyscraper, for example, appear to converge when shot in this way. But although this view exaggerates the height, the technique can be overused.

With pictures of people, a low camera angle again exaggerates height, and can give the impression that we are looking up at them. It is therefore a great technique if you want to convey the importance or power of a person that you are photographing. This technique also works well with children; if you can get below their eye level, you make them appear more confident and independent, and provide a view that even their parents may not be used to seeing regularly.

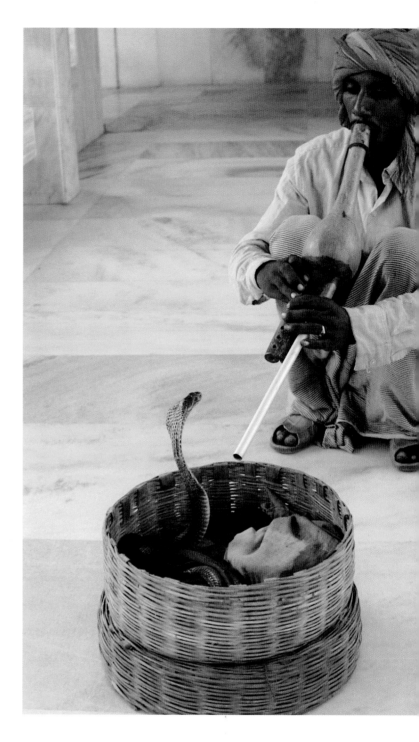

ABOVE: There were two reasons for getting low for this shot. Firstly, the snake charmer is crouched down, so getting down nearer to his eye level makes a more natural shot. Secondly, a lower viewpoint let me see more of the snake, which shows up clearly against the white floor.

PRACTICAL TASK

■ Assemble a collection of glass bottles and place them on a table against a dark background. Light the arrangement from the side.

■ Now photograph it three times – with the camera at subject height, from a high camera angle, and from below the level of the table.

■ Carry out a similar exercise outdoors, photographing a member of your family – preferably a child. Shoot them from a kneeling or lying position, from their eye level, and then from the top of a set of portable steps.

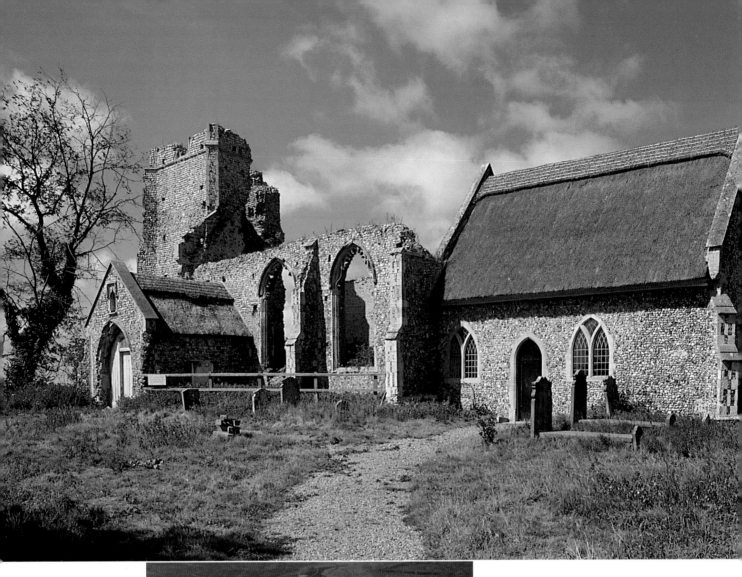

RIGHT: I spotted this bather at the side of the pool, and could see the potential for a shot that emphasized the curved lines of her costume, hat and arms. However, I wanted to avoid looking down on her, so I crouched down on the ground to get a clean shot.

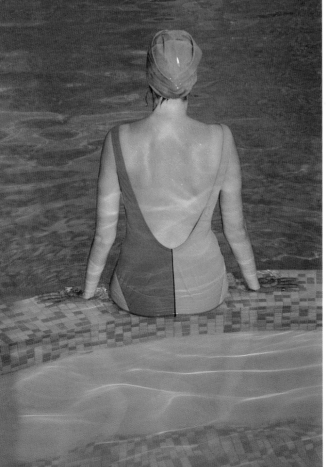

ABOVE: By kneeling down low, and using a 28mm wide-angle lens, I have exaggerated the height of this church. The low camera angle also increased the prominence of the path in the foreground, which now leads the eye gracefully to the main subject.

Filling the frame

Cramming the picture with a mass of detail may involve breaking one of the fundamental rules of composition, but the results do not need to be chaotic.

SIMPLICITY, AS STATED at the beginning of this chapter, is one of the, if not the, most important rules of composition. If you want a strong picture, then don't put in more detail than you need. But, just as with all the other guidelines of photography, this 'rule' can always be broken. The real world, after all, is not always simple, and there are times when you need to show it in all its complexity.

In the studio, filling the frame with lots of different subjects is not for the faint-hearted. Each addition takes time to get into the right place, and it can take hours before you can get to a position where you can take a shot.

However, one of the advantages of such constructed shots is that you can ensure that everything in the frame is in focus. With a small aperture and a tripod, subjects can be placed so that every one is pin-sharp. ▷

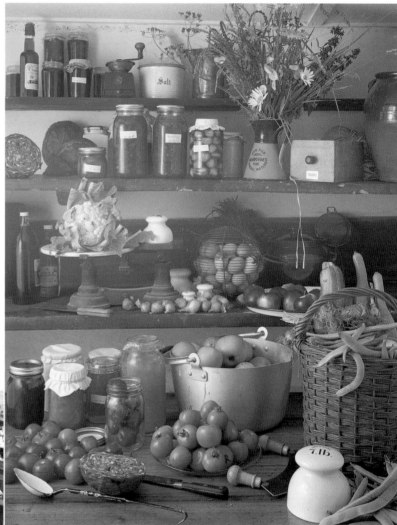

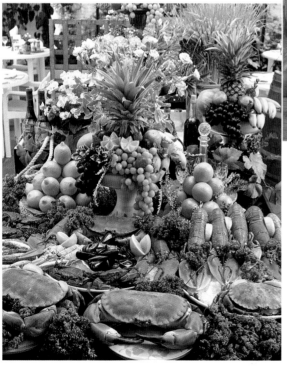

LEFT: Such elaborate displays are no longer found everywhere in restaurants and shops, but they are not uncommon. I spotted this lavish arrangement of seafood in a Jersey restaurant, and shot it with diffuse sunlight.

ABOVE: The shelves in this farmhouse pantry allowed me to fill the frame with garden produce, without having any problems with depth of field. The diffuse sunlight from a doorway and the dust from the adjacent corn store combine to create a soft image. The reddish tone to the picture, created by using a warm-up filter over the lens, contributes to the overall mood of the photograph.

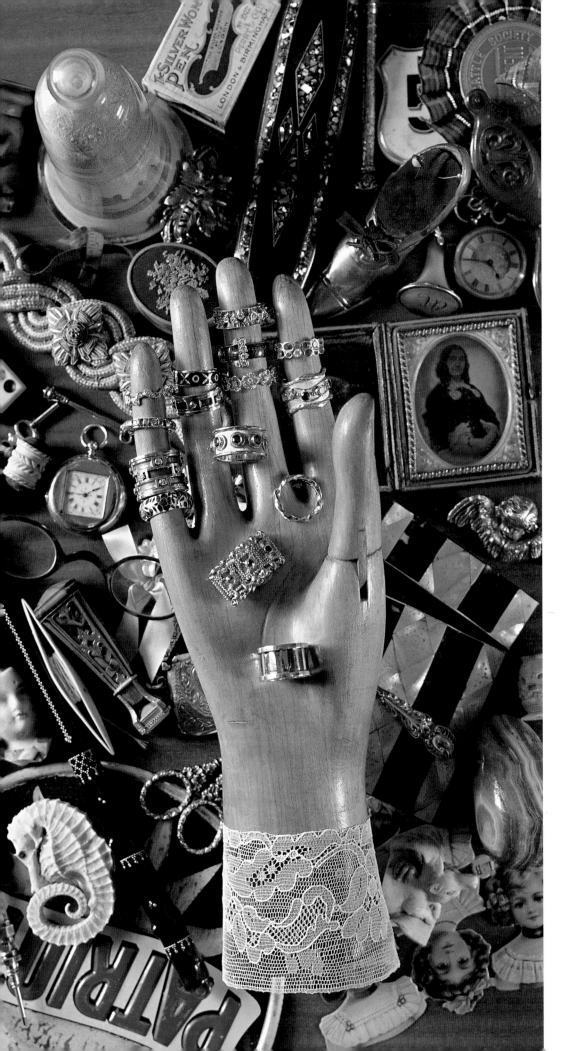

LEFT: By laying small objects on a tabletop or tray, the picture can be shot straight-on at any aperture. Here, the assorted contents of dressing table were arranged to provide a rich mosaic, which you can look at again and again and spot something new each time.

PRACTICAL TASK

■ Take the contents out of a desk drawer or sewing box.

■ Arrange the items carefully over a flat wooden surface, checking that your camera can focus close enough to fit the whole arrangement tightly into a single frame.

■ Use window lighting, covering the window with net curtains if necessary to soften the light. Or you can use bounced or diffused flash.

■ Use a large reflector on the other side of the camera to the light.

Filling the frame

If the subjects are small or flat enough, then depth of field need not even be an issue. All the objects can be laid out on a single plane, and then photographed from straight on. As all will be the same distance from the camera, you can even use a wide aperture without any problem with sharpness.

With such pictures, it is best to have a theme so that the different objects are connected in some way – whether in purpose, colour or origin. The resulting picture is like a complex jigsaw puzzle – the longer you look at it, the more detail you discover.

The same approach can be used outside the studio, and can be a particularly rewarding one when taking pictures of people. For a portrait to be informative, the environment is as important as the subject.

Showing the person's workplace – or the possessions in their home – gives a better understanding of their profession or their lifestyle. The more detail you can add to the shot, the more clues and information are provided for the viewer.

With all such complex shots, hard lighting is almost always out of the question. The mass of shadows that would result would complicate the picture still further. Soft, even illumination eliminates such problems.

ABOVE: Rather than cropping in tightly on the old men playing cards, I wanted to show the room they were sitting in. The walls of this fishermen's club in Southwold, Suffolk, were crammed with nautical memorabilia and pictures of boats and remembered seamen. This busy backdrop provides plenty of clues as to the way of the life of the men in the picture.

LEFT: A smiling bridesmaid at a wedding stands behind a huge display of flowers and fruit. Sometimes you find that the setting is as interesting as the subject you are photographing, so you should not be afraid to make the person secondary in some of the shots that you take.

See also:
← PAGE 46
Simplifying the image – the basic tools and techniques of photographic picture composition.
→ PAGE 122
Open aperture – using shallow depth of field when everything in the frame is equidistant from the camera.
→ PAGE 134
Direction of lighting – identifying and using soft and hard light.

Simple backgrounds

Choosing a suitable backdrop for your pictures is a particularly important task when shooting in the home studio, so that the subject remains the focus.

Backdrops do not always have to be plain and simple, but as you usually want the subject to be the main focus of attention in the shot, simplicity is a good rule to adopt.

Away from the studio, you do not always have the freedom to choose your own background, and the best you can do if it is distracting is to throw it as far out of focus as possible. In your own home, you have far more control with your studio shots and can select backdrops that tone with or complement the subject that you are photographing.

A favourite background for the studio photographer is paper. This comes in rolls, and can be suspended high on a wall and extended not just to the ground, but to curve round under the subject itself, so that it also acts as a foreground. It is available in a wide variety of colours, but white is used most frequently, as it can be made to appear any shade of grey that you want, from pure white to jet black, depending on how it is lit. ▷

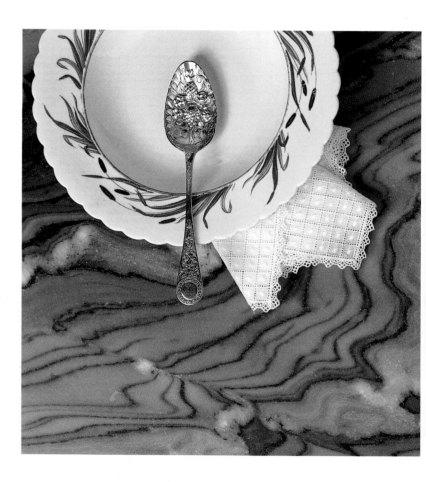

PRACTICAL TASK
■ Find an old pair of shoes or boots.
■ Find different backdrops to shoot them against – tablecloths, curtains, wood, painted walls, rolls of wallpaper, and so on.
■ Use some of the backgrounds so they also form the surface to arrange the footwear on, forming a curved L-shape with the material.
■ Experiment by varying the distance between the shoes and the background, which will affect the sharpness and brightness of the backdrop.

ABOVE: Although the pattern on this piece of marble is not simple, its wavy lines complement the scalloped edge of the plate and the napkin. Shot from above, the background also becomes the surface on which the arrangement is composed and the foreground.

OPPOSITE: Large sheets of canvas can be easily painted to create backgrounds in whatever colour you wish. In this food shot, a diffused studio light above and to the side of the subject shows up detail and texture without interfering with the composition.

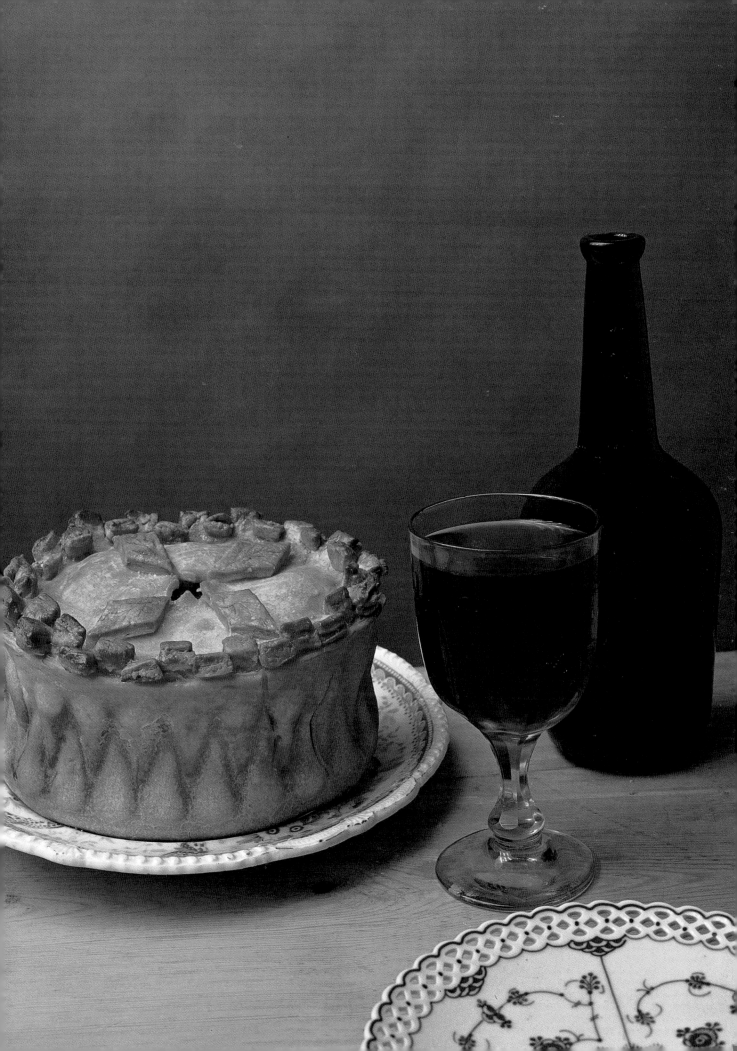

OPPOSITE: With portraits you can have almost as much choice with the background as you do in the studio, since you can move the subject to a suitable location. Archways and doorways are particularly good backdrops, as they create a frame against which to pose the person.

LEFT: The colour and tone of a background will alter depending on how it is lit. Here, a white archway appears a greyish-blue because it is that much darker than the girl's face, which is lit by direct sidelight.

Simple backgrounds

Black velvet is also a good choice, as it can be placed under and behind a subject – and however well it is lit, it will still appear black.

However, with still-life compositions, where great expanses of background might not always be necessary, you can be more adventurous with your choice of materials. Studio photographers often become keen scavengers, collecting planks of weathered timber, sheets of slate, secondhand table-cloths, chunks of off-cut marble, sheets of glass and so on. A good collection of such materials can be accumulated from skips, friends' garages and so on, providing you a great choice as to surfaces on which to arrange a still life, as well as what to put behind it.

Ideally, you should try to position back-drops so that they are far enough away from the main subject, so that they can be indepen-dently lit, allowing you to make them appear lighter or darker to suit the composition.

See also:
← PAGE 20
Harmonic colour – toning the backdrop to the subject.
← PAGE 32
Emphasizing shape – using light-coloured back-drops to accentuate outline.
← PAGE 66
Frames within a frame – creating and finding enclosures for the subject
→ PAGE 86
Elaborate backgrounds – using backdrops to add more detail and information to the composition.

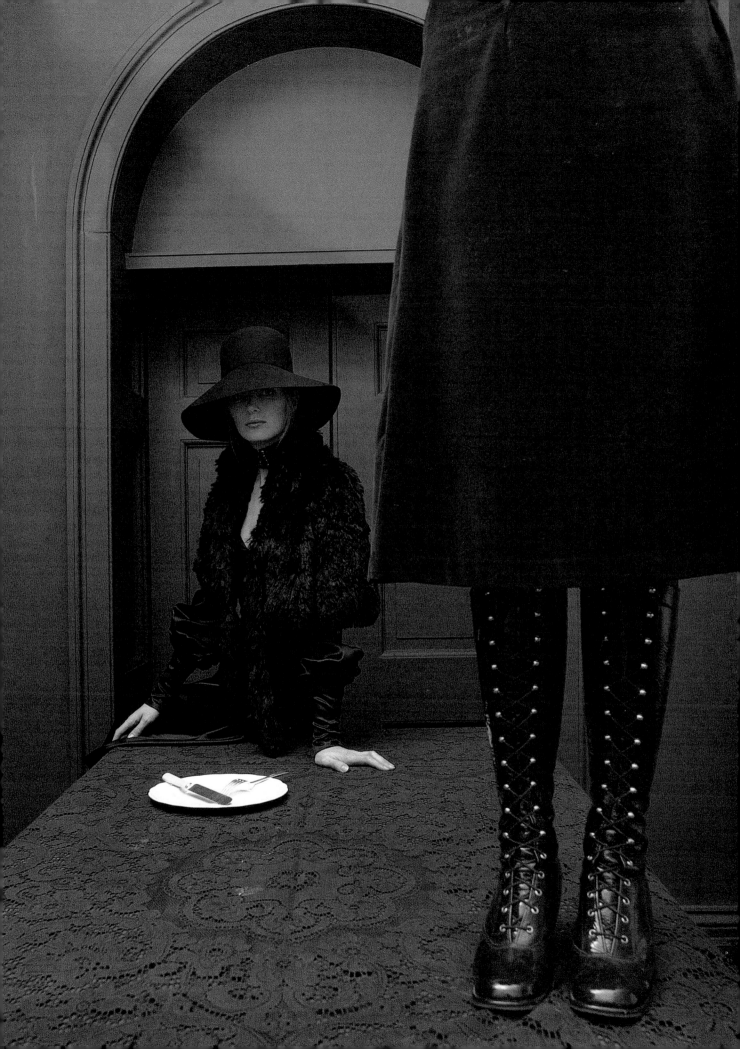

Elaborate backgrounds

Detailed backdrops may be more difficult to work with than plainer ones, but they can set the scene for the picture, adding detail and context for the subject matter.

WHILST SIMPLE BACKGROUNDS are the safest option for most types of picture, there are times when you want to use the backdrop to help you tell the story. Just as the scenery in the theatre can show complex images, so a background in the studio can provide a context for the subject, helping to explain it, or simply helping to create the right mood.

Complicated backgrounds, of course, are part of many types of photography. Reportage invariably shows people in their surroundings, holiday snaps show family members in front of famous landmarks, and in landscapes the background is frequently the most important part of the picture. However, in the studio, a less distinct background is usually the most obvious choice.

In the home, all manner of items and settings can be used to create a backdrop that suits the picture, as well as giving useful information about the setting. Murals, paintings and wall hangings, for instance, can be used, just as long as the subject matter is connected to the subject in some way. ▷

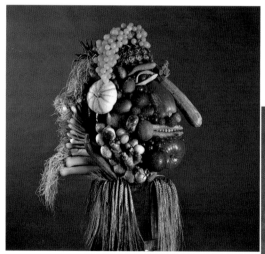

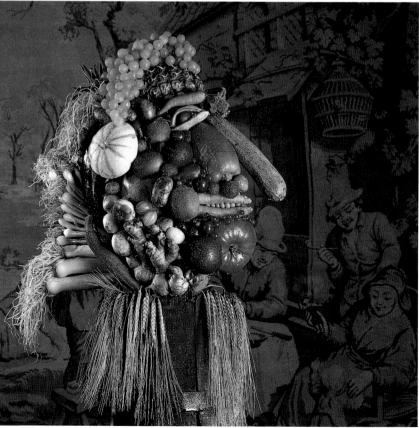

ABOVE AND RIGHT: This elaborate sculpture of a head, made out of fruit and vegetables, looks interesting enough photographed against a plain backdrop (above). But it is little more than a record shot of the artist's work. By shooting against a tapestry (right), the peculiar bust becomes more personalized, almost becoming one of the characters in the rural scene behind.

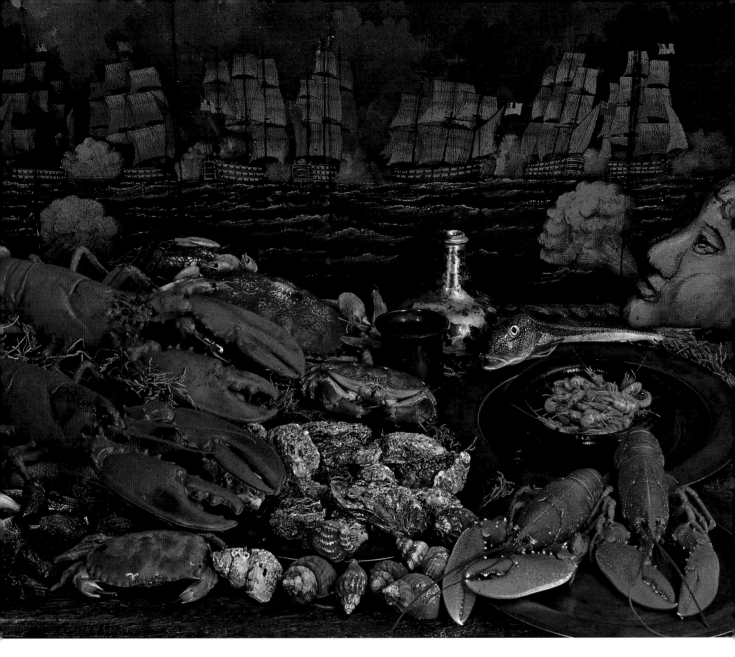

ABOVE: A pub sign with a nautical theme acts as a complementary backdrop for this display of seafood. The ocean landscape sets the scene and almost accentuates the richness and flavour of the shellfish before it.

PRACTICAL TASK

■ Find a striking picture, poster or wall hanging. Take a good look at it, noting its colours, style, subject matter, opulence, period, and so on.

■ Using this as a background, think about the subjects that you could place in front of this picture that match some of the qualities that you have already noted.

■ Arrange these items in a way that makes the most of this connection, taking a variety of different pictures.

■ Alter the distance between subjects and background, and use wide and small apertures, so as to give the background varying prominence.

■ Now persuade a family member of friend to pose with this same background. Find ways in which you can dress the person so as to accentuate some of the qualities of the picture. You can also use props, held by the model, which help to accentuate the connection.

Elaborate backgrounds

Furniture can also be used in this way. A Welsh dresser, for instance, brimming with pots, plates and spice bottles, would make a suitable backdrop for a still-life arrangement of fruit, vegetables or any other food.

It does not matter if there is too much detail, because you can still ensure that the foreground retains the emphasis in the composition. This can be achieved by limiting the depth of field, so that the background is slightly out of focus. Just how unsharp it is can be varied by changing focal length, aperture and focused distance until you achieve the weighting you desire. Alternatively, the background can be under-lit to make it darker – assuming that it is far enough away from the subject so that the foreground lighting does not reach the backdrop.

In portraiture, pictures in a person's house frequently have some connection with the sitter, making them ideal contextual material. It might be a painting of an ancestor, a poster of a hero, or a favourite hobby. You can then ask the person to dress in a way that suits the picture's style or theme.

ABOVE: Combining a painting with a person in a photograph is a fun way of taking a portrait. Although you are putting two disparate images together, the viewer automatically seeks a relationship between the two, and you can exploit this in the way you take the picture. Here the painting of St George makes the woman's pose look more heroic.

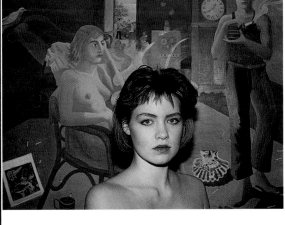

ABOVE: Despite her fine evening dress, the woman is made to look rather plain against the elaborate clothing of the two busts on either side of her.

LEFT: Shot with on-camera flash at an exhibition, the surreal painting in the background surrounds the young girl in the foreground, adding colour and mystery to the impromptu portrait.

LEFT: In this shot, the painting of the horse completely encloses the head of the woman, creating a frame within a frame within a frame. The light from a window lights the face directly, making it brighter than the picture beyond.

Strengthening the image

In addition to subject composition and the background, the props you use to embellish your shots can make or break a picture. But all three elements must work together.

RIGHT: Here, two separate still-life arrangements have been deliberately put together, creating a rich, lush image, full of texture and form. By using two bowls of different heights, the frame is filled well, whilst an imaginary diagonal line between the two set-ups has been created.

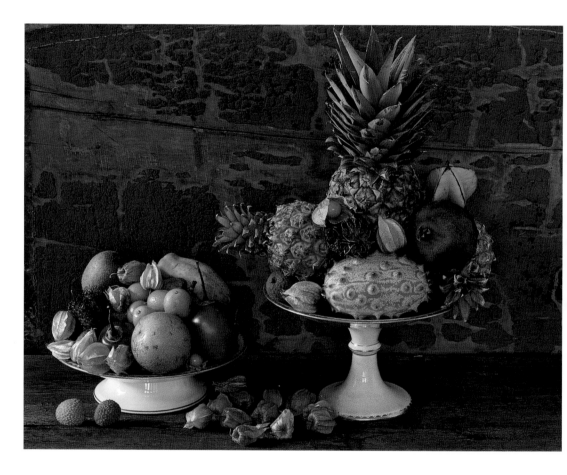

IT SHOULD HAVE ALREADY become clear from the pictures already shown in this book that there is more to taking a great still life than getting the subject to look right and finding an appropriate background. It is the small, seemingly unimportant, things that you also add to the composition that can really make a picture. In short, the props can be as important as anything else in the shot.

A prop can be anything from the plate your arrange your fruit in, to the tools that you purposely leave in the scene. And when it comes to portraits, a successful prop can be a theodolite held by an architect, a pipe clasped by an old man, or the teddy that is waved by its arms by a toddler. Hats, cars, bikes and telephones are other useful items that can be added to a portrait without too much trouble – but which can suddenly make a shot that much more interesting.

The key is that props should have some relevance to the picture and should not detract from the main subject matter. For the still-life photographer, the one thing that you can never have enough of is plates, bowls, trays and the like. These need to be in a variety of different materials, colours and designs so that they tone into the composition, or provide a strong shape or frame in which to arrange your still life. ▷

ABOVE: A quartet of tiered vegetable baskets creates a strong pattern across the frame, whilst showing off the produce well. I spotted this unusual presentation in a French kitchen, owned by a designer, but it is an idea that you could copy successfully at home.

RIGHT: The gold fruit bowl, found in a Venetian hotel, sums up the opulent surroundings. Behind, you can see the elaborate architecture of the building across the Grand Canal. The set-up was shot with fill-in flash.

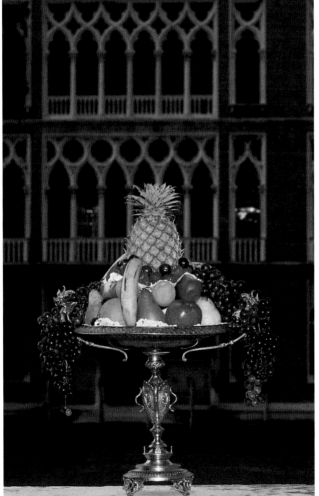

PRACTICAL TASK

■ Take a simple subject, such as an onion neatly cut in half to show its layers and white flesh.

■ Choose a piece of material which can cover your table as well as acting as the background.

■ Shoot the onion on its own, using soft lighting.

■ Now try accessorising the shot in as many ways as you can think of, shooting pictures each step of the way.

■ Try arranging the onion on different plates, bowls and chopping boards. Vary the height of the camera to suit.

■ Add different knives to each composition, creating a strong diagonal across the frame.

BELOW: This portrait was shot on the set of the television period drama *Upstairs, Downstairs*. Every detail is carefully chosen to suggest the Edwardian period, whilst showing off the proud achievements of the family cook.

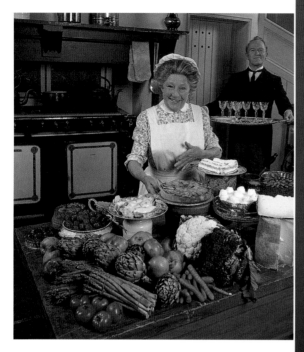

Strengthening the image

Props can be bought cheaply from garage sales, bric-a-brac stores and so on. An alternative way of extending your armoury of props is to take note of what family and neighbours have in the cupboards, borrowing items when the need arises.

Other useful add-ins for the food photographer are pieces of cutlery – these can be used to provide a strong diagonal line in what may otherwise be a symmetrical composition. Glassware, cruet sets and jugs are also worth having in abundance.

With the right props, you can accessorize your pictures to create the perfect balance between the main subject and the background. But remember, it is easy to overdo the props – even if you have lots, you should usually only use those that add to the picture.

ABOVE: With a still life on his head, and the matronly dress, the props and costume leave no doubt as to the fact that this actor is dressed up ready to play a pantomime dame.

OPPOSITE: Sometimes it is the background or props that can suggest the theme for a photograph. Here, the model has been dressed up and adorned with an artichoke and grapes, to mimic the Roman statue in the background.

See also:
← PAGE 66
Frames within a frame – using props to create a secondary frame within a still-life composition.
← PAGE 82
Simple backgrounds – as well as collecting props, you should also keep an eye out for useful backdrops.
→ PAGE 94
Developing a theme – once you have a good selection of props and backgrounds, don't be afraid to use them by trying different arrangements with every subject you attempt to shoot.

Developing a theme

Don't ever be content with taking just one picture – you will learn more, and help improve your chances of success, if you shoot as many different variations as possible.

HOWEVER GOOD a photographer you are, and however pleasing your individual shots, perfection is rarely, if ever, achieved with a camera. Upon studying the results, you can always spot some aspect of the composition, lighting or exposure that could have been improved, even if slightly. More irritating are the times when you look at your pictures, saying 'If only I had…'.

There is one simple way of trying to get closer to the ideal picture of the scene or set-up in front of you – and that is to use more film. In comparison with the time and effort it can take to get to a location, or to arrange items carefully and hunt out the perfect backdrop or prop, film is relatively cheap. For the digital photographer, using rechargeable batteries, the cost of each frame taken is zero.

But as we have already explored in this book, small changes to a picture can have a fundamental impact on its success. Exploring each of these can take time, and although some of the possibilities can be dismissed immediately, without the need to actually take a picture, there are always plenty of good alternatives and 'maybes' that are worth recording on film.

This is particularly important for the still-life photographer, as time is on your side – the subject is not going to change or move. ▷

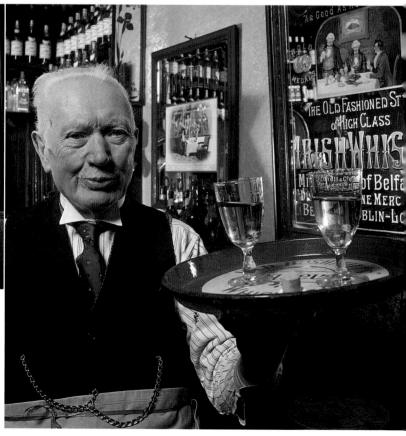

ABOVE AND RIGHT: These shots are from a portrait session with W.B. Yeats' favourite barman, taken in the Dublin pub where he served the Irish poet. The shot above shows the man sat at a stool, showing the bar well. But the shot on the right works better, as the addition of the tray of whiskey makes his profession more obvious.

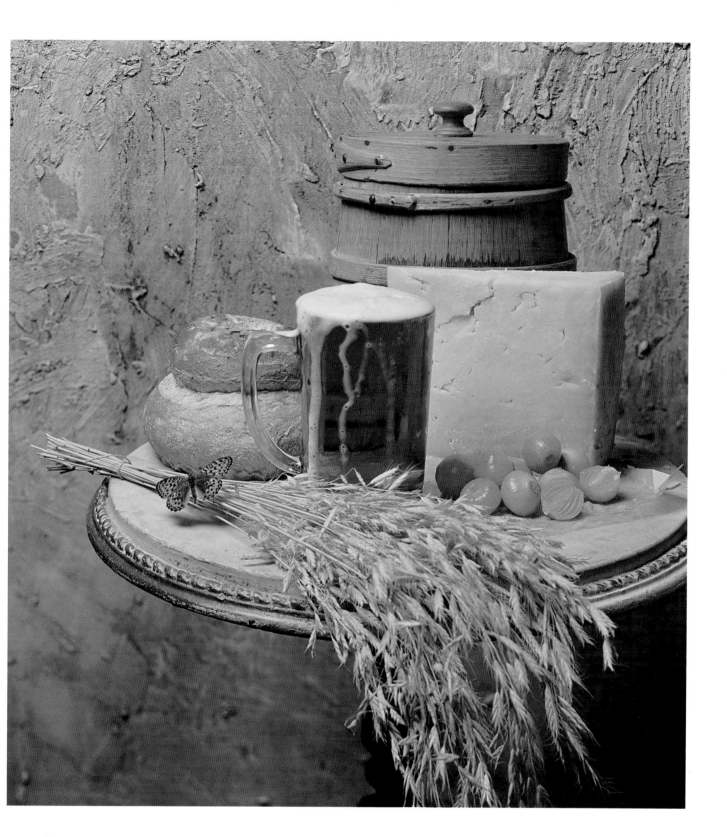

ABOVE: Sometimes you need to go to great lengths to get the picture that you want. The pastoral theme is evident in this shot, and the harmony has been stressed by using similar colour throughout. However, when I originally set up the arrangement, I found the wooden table looked far too dark and therefore did not blend in well with the rest of the shot. The solution was to get out the emulsion and give the table a fresh coat of paint. The extra effort, and the delay in getting the shot taken, were well worth it.

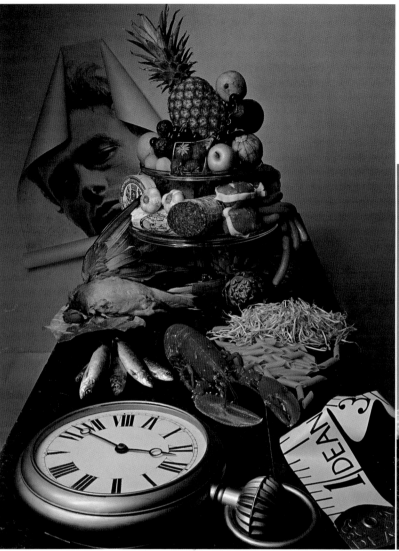

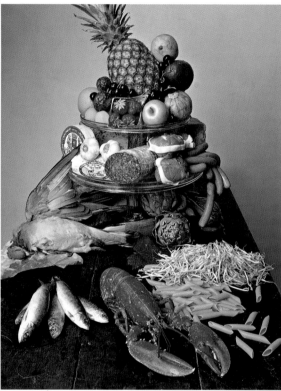

LEFT AND BELOW: When you spend days collecting items for a shoot, ensure that you use them in lots of different arrangements. My main intention was to use the over-large watch and measuring tape to add a surreal, Daliesque, feel to a conventional still life (left). However, having gone to the trouble of getting all the food into perfect position, I used the opportunity to take some 'straight' shots as well.

Developing a theme

To avoid wasting film, however, you must learn to study the viewfinder carefully – so that distractions are noticed before pressing the shutter. This can take practice. The digital photographer has the advantage here, as built-in LCD screens allow you to review the pictures you have just taken. A Polaroid back gives a similar facility to the conventional photographer, but the film is another expense. Furthermore, such accessories are not available for all cameras, and the size of the image can be too small to be of real benefit.

Away from the studio, the photographer has less control. A sports photographer can only have a split second in which to capture the shot of the winning goal being scored. But in many other instances it is perfectly possible to take a selection of different shots of the same scene or event. Here, using film freely is perhaps more important than in the studio. Whilst the still-life photographer can set up the arrangement another day, should the processed results look disappointing, others will not have this luxury.

Whether photographing a holiday destination or a wedding, it can be a once-in-a-lifetime opportunity. Exploring all of these angles thoroughly, therefore, is not just highly recommended – it's common sense.

OPPOSITE: One way of working, when you are trying to take a series of similar still-life shots, is to add as much detail as possible for the initial shot, and then keep taking things away for subsequent images. This arrangement was one of the last and best shots, and it necessitated chopping the pineapple in half and removing the majority of items.

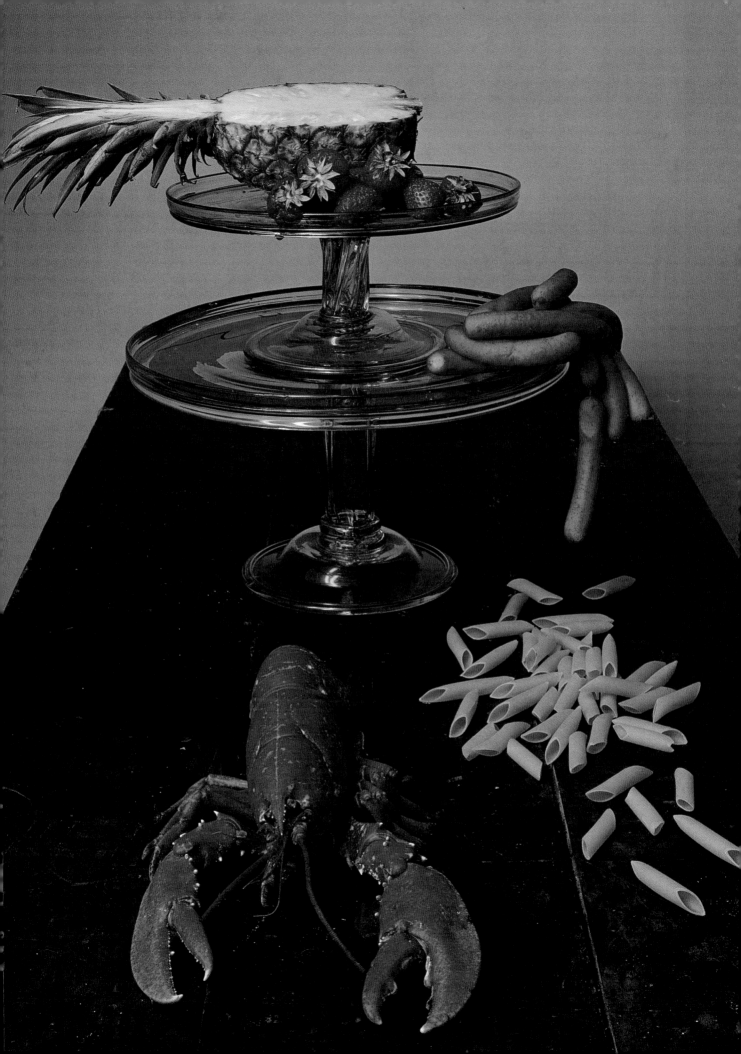

PART THREE

Technical aspects

Different films

When should you use a fast film or opt for a slow one? What are the advantages of using slides rather than prints? The ideal choice is not always obvious.

FOR THE TRADITIONAL photographer there are two main types of film. Negative film is intended for making prints, whilst reversal film produces transparencies (which, when mounted in plastic or cardboard holders, are known as slides).

Print films are by far the most popular type. Print's great advantage is that exposure need not be accurate – it can be grossly over-exposed, and reasonably underexposed, and still you will get a reasonable result. This makes it a perfect choice for use in simple cameras, without sophisticated metering systems. However, the print-making process is interpretative – and the results you get back may not be what you intended.

Slide film demands extreme accuracy in exposure and requires the use of an SLR camera. However, the processed results are much more likely to provide the photographer with consistent results in terms of reliable saturation and exposure.

Both types of film are available in a variety of speeds, related to their sensitivity to light. Faster films need less light to produce an image than slower ones. Film speed is measured using the ISO scale – a film that is rated at ISO 400 is twice as fast as one rated at ISO 200, so needs only half as much light to produce a similar picture. Slow films tend to have an ISO rating of ISO 100 or lower. Fast films have a speed over ISO 400. ISO 200 and ISO 400 films are nowadays regarded as all-round films.

The faster the film, the grainier the picture and the duller the colours. Usually a photographer will use the slowest film that they can get away with for the lighting conditions and

Fast film

LEFT: With a hand-held camera and only dim window lighting, I used a faster film than I would usually use for portraiture. The subject here is the novelist and academic Malcolm Bradbury.

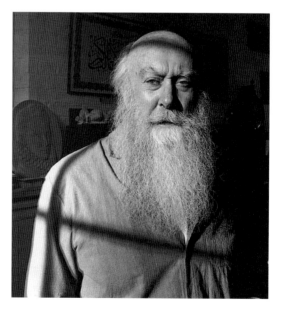

ISO 400

LEFT: Another hand-held shot taken with available light. An ISO 400 film was used to ensure that I could engage a fast enough shutter speed to avoid any signs of camera shake. With portraiture and other subjects such as landscapes, the grainy texture of faster film can be beneficial to the mood of the picture.

the subject they are shooting. However, it is a mistake to believe that fast films are necessary in low light. Often in dim conditions (in the studio or at a firework display, say) you can use a tripod and slow shutter speeds so that a less sensitive film can be used.

ISO 100

BELOW: With a set-up group portrait, I was able to set the camera up on a tripod, allowing me to use a slow ISO 100 film. However, the less-than-bright conditions made using a slower film a gamble, as the shutter speed needed when shooting people always needs to be reasonably fast to freeze any slight movement of the bodies.

ISO 25

BELOW: With a tripod and a stationary subject, you can use any film that you please – whatever the lighting conditions. Here, I used a fine-grained slow slide film so as to capture as much detail as possible in this shot of Moroccan pottery, without the intrusion of grain.

See also:
→ PAGE 104
Colour or black and white? – the advantages of the monochrome approach.
→ PAGE 116
Exposure – film speed is just one of the factors that need to be taken into consideration when measuring the best exposure for a given scene in given lighting conditions.
→ PAGE 146
Exploiting ambient light – it is the quality of light, not the quantity of light, that counts in many forms of photography, allowing you to keep on shooting in dim conditions without using high-speed films.

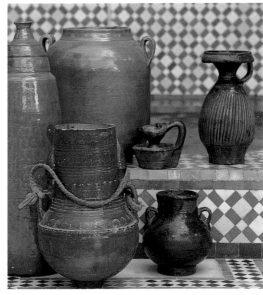

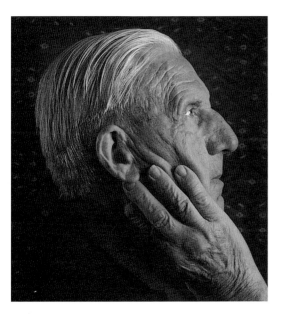

ISO 125

ABOVE: Black-and-white film is ideally suited to portraits, as blemishes and the colour of people's clothes become unimportant, allowing you to concentrate on the features and the expression. Here, a medium-speed film was used for this studio session.

ISO 50

ABOVE: This close-up of a statue was taken in low light in a church, and required a small aperture to keep both the face and hands sharp. Being able to use a tripod, I did not have to sacrifice image quality by using a fast film. Instead, I used a 2-second exposure with ISO 50 film.

Different formats

The shape and proportions of the pictures that you take vary according to which camera you use, and which way you hold it. Some models even give you a multiple choice…

See also:

← PAGE 46

Simplifying the image – the basic rules of picture composition. The ways in which you arrange your subject in the viewfinder will be limited by the number of formats that your camera has to offer.

→ PAGE 108

Cropping for impact – unhappy with the limited formats offered by your camera? You can always cut the picture into the shape you want afterwards, with scissors or on the computer.

FILM COMES IN ALL shapes and sizes. The most popular of all the formats is 35mm, which uses 135 cassette film to produce images that are 24x36mm in size.

This is the film that is used on most SLRs and usually means that you have only two picture formats to choose from. Hold your camera horizontal for landscape-format shots, and hold it upright for portrait-format shots. Having the two choices is invaluable in being able to compose a shot tightly.

Not all cameras give this two-way option. Some medium-format cameras produce square images from 120 roll film, which each measure 60x60mm. The larger image area means that the negative or slide has to be enlarged less to make an enlargement. Other medium-format cameras offer a variety, or choice, of rectangular formats.

Some may even allow 'panoramic' formats with images that are two or more times wider than they are high. This is also an option on some 35mm cameras, where the negative is masked to produce elongated proportions.

The arrival of the APS format (used in both compacts and SLRs) has allowed users to choose from three horizontal and three vertical formats whilst shooting. A widescreen format offers 16:9-proportioned images; a classic format offers the same 3:2 ratio offered by 35mm cameras; and a panoramic mode offers a 3:1 aspect ratio. The format chosen is marked magnetically on the film, rather than by masking the negative, so that the ratio is selected automatically by the processing lab at the printing stage. This has the benefit that you can change your mind about the format after you have taken the picture.

35mm format, 135 film

ABOVE: The most popular film format usually has a fixed image size. But as it has rectangular proportions, you have two aspect ratios. Its landscape and portrait formats give additional choice when composing your shots.

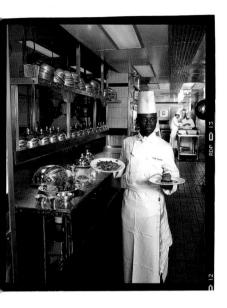

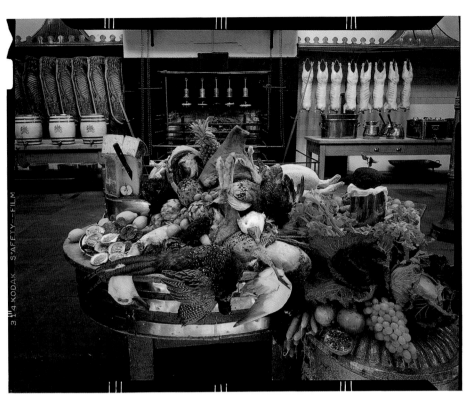

x7cm format, 120 film

ABOVE: Medium-format cameras give big
egatives or transparencies, using a variety of
rmats. 6x9cm, 6x7cm, 6x6cm and 6x4.5cm are
e common image sizes available.

5x4in format, sheet film

ABOVE: Large-format cameras produce the biggest images, using sheets of film measuring 5x4in or
10x8in. These cameras cannot be used without a tripod, and are primarily used for studio and
architectural work. The cameras are usually designed so that the film plane and lens plane can be
independently manoeuvred to give unparalleled control over perspective and depth of field.

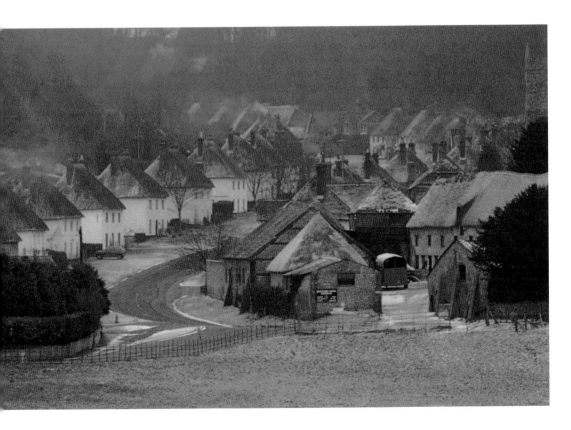

Panoramic format

LEFT: Panoramic formats
used only to be available
from specialist 35mm and
medium-format cameras.
Nowadays, APS cameras
and many normal 35mm
cameras offer panoramic
modes. These are useful
for shots of wide land-
scapes or tall buildings.
This panoramic shot is of
the village of Milton
Abbas, Dorset.

Colour or black and white?

Black-and-white pictures not only have a timeless beauty, but the lack of colour allows you to concentrate on shape and tone without worrying about mixed lighting.

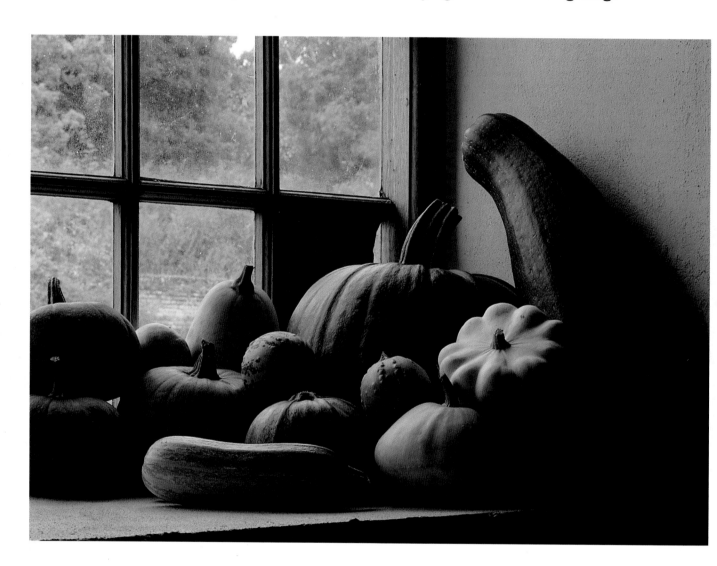

ABOVE AND OPPOSITE: Weak, soft sidelighting from a window produces pastel shades in this still life. The hues are subtle, but they still help to identify the different varieties of gourd. With black-and-white film, the picture is automatically made more abstract.

BLACK-AND-WHITE film may no longer be popular for snapshots, but it is still highly valued by serious photographers. Without the distraction of colour, monochrome films allow you to concentrate on other elements within the picture, such as shape and texture.

Care must be taken when using black and white, as two very different colours can become the same tone of grey, and a subject can end up being lost against the background.

One of the attractions is that black-and-white film is easier to develop and print yourself. This gives you increased control over your results. In the darkroom, you can crop your shots as you want them, change the contrast, and darken distracting detail. For studio and interior photographs, there is a further advantage: black and white is unaffected by the different colours of light, allowing you to mix daylight or electronic flash with ordinary bulb lighting in a way that is practically impossible with colour film. ▷

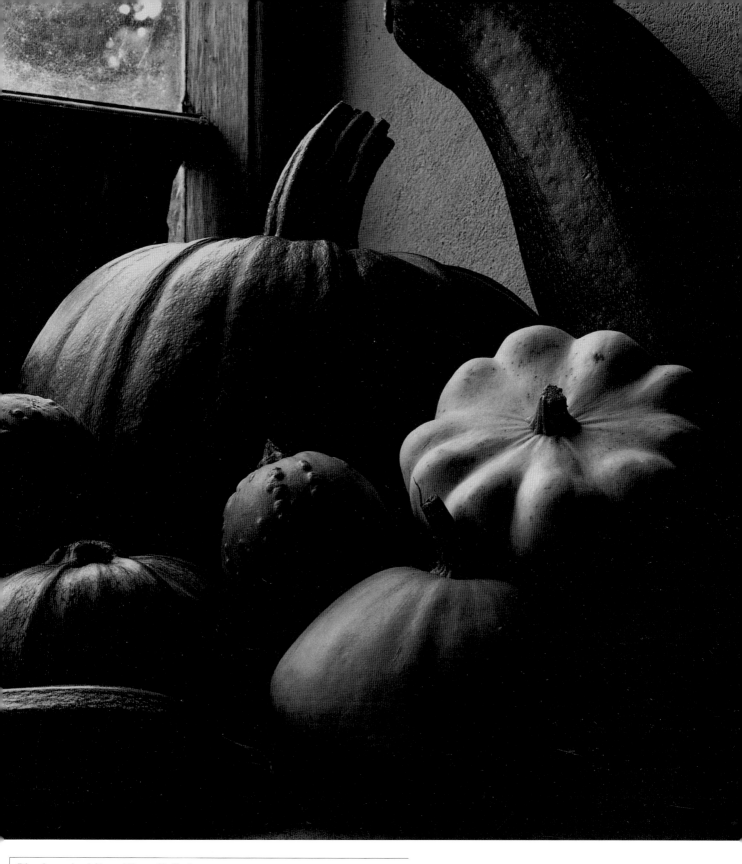

Black and white with a digital camera

With digital cameras you cannot change the film to handle different lighting or achieve different effects. However, many allow you to affect film speed electronically, to facilitate low-light shooting or to achieve a grainy image. Many also offer special modes, where the picture can be recorded in black and white, sepia and so on. Often, however, it is preferable to record the image in colour and then to change it to a black-and-white one later, using basic image manipulation software. Many traditional darkroom effects can also be tried out easily on the computer, such as selectively brightening or darkening parts of the image, changing the contrast, adding grain, and toning in a full palette of colours.

OVERLEAF: Without colour detail, it is the curious three-dimensional shapes of the produce and snails that become the focus of attention; the way that the shadows and highlights fall on the rounded surfaces creates elaborate patterns that are not as visible in a colour version of the same subject.

Cropping for impact

The printing stage gives you an opportunity to reassess your composition, and to crop out unwanted areas or distracting details in order to improve your photograph.

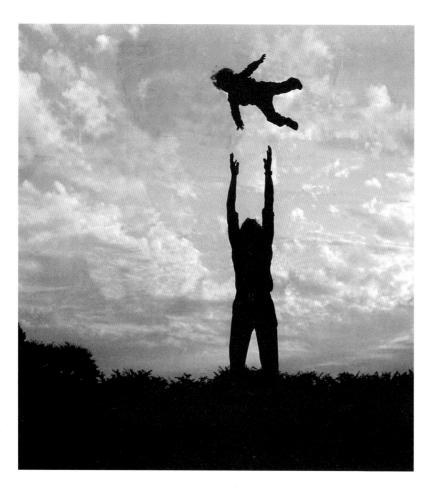

LEFT: Original composition – the moment is well captured, but the composition is rather symmetrical.

ABOVE: Being dissatisfied with the original, I used masking tape on a differnt version, experimenting to find a more dramatic composition from the full-frame original.

OPPOSITE: The re-cropped final result creates an upright frame, suiting the picture well. The image is also rotated to create a strong diagonal leading the eye across the frame.

I N A PERFECT WORLD, every frame on your film would be well composed, showing the subject at its best. In reality, however much time we spend arranging the subject in the frame, it can always be improved upon. Fortunately, this can often be done without having to go back and take more pictures.

Moreover, there are times when you don't want to crop your pictures too tight at the time of shooting. You may use a loose composition with a fast-moving subject, say, to ensure that the subject is well within the frame.

Professionals may leave empty areas, so that magazines have a more flexible image to work with – allowing them to print type over part of the picture, for instance.

Cropping can be done in a variety of ways: by selective enlargement in a traditional dark-room; by giving explicit instructions to a processing laboratory; or by manipulating a digitized image on a computer.

With the full-frame print, you can use four pieces of paper or two L-shaped boards to experiment with cropping pictures in a variety of ways. Not only does this allow you to cut away unwanted detail, it also allows you to re-shape the format of the picture itself so that the picture has more impact.

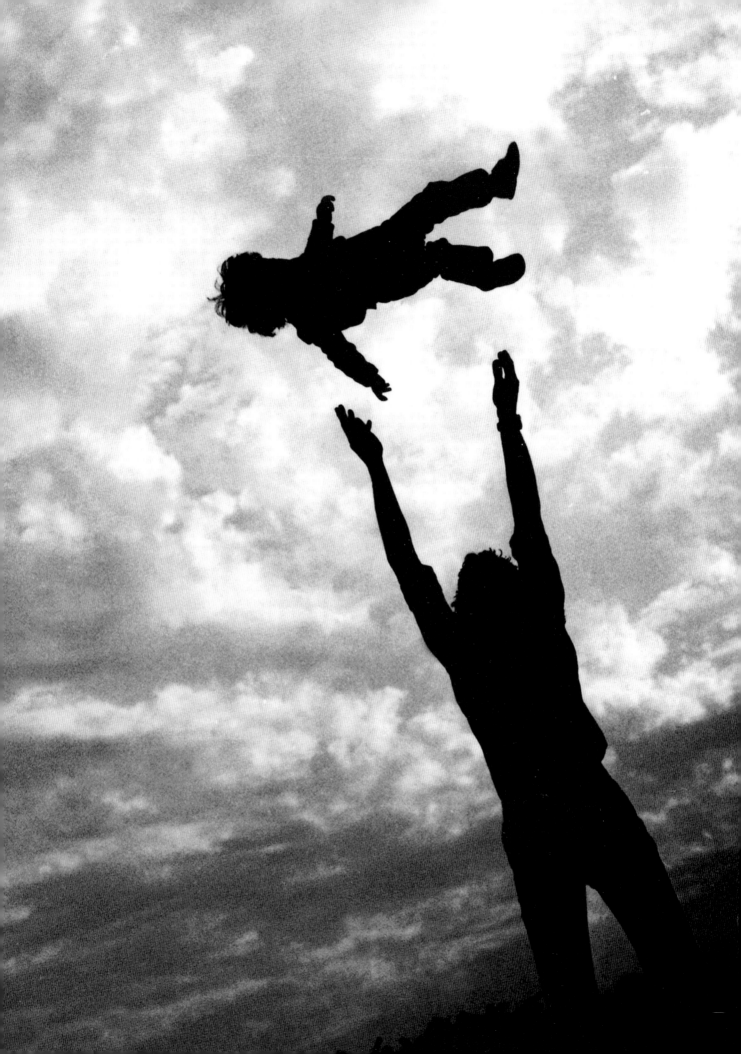

Digital imaging

Digital photography is not just revolutionizing the way in which photographs are taken and used – it also brings darkroom effects to everyone.

As DIGITAL CAMERAS continue to offer better resolution and better handling, they are becoming a serious alternative to film for the enthusiast. They are cheap to run, and provide almost instant results.

But the uses of digital imaging are just as interesting. Encoded in binary data, photographs can be easily shared with a wide audience. They can be emailed, presented on websites and put into presentations. And they can still be printed out at home onto conventional photographic paper.

To join the digital revolution, however, you don't need a digital camera. Traditional images can be digitized using film and flatbed scanners (at home or in a lab); once this is done, your computer becomes a sophisticated darkroom that you can use with the lights left on.

RIGHT: The pictures on these pages are typical shots from a family album. Once digitized, they can be shared with friends worldwide either by email or by posting them on an internet site.

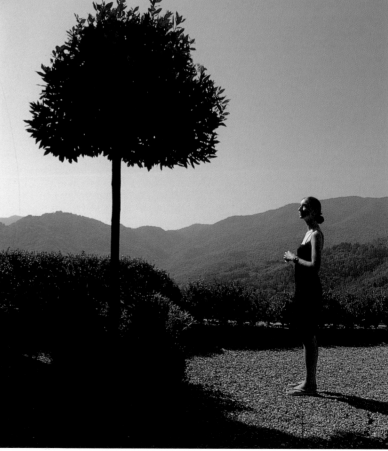

LEFT AND ABOVE: One way of presenting favourite pictures is to use a montage. Traditionally, this has been done with scissors and glue. However, with digital images it is easy to combine different shots on a computer. If you make a mistake, you can start again – and each shot can be individually sized so that all the elements fit.

ABOVE AND TOP RIGHT: Image manipulation software provides a number of different tools that allow you to cut out around the outline of even the most intricate of shapes – removing it from its background. Once isolated in this way, the cut-out picture can be saved separately on the computer, and then incorporated into a montage.

BELOW: A basic montage, which combines elements of the other five photographs on this page. Such shots can be fun to create, and can be made without ruining your prints. However, combining different shots together more realistically, so that you can't see the joins, takes a certain amount of skill at the computer – and a great deal of patience.

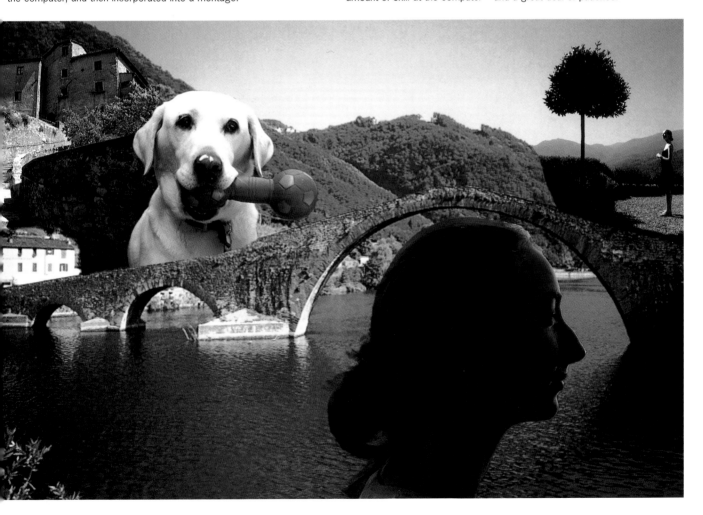

Digital effects

Image-manipulation programs allow the digital darkroom worker to add all manner of special effects to their pictures. Be careful, as it is all too easy to get carried away.

LEFT: The original slide was turned into a digital file by a processing lab, ready for computer manipulation.

OPPOSITE: Some of the simple effects that can be achieved with standard desktop image software. With the posterization effect (top left and bottom left) the number of different tones that your picture is reduced to can be selected on-screen and changed until you are happy with the result. A speckled mask can be added to the image for a grainy appearance (top right). Once you are happy with the overall effect, the colour range used in the picture can also be changed, here adding an overall turquoise tinge across the image (bottom right).

IMAGE-MANIPULATION SOFTWARE that allows you to change your digital pictures in all manner of ways need not be expensive. In fact, basic programs are often given away with scanners or digital cameras. Professional programs, on the other hand, may cost more than your camera. But whatever you spend, the program will allow you to do far more than re-crop your pictures

It is tempting to get carried away with the more outrageous effects that are provided by the program. Tricks that have kept traditional darkroom workers toiling for hours can be achieved in a few seconds on the computer. Posterization, solarization, lith printing, high-key, tonal separation – all may be expertly performed on a PC with little effort. Screens that create an overall pattern over the picture can be added and removed without fuss. Photographs can be made to appear to look

like oil paintings or watercolours with the help of an appropriate 'filter' or 'plug-in'. Zoom bursts can be added after the picture is taken, whatever lens and shutter speed you used.

These effects all have their uses – but, as with all such tricks, they can often be over-used, and are unlikely to meet with universal approval. But this does not mean that image manipulation does not have its uses.

It is the small adjustments to your picture that are often the unsung saviours of the world of digital manipulation. Small problems with colour casts can be changed, for instance. The contrast of colour, as well as black-and-white, images can be adjusted. Foregrounds can be made to appear slightly sharper, and back-grounds can be thrown out of focus. Red-eyes caused by flash can be painted black. In short, all manner of irritating mistakes, that we all occasionally make, can be covered up.

Digital retouching

The camera never lies, so they say. But with digital image manipulation software, small blemishes and even whole people can be surgically removed from your pictures...

RIGHT: A favourite portrait of mine of Alfred Brendel. But I have always been slightly irritated by the harsh shadow immediately to the left of the pianist – caused by the strong sidelighting, and the sitter's proximity to the wall behind him.

OPPOSITE: By using the 'clone' tool in a image-manipulation program, the shadow is simply removed by copying evenly-lit sections of the wall onto the dark areas.

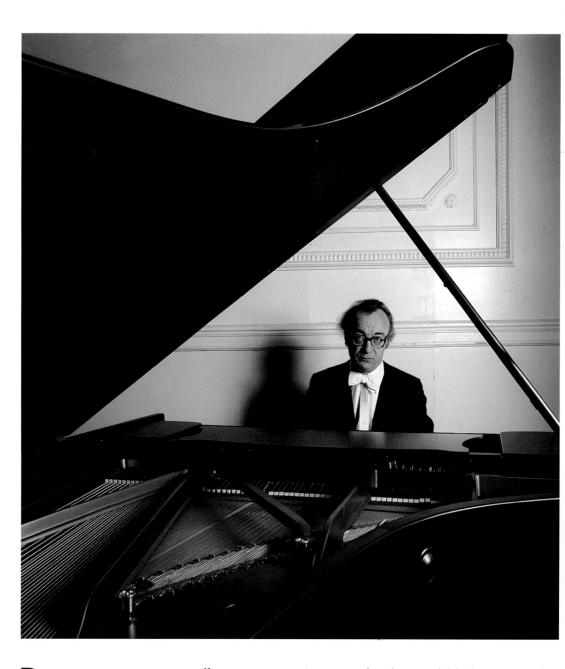

DIGITAL MANIPULATION allows you to work on tiny parts of a picture at a time – not just the whole image. Each image is made up of thousands or millions of tiny dots known as pixels, and each of these can be changed individually, if you wish.

A variety of tools is available for you to select whole subjects easily. A 'magic wand' tool, for instance, allows you to pick all the pixels in a particular area with a similar tone or colour. Once selected, these areas can be altered without affecting the rest of the picture –

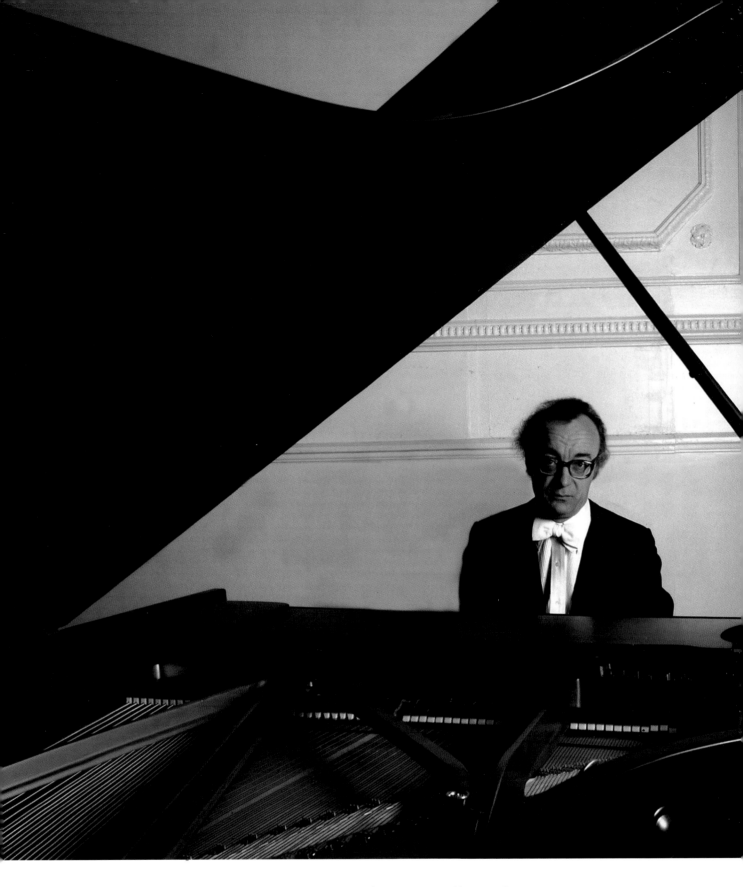

changing their colour, contrast, sharpness and so on. Areas of the picture can be rebuilt. A scar on someone's face, for instance, can be removed by 'cloning' areas of skin from elsewhere and sticking them over the blemish. With medium skill, the joins can be made invisible. But this rewriting of history does not have to end here. Individuals can be removed from group portraits in a similar way and replaced with new people, if you so wish.

Different images can also be combined to make a very realistic-looking photomontage.

Exposure control

Although the camera can usually work out the 'correct' exposure for you, it is often necessary to take control yourself to ensure you get the picture that you want.

CAMERA METERING SYSTEMS have got increasingly sophisticated in recent years, so that it is possible to take well-exposed shots without even thinking about aperture and shutter speed. But this is not a good idea, as however clever the built-in meter, it can't tell what sort of picture you want to take.

The two fundamental factors in exposure are the size of the aperture and the length of time the shutter is open for. But as well as controlling the amount of light reaching the film, these have other consequences for the picture. You may want to deliberately blur a moving subject on film, by using a slower-than-usual shutter speed, for instance. Any change in aperture, meanwhile, affects depth of field. Only the photographer can decide how to balance these two variables.

Even the actual light reading taken by the meter can disagree with your interpretation of a scene. A camera may decide a backlit subject needs more light to expose it, whilst you would prefer a shorter exposure to ensure that the subject becomes a dark silhouette.

ABOVE: The photographer constantly has to decide on an aperture that provides enough depth of field to a scene, whilst simultaneously ensuring that the shutter speed matches the subject matter and is fast enough to avoid camera shake. In this shot, I wanted to keep the foreground sharp so I used a small aperture. The car in the background is blurred as I used a shutter speed of 1/60sec, which was too slow to capture the moving vehicle sharply. The shutter speed, however, is fast enough to ensure that the enraged woman in the stationary car is caught sharply.

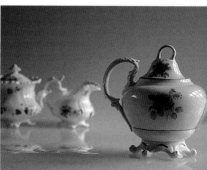

ABOVE: There is rarely one 'correct' exposure for a subject. Here, each shot in the sequence is progressively darker, but each can be viewed as being acceptable. The first exposes for the highlights, the second for the midtones, and the last for the shadows. With difficult subjects, you may shoot several different exposures of the same set-up (known as 'bracketing'), to ensure that you'll be happy with at least one of the shots.

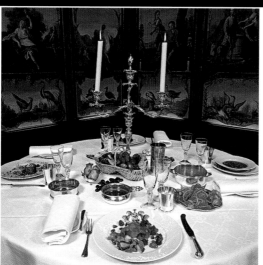

RIGHT: Film is incapable of recording detail in both the shadows and the highlights simultaneously, if there is a great contrast between the two. Here, the white tablecloth is significantly brighter than the dark background. The exposure, therefore, is a compromise, with neither area perfectly exposed.

ABOVE: Very dark, or very bright, backgrounds usually cause the camera's exposure systems to get it wrong, so you need to compensate manually. Here, the black backdrop would fool the meter into giving a longer exposure; the resulting overexposure would make the black more grey, and the colour of the flowers less intense. By 'underexposing' the shot using the camera's compensation control, the exposure is better balanced.

Depth of field

Depth of field is one of the photographer's most important creative tools,
and the aperture you use is one of three ways with which you can control it.

A line of bottles in the
studio provides a simple
study on which to
experiment with depth of
field. As subject distance
is limited in this
environment, maximizing
depth of field is always
going to be a problem.
Here, using a standard
lens focused on the
central bottle, only the
aperture has been
changed between the two
shots. In the shot on the
right, it is set to f/3.5,
whilst on the facing page
it is set to f/22.

ALENS CAN ONLY FOCUS precisely, in strict scientific terms, on one plane at a time; and everything nearer or farther from this plane appears progressively less sharp. However, in reality, there is always a certain range of distances in front of and behind this focused plane that will appear sharp to the human eye – and this is what is known as depth of field.

The amount of depth of field in a shot can be varied using three main factors: the focal length of the lens used, the aperture, and the distance the lens is focused at.

The aperture is normally the easiest of these for the photographer to control, as it does not necessitate changing the camera's position. The smaller that the aperture is (confusingly, this means the larger its

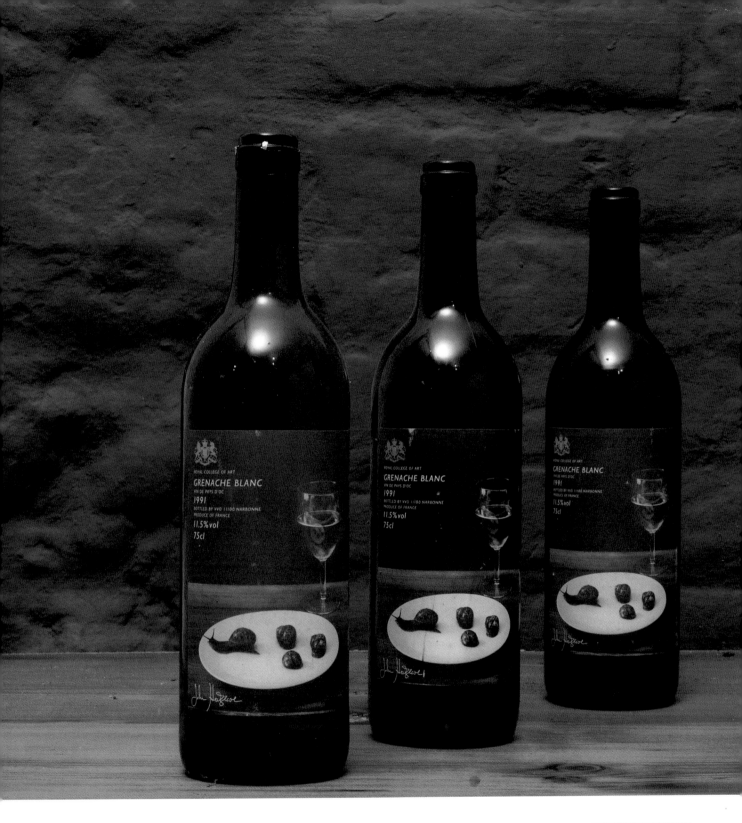

f/number), the greater the depth of field. With a typical lens, the maximum aperture of f/3.5 would give the least depth of field, whilst a setting of f/22 (the smallest opening) would keep as much of the photograph as sharp as possible.

You can also alter depth of field by altering your distance from the subject, or by changing where you focus within the frame. ▷

See also:

← PAGE 40

Creating distance – adding the missing third dimension.

← PAGE 116

Exposure control – juggling shutter speed and aperture.

→ PAGE 122

Open aperture – using selective focusing to concentrate the attention on the main subject.

→ PAGE 128

Wide-angle lenses – using focal length to maximize depth of field.

Depth of field

The closer the point you focus on, the less depth of field , and with subjects very close to the lens, this may only extend a few millimetres. Depth of field is therefore greater with distant subjects, generally extending further behind the focused point than in front of it.

You can also choose your lens or zoom setting so as to deliberately accentuate or control depth of field. Wide-angle lenses provide more depth of field than telephoto ones. A 28mm wide-angle setting can keep everything from in front of your feet to the horizon in focus when shooting landscapes with a small aperture. A 300mm telephoto, on the other hand, will provide far more limited focus range, whatever the aperture.

Changing focal length, however, for a particular subject will not always change depth of field significantly, as you will also need to adjust the subject distance.

It is important to realize that just because part of a picture is out of focus, it does not mean that it is unrecognizable. The degree of un-sharpness will vary depending on the distance from the focused plane, becoming progressively more blurred the further it is away from the subject. If you are trying to eliminate a distracting background from a photograph using depth of field, then throwing it out of focus is rarely enough. It needs to be significantly out of focus.

BELOW: In this shot, depth of field has been severely limited using a wide aperture. This not only ensures that the background does not appear sharp, but also gives a soft overall appearance to the tulips, many of which are not critically sharp.

LEFT: When photographing a flat surface, you can ensure that everything is sharp, whatever aperture you use, just by shooting the subject from straight on. This ensures that the back of the camera (the film plane) remains parallel with the surface. However, don't use your widest aperture unnecessarily, as lenses usually perform at their best when closed down by a couple of aperture settings.

PRACTICAL TASK

■ Set up a line of beer cans or baked bean tins at home, extending in a diagonal line away from the camera. Use a tripod, so that you are free to use any shutter speed, and focus on the can in the middle of the line.

■ Shoot a sequence of pictures, changing the aperture each time. Keep a list of the apertures used.

■ Repeat the exercise, focusing on the front can, then on the rear can.

■ Now, experiment with different focal lengths and subject distances.

■ Compare your results carefully, using a magnifying glass.

ABOVE: To ensure that you get the maximum depth of field in a shot, you can ensure that all three of the main factors work together. Here, everything is sharp in the shot, from the sign in the foreground to the buildings in the distance. This is achieved by using a wide-angle lens at f/22 – in addition, the lens is focused part of the way into the composition, rather than on the foreground.

Open aperture

Shooting with the lens aperture wide open allows you to concentrate on just one part of the composition, throwing the other elements in the frame out of focus.

RIGHT: For hand-held photography in low light, the maximum aperture is often essential if you are to avoid having to change to a faster film. Here, an aperture of f/1.8 is used on a 50mm lens – and although the prawns in the centre of the composition are sharp, the bowl itself appears softer around the edges.

RESTRICTING DEPTH OF FIELD is a powerful weapon for the photographer, allowing you to improve and simplify the composition of the shot.

In the studio, you have control over the situation, and can ensure that the background does not distract from the main subject, or that there are no annoying details in the foreground. But in many other situations you do not have this luxury. The angle of view is limited by circumstances, and you cannot just move things to suit your composition.

By using a wide aperture, it is possible to ensure that only the most important element in the picture appears sharp – anything else in the picture appears with less emphasis, because it is out of focus. ▷

ABOVE: When photographing nature subjects, selective focusing with a wide aperture can be used to your advantage. Here, by using an aperture of f/4, the viewer's eye is drawn to the wasps as the subject of interest, whilst the background detail remains a soft, atmospheric blur.

ABOVE: At close distances, depth of field is restricted,
whatever aperture that you use. This fact can be used to
your advantage, exaggerating the shallow depth of field
with a large aperture. Here, an aperture of f/2.8 ensures
that only one of the flowers appears acceptably sharp,
whilst others in the composition have been converted into
an abstract blur of colour.

RIGHT: Here, I chose the widest aperture available on the camera's zoom so that the busy garden in the background has been significantly softened and becomes virtually unrecognizable. This concentrates the eye on the interesting selection of shapes, patterns and colours on the balcony.

Open aperture

Shallow depth of field becomes particularly important in an otherwise busy composition. A face in the crowd remains lost unless you can blur the surrounding throng, so that your eye is immediately led to the person that you want the viewer to see.

Being slightly out of focus is not always enough – particularly if the unwanted elements are recognizable. However, by using the widest aperture available you can throw the background as far out of focus as possible.

The maximum aperture on a particular focal length of lens will vary enormously. A 300mm setting on a low-cost telephoto zoom may only have a maximum aperture of f/5.6; an expensive prime 300mm lens, used as the standard lens by many sports photographers has a maximum aperture of f/2.8 and is far more capable of making advertising hoardings and spectators on the other side of the pitch or field unrecognizably un-sharp.

BELOW: The maximum aperture of a zoom often varies depending on the focal length that it is set to – with the largest available aperture becoming smaller as you zoom in. This was taken with a 28–70mm lens, which has a maximum aperture of f/2.8 at its wide-angle end, but f/4 at its telephoto end.

LEFT: Among a collection of similar objects, it can become hard to see individual characteristics. A mass of snowdrops can make an interesting picture, but using a macro lens at maximum aperture, I emphasized the shape and form of the delicate winter flower.

ABOVE: Using maximum aperture means that the lens must be focused that much more accurately, as you don't have enough depth of field to hide any slight mistake. With pictures of people it is essential that you focus on the eyes, rather than on other facial features. If these don't appear sharp, the whole portrait will look out of focus.

Focal length

Changing the focal length of the lens allows you to home in on distant detail, or lets you squeeze more of your surroundings into a single image.

IT IS NOT ALWAYS POSSIBLE to get close enough to a subject with a single lens to enable it to fill the frame sufficiently. And on other occasions, you can't get back far away enough to fit everything into the viewfinder. It is in these situations that changing the focal length of the lens being used becomes essential.

Many cameras, digital and conventional, have built-in zooms, which give varying control over the focal length and angle of view. But even better are models that have inter-changeable lenses which give you a full choice of zoom and fixed-focal-length lenses. Lenses can be changed between each shot.

Lens focal lengths fall into three broad categories. Those which give an angle of view equivalent to the central field of vision of a human eye are called standard lenses. For the 35mm format, this is roughly a 50mm lens.

Lenses with a shorter focal length than this, and with a wider angle of view, are known as wide-angles. Anything with a 35mm focal length or less fits into this category for a 35mm format camera. Those lenses with a narrower field of view than a standard length, and a longer focal length, are the telephotos.

Focal length, however, cannot be directly compared between formats, as the smaller the format, the shorter the lens needed to give a particular angle of view. A 100mm lens on a 35mm-format SLR would be equivalent to an 80mm lens on a APS camera and similar to a 185mm lens on a 6x6cm medium-format camera. For digital cameras, the same field of view might be given by a lens with a focal length as short as 12mm (depending on the exact size of the miniature imaging chip it uses, instead of film, behind the lens).

28mm wide-angle

ABOVE: An excellent all-round wide-angle lens that is particularly well suited to landscapes and architecture. It creates hardly any visible distortion – unlike wider lenses, where lines at the edges of the frame can noticeably bulge out like barrels.

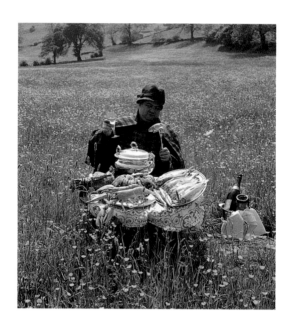

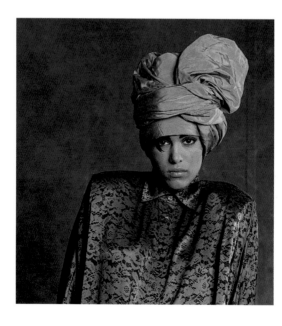

85mm telephoto

BELOW: Short telephoto lenses are ideal for portraits as, unlike wider lenses, they do not distort facial features, accentuating noses and chins. However, unlike longer telephoto lenses, they allow you to be close enough to the subject to give instructions – and you can work in a modestly sized studio.

35mm wide-angle

BELOW: Wide-angle lenses are known for their uses for architecture, interiors and landscapes, but they can also be very helpful with posed portraits, providing a wide enough view to show the person's working environment or home. The 35mm lens (for the 35mm format) is the least wide-angle of all the wide-angle lens settings.

50mm standard

BELOW: The 50mm focal length on a 35mm camera is a useful all-purpose lens, producing pictures which are very similar in angle of view and perspective as that provided by the human eye (without its peripheral vision).

See also:
← PAGE 118
Depth of field – focal length is just one of three main factors that affect how much of the image is sharp.
→ PAGE 128
Wide-angle lenses – with a wide angle of view, you have to work particularly hard to ensure that the whole picture area is used effectively.
→ PAGE 132
Specialist lenses – whilst many focal lengths can be covered by a zoom, there are some lenses that have to be bought with a fixed focal lengths – such as macro and perspective control lenses.

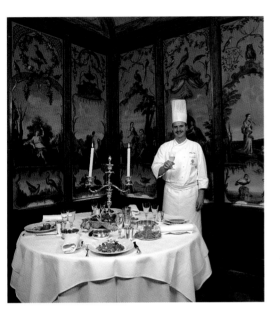

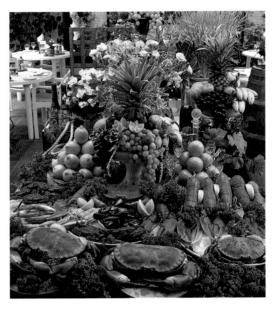

135mm telephoto

ABOVE: Another popular focal length, suitable for both posed portraits and for candid photography. Nowadays, you can make do without a bagful of lenses, instead opting for, perhaps, just two zoom lenses which cover the focal lengths that you most use.

200mm telephoto

ABOVE: The 200mm telephoto (on a 35mm SLR) is about the shortest focal length that you can get away for general sport and wildlife shots, where you can't usually get close enough to frame the shot well enough with wider lenses. It is also a good lens for candid portraits, allowing you to pick out interesting faces and expressions across a crowded room or street.

Wide-angle lenses

The perspective created by using wide-angle lenses means that the foreground can be made to loom larger than life in your picture. But you need to use them with care.

BELOW: To ensure the maximum feeling of depth in the picture the duck press was kept out of focus – keeping the food as the main emphasis and giving a feeling of abundance.

THE FOCAL LENGTH of lens that you use doesn't just affect how big a subject appears in the viewfinder. It also seems to affect the perspective, altering the relative sizes of background and foreground.

In reality, perspective is controlled by one factor alone. It has nothing directly to do with focal length, but depends solely on the distance of the subject from the camera. In reality, the lens that you use is important – whilst you might take a head-and-shoulders portrait of a person from just 1m away with a wide-angle lens, you might stand 10m away to fill the frame so completely with the same subject if you were using a long telephoto lens. Wide-angle lenses, in short, are used at closer shooting distances than telephoto ones, which is the reason why they seem to have an effect on perspective.

The great advantage of the wide-angle lens is that it allows you to give prominence to the foreground, with items further away from the camera rapidly falling away in size.

This technique can also be used successfully to add back the missing third dimension from our otherwise flat photographs. Because items look smaller we assume they are further away, creating an appearance of depth. Parallel lines, such as those of a railway track, tend to converge steeply, again effectively suggesting depth through perspective. ▷

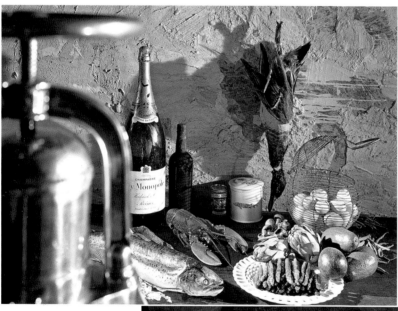

RIGHT: Because a wide-angle lens brings the foreground to the fore, it can be very useful for still life photography – allowing you to almost feel the food.

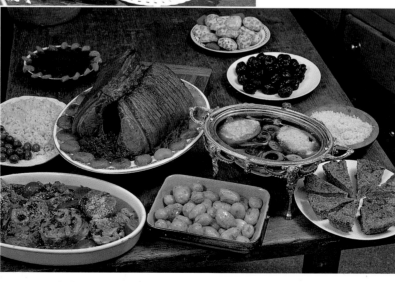

OPPOSITE: When photographing a collection of similarly sized objects, such as these antiquarian books, a wide-angle lens will allow you to make those in the foreground appear larger than those further away. This adds depth to the picture, and allows you to lead the eye into the frame.

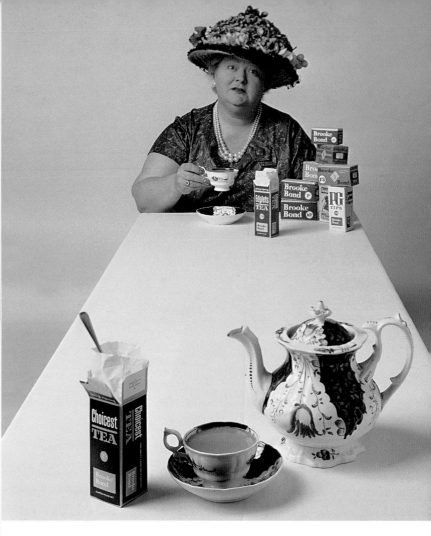

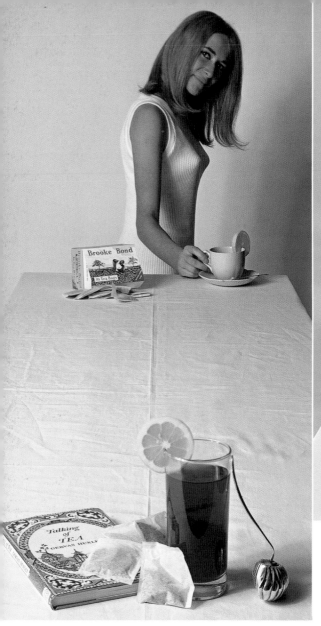

Wide-angle lenses

But the factors that make a wide-angle such an interesting one to use also make it a difficult lens to use well. For a start, the emphasis on the foreground can sometimes lead to compositional difficulties. Unfilled spaces in the foreground create a large visible hole, which proves a particular problem in landscape photography, where the natural emphasis is on the horizon. This usually means that an otherwise unimportant detail – such as a flower, a branch of a tree, or a gateway – has to be arranged so that it makes adequate use of this foreground area.

In the studio, this is less of a problem, as the main focus of attention in a still life can be placed in the foreground, so that it becomes the natural focus of attention. However, by doing this other problems can be created.

By its very nature, a wide-angle lens may make items in the background small – but at the same time more of the background is shown. A bigger backdrop is therefore needed, and this may be difficult to incorporate in a small home studio – particularly if the backdrop is to be placed a sufficient distance away from the subject so that it is not to be in focus, and can be lit independently.

The same problem can manifest itself in other areas. With a telephoto lens, perspective seems to be compressed, making a area of the background shown in the picture appear large in the frame. But on occasions this may make it less recognizable. With a wide-angle lens, a portrait shot may mean that a whole room or an entire house is shown in the background, making its identity obvious, even if detail is

ABOVE AND LEFT: These shots were set up with the camera giving the same view as someone having a conversation with the two women at the other end of the table – a 'point of view' shot as it is known in the movie business. The overall theme of 'tea for two' is used to fill the foreground successfully, whilst the 28mm wide-angle lens on a 35mm SLR causes the parallel lines of the table to converge sharply.

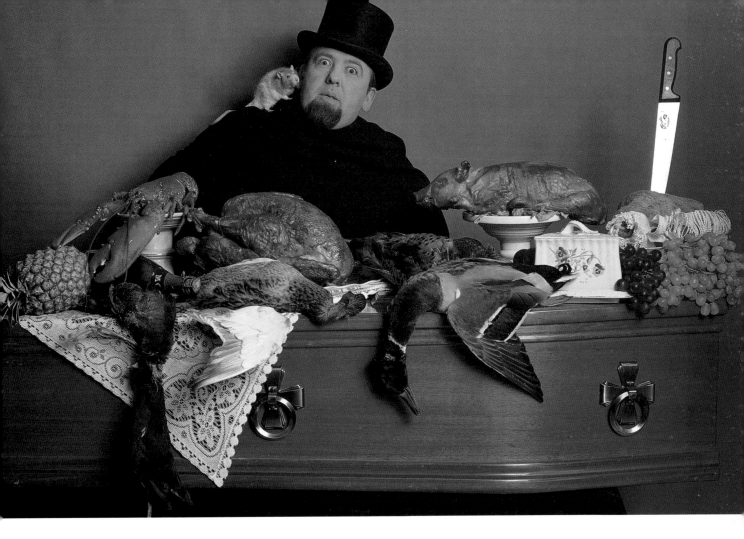

less visible. With a similar shot, a telephoto lens may mean that a single window becomes used as a backdrop.

These problems are compounded by the fact that wide-angle lenses provide more depth of field than telephoto lenses, making it much harder to minimize the visibility of the background by using a wide aperture.

The exciting lesson, using a wide-angle lens, is learning to look at subjects in different ways. You need to keep an eye out for how the foreground can be used effectively, whilst remembering that the background is going to be hard to control. The effect of camera height is particularly important with wide-angles – low viewpoints exaggerate the height of what is in the foreground, and often have a surprising effect on the prominence of the background.

Those with digital cameras can often get a wider angle of view than is afforded by a built-in zoom by using a converter attachment that fits directly on the front of the lens.

PRACTICAL TASK

■ Gather together a collection of teddy bears or children's dolls. Larger-sized ones will work best, as small ones will be harder to focus close enough to get them to fill the frame. Aim for three, four or five.

■ You will need a large backdrop which can cover a wall and stretch over a table, to form both the background and surface for your still-life arrangement. A white double sheet will suffice.

■ Arrange the toys at different distances on the curved backdrop.

■ Now shoot the set-up so that the toy in the foreground fills the height of the landscape-format frame, using the widest-angle lens setting that you have available.

■ Repeat with a longer lens, moving the camera so the object in the foreground remains the same size. Try other focal lengths as well, seeing how the perspective changes.

ABOVE: This picture was shot on a 5x4in camera for a glossy magazine to illustrate gluttony. A 'Doctor Death' character sits with a coffin on his knees – forming a table on which a lavish display of Christmas food is laid out. A wide-angle lens ensures that the larger figure of the man does not dwarf the subject matter in the foreground.

Specialist lenses

As well as zooms, the next most important lens for a photographer's camera is the macro lens. For architectural photographers a must is a shift lens.

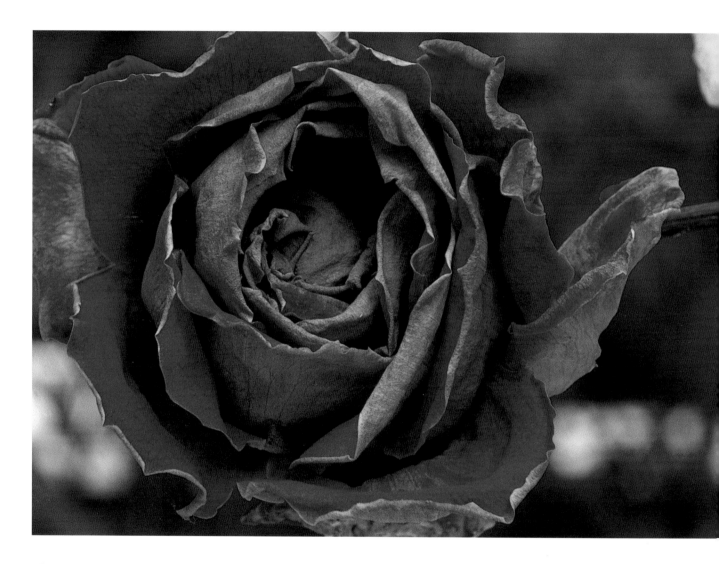

ALTHOUGH ZOOMS CAN be used to cover most focal lengths and eventualities, there are still some lenses that have to bought as 'primes'. For most photographers, the most important of these is the macro lens. This is designed for short shooting distances, and can focus close enough, if necessary, to produce a life-size image on the film, but can also be used at any subject distance.

Macro lenses are available in several focal lengths, but the best all-round choice for the 35mm-film user is undoubtedly 90mm or 100mm. This allows you to work at a reasonable distance when shooting timid insects, and can also be used for portraits.

Almost as useful, but more expensive to buy, are shift or perspective control lenses. These allow limited camera movements with a wide-angle lens, shifting the front element left or right, and up or down. This allows you, amongst other things, to avoid converging verticals when photographing tall buildings.

ABOVE: A macro lens allows you to get much closer to a subject than normal lenses. An alternative is to use extension tubes, which fit between the lens and camera. Good macro facilities are built in as standard on most digital zoom cameras.

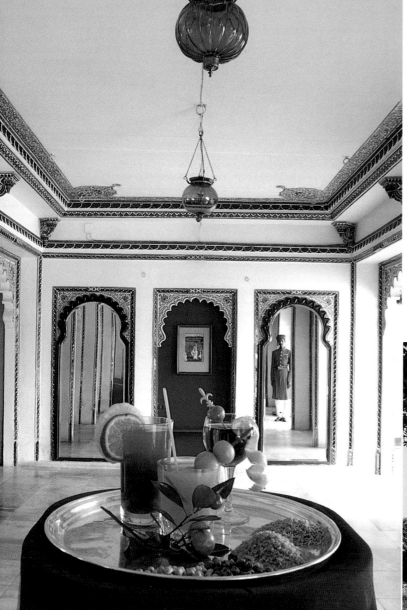

LEFT: Using a normal 28mm wide-angle lens on a 35mm SLR would usually mean that it would be impossible to look down at the table in this shot without making the verticals of the room appear to converge. With a 28mm perspective control (or PC) lens, you can keep the film back parallel to the walls, to keep the verticals straight – then move the front of the lens up so that you have a more elevated view of the tray.

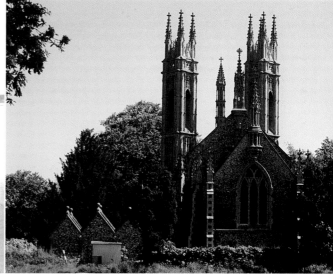

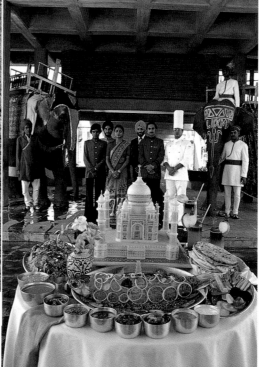

ABOVE: To fit in the tops of buildings, you need normally need to tilt the camera. With a shift lens, you can tilt the lens alone – so that the buildings look architecturally correct, without leaning verticals.

LEFT: Shift lenses, available for 35mm and medium-format cameras, offer a limited range of camera movements compared to large-format cameras. Here a shift lens has been used to improve depth of field.

ABOVE: When using macro lenses at close distances to the subject, camera shake becomes very apparent, so a tripod is necessary. Very small apertures (f/32 or smaller) are available to maximize the limited depth of field.

Direction of lighting

Sidelighting, frontal lighting or backlighting? The angle at which the light hits the subject has an enormous effect on how it appears in your photographs.

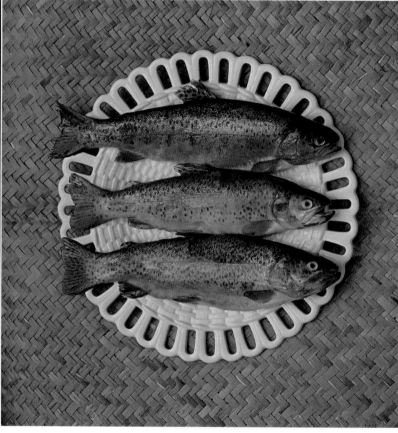

ABOVE: Backlighting works extremely well with translucent subjects such as glassware and foliage. Here, the edges of the wine glass catch the light, creating a bright outline, due to an effect known as rimlighting.

UNDERSTANDING LIGHT, and how it can transform a dull scene into a magical picture, is a fundamental skill of the serious photographer. Lighting arrangements, in the studio and outdoors, can vary enormously, and each will have a different effect on the way the subject appears on film. Lighting types can be broken into three broad categories, to make them easier to understand, although it must be noted that each can be combined to get some of the advantages of each.

Photographers used to be told to stand with the sun behind them – and this can still be good advice in many situations. With frontal lighting, you get minimal shadows and

ABOVE: Here, frontal lighting shadows are minimized, creating a low-contrast scene. With direct light, colours are accentuated, but here the lighting is kept diffuse.

OPPOSITE: Sidelighting is the classic way to accentuate the three-dimensional form of a simple subject.

the scene is evenly lit, causing few exposure and contrast problems. A pictorial benefit, meanwhile, is that colours are shown at their best. However, with the shadows unseen behind the subject, this lighting gives precious little information about form, or texture, and the subject can appear much like a two-dimensional cut-out. ▷

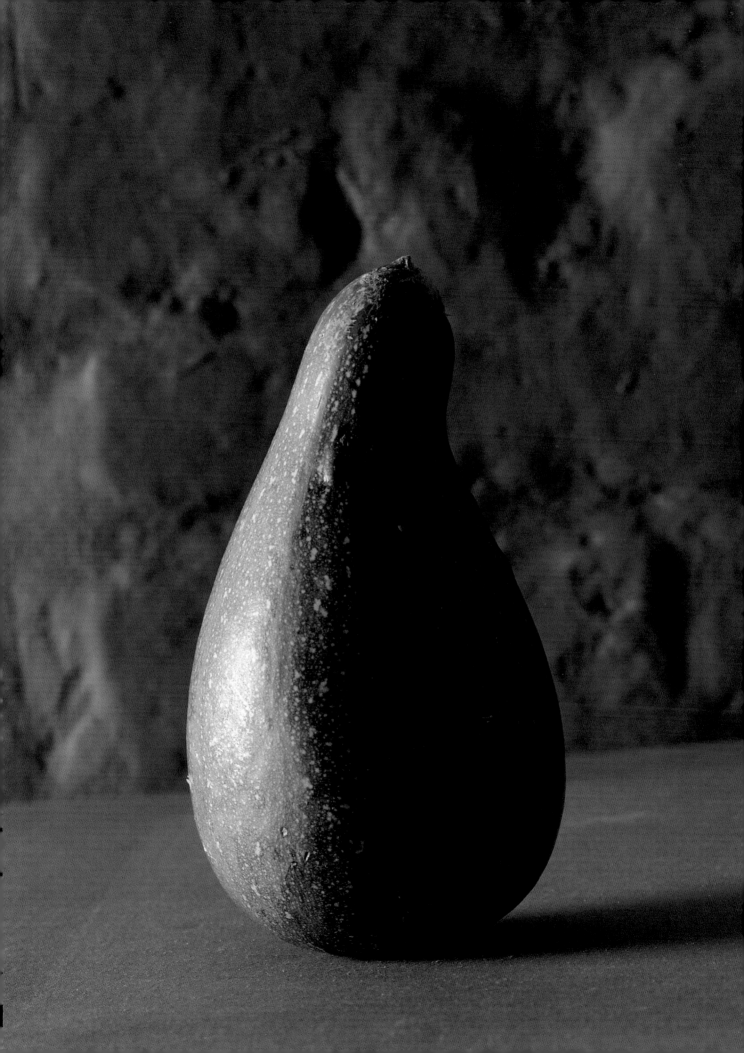

RIGHT: Rimlighting is particularly impressive when photographing people with fair hair – the high backlight creates a halo around their heads. In this particular shot, the sun provided the backlight, whilst a large white reflector in front of the model bounced enough light into her face that it was not lost in the shadows.

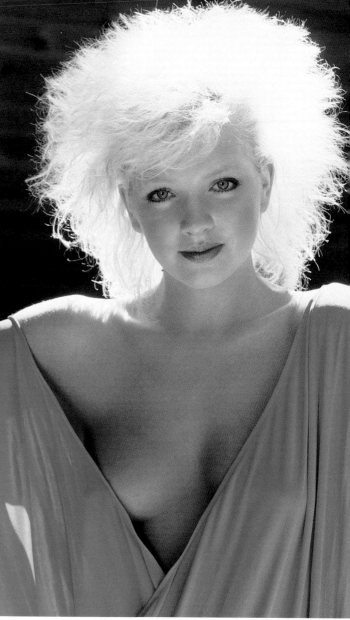

ABOVE: You do not need special lighting to create a moody sidelit portrait. For this shot of a little boy, the light is simply provided by a window. Modest fill-in is provided by daylight reflecting off walls and furniture.

Direction of lighting

If the main light source is to the side of the subject, however, some of the surfaces will be well lit, whilst others will be thrown into shadow. It is this contrast that makes side-lighting so interesting to the photographer.

Whilst frontal lighting tends to illuminate everything evenly, and backlighting puts everything in the shade, sidelighting creates immediate drama. The shadows that are formed provide information about the subject's three-dimensional shape – its form – and accentuate the texture of its surface. This works particularly well with simple subjects – in complicated scenes, the mass of miniature shadows can tend to obscure detail.

Backlighting, where the camera faces the light source, creates a subject that is basked in shadow. The high-contrast can mean exposure problems, which result in a silhouetted subject or a burnt-out background.

Rimlighting is a special type of back-lighting. If the light source is behind the subject, the rim of the subject can be lit up, creating a surrounding glow. For the effect to be noticeable, the surface needs to shiny or covered in hair or fur. The effect works best when shown against a dark background. As the backlighting shows little detail, it is best combined with side- or frontal lighting.

LEFT: In reality, you rarely use backlighting, sidelighting or frontal lighting alone, as there are infinite lighting angles in between that combine two of these. Here the sun, partly obscured by cloud, is just over the photographer's left shoulder – combining the effects of both side- and frontal lighting.

LEFT: With the sitter looking directly into the sidelight, only part of her face is lit, with the rest in deep shadow. A snoot over the high spotlight ensures that the light does not spread further afield.

See also:

← PAGE 24

Emphasizing form – using sidelighting and soft shadows to stress three-dimensional shape.

→ PAGE 138

Using reflectors – it is not just the direction of light that counts – its harshness is also important. Reflectors and diffusers can be used to create soft light sources and to soften shadows

→ PAGE 146

Exploiting ambient light – it's not the quantity of light, but the quality. So as long as you have a tripod, you can capture great pictures just by keeping your eye out around the home.

Using reflectors

It is not just the direction of light that counts – its harshness is also important.
Reflectors and diffusers can be used to soften light sources and to fill in shadows.

RIGHT: Soft light creates soft shadows, which can suggest form in a subtler way than direct light. For this set-up I used the light from a window, but so as to diffuse the sidelight more evenly over the scene, I covered the window with fine netting. Reflectors were not needed, as the white walls and white table bounced back enough light into the less lit areas.

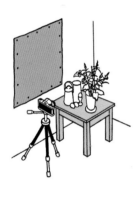

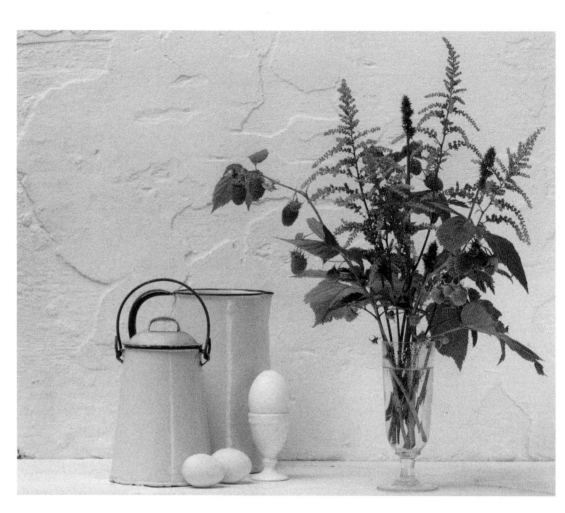

O<small>N A SUNNY DAY</small>, out of the shade, the sunlight that reflects off a subject hits it directly. This is known as harsh lighting – casting dark shadows with distinct edges.

But sunlight is not always direct. Clouds act as giant diffusers, scattering the light in thousands of different directions, and this has a great effect on shadows, making them less distinct. With partial cloud cover, just some of the light is diffused in this way – so that subjects are partly lit by direct light, and partly by this scattered, or indirect, light. On a more overcast day, shadows can virtually disappear,

although the direction that the light is coming from is still just about apparent in photographs, as well as in real life.

Sunlight also reflects off surfaces – off buildings, off the ground, off objects, and even off the sky. Again, this scatters light to a certain extent. So even the shadows are not pitch black on a sunny day.

These effects can be mimicked by the photographer, softening light to avoid over-strong shadows. This is particularly important when using artificial lighting, which can appear particularly harsh. ▷

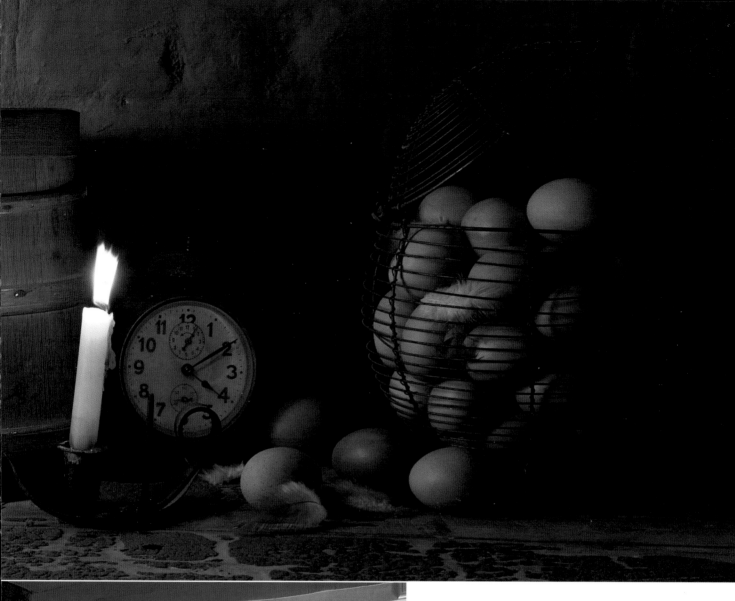

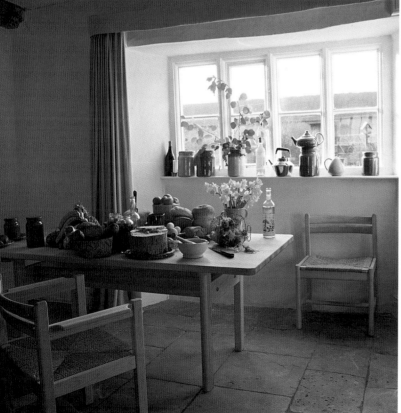

ABOVE: Candles create a warm light that brings an orange glow to your pictures. To maximize the illumination from this low-power light source, I used a mirror to the left of the set-up to reflect the light back into the frame. In addition, a white reflector to the right of the arrangement provided fill-in.

LEFT: The setting sun creates a warm glow across a farmhouse kitchen. To minimize the high contrast in this scene, I supported a white sheet just to the left of the camera, extending the full width of the room. This bounced back enough light to make the foreground subjects recognizable.

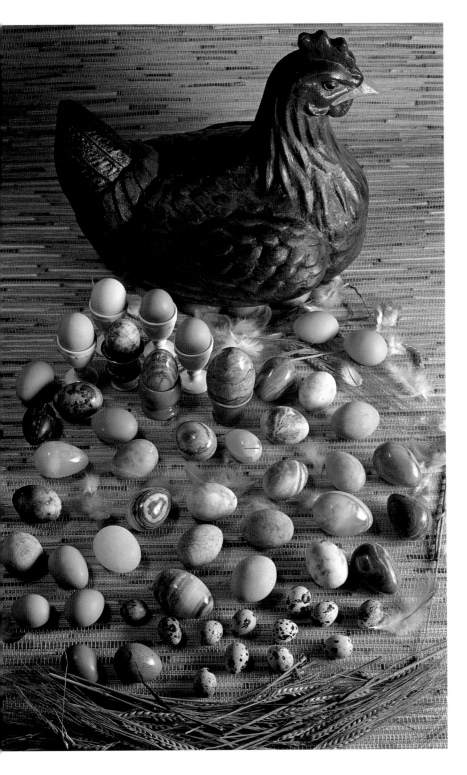

ABOVE: This collection of miniature eggs was photographed using one of the simplest, and most useful, lighting set-ups for still-life and portrait photography. A studio light fitted with a large softbox diffuser is placed to the side of the camera and angled to provide both side- and frontal lighting. A large white reflector is then put into position on the other side of the subject to soften the shadows.

Using reflectors

Diffusing a light source to mimic the effect of clouds can be achieved in a number of different ways. With windows, the light can be softened by covering them with net curtains or some other diaphanous material. With flash units, a piece of tracing paper can be used, shop-bought attachments of translucent plastic can be fitted. With studio lights, softbox attachments can be fitted over the heads.

Reflectors are even more useful, indoors and out, allowing you to soften the shadows by bouncing some of the direct light back into the unlit areas of the subject. These, ideally, need to be as large as the subject you are photographing, and of a highly-reflective colour. White is the best all-round choice, as it does not reflect a particular colour. Reflections can be made using a large piece of card or painted plyboard. A white sheet is also useful, as it is big and can be folded up and carried around easily. This can be held in position by an assistant, pinned to a wall, or draped over a piece of furniture or clothes horse. A sheet can also be used as a diffuser.

Shop-bought reflectors are collapsible, springing open to create large circular or oblong surfaces. As well as being available in white, they are available in a number of other finishes, with some being double-sided. A popular choice is gold, which reflect a warm-coloured, diffuse light that can be flattering when used for photographing people. A silver reflector, on the other hand, reflects light more efficiently than even a white reflector, providing a fill-in light that is harsher, brighter and slightly cooler in colour. A large mirror makes a good impromptu silver reflector.

A reflector is generally placed on the opposite side of the subject from the light source, so that the light bounces back directly into the least lit areas. It can then be angled sideways or up and down, until it provides the amount of fill-in that you desire.

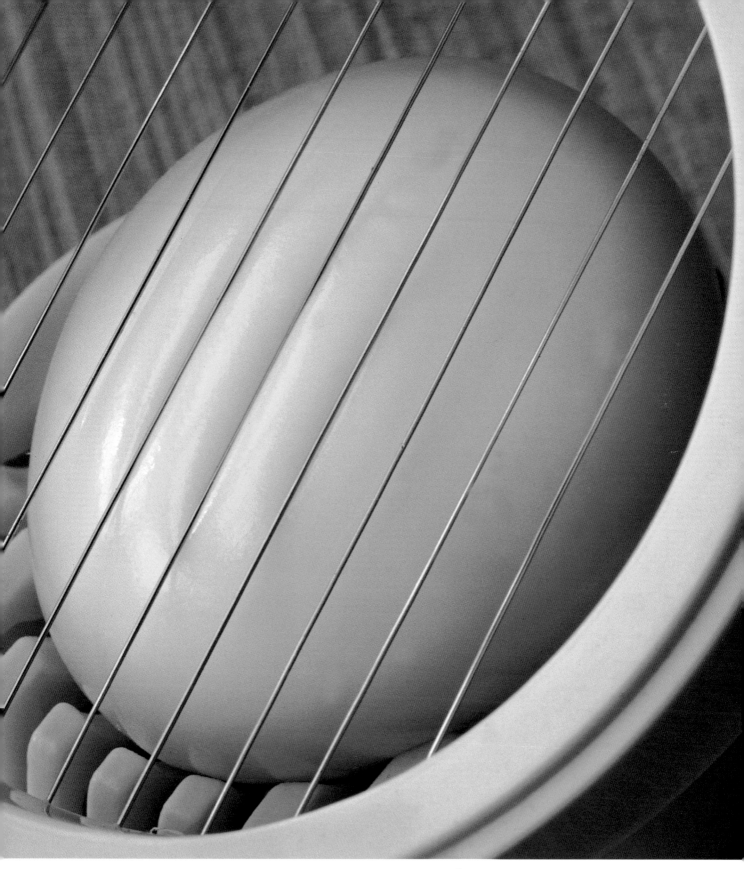

ABOVE: In order to accentuate the texture of the hard-boiled eggs and the diagonal lines created by the wire cutter, I used reflected light, which skimmed across the surface of the subject. A large piece of hardboard painted white was positioned close to the set-up, and a studio light was placed to bounce light off it. The lamp is fitted with barn doors, adjustable shields that ensure that light does not spill out where it is not wanted.

Shafts of light

A ray of light breaking through a window or through the cloud creates a selective spotlight on a scene.

BELOW: A spotlight can be created by masking off some sunlight streaming through a window, by partly drawing curtains, or by blocking out unwanted light with black polythene cut to shape.

LIGHT IS NOT JUST the basic medium that illuminates the subject – it can frequently become the subject itself.

Not only is this true for pictures of things like candles, fireworks and neon signs – the sun often creates patterns of light across a landscape or room that are interesting in their own right. Direct sunlight streaming through a window acts as a spotlight, highlighting some areas and leaving others in darkness. Not only can the shapes it creates be worth photographing, but it can also be a device that is used to highlight a particular subject or to hide unwanted detail. And by manipulating the light, you can get it to create the exact effect that you want. ▷

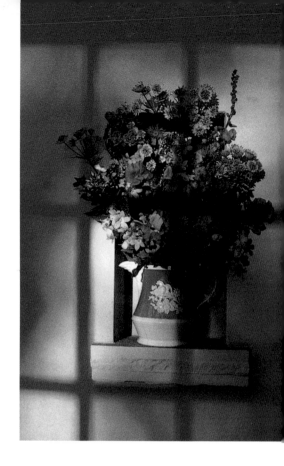

ABOVE: The pattern cast by a window's shadow can itself create an interesting picture. Such an effect can be faked in the studio with a handmade cardboard mask or by using a metal gobo, available in a variety of patterns from theatrical and TV lighting suppliers to fit on a spotlight.

OPPOSITE: Here, a light positioned below the table is used to create a highlight on the wall behind, reflecting light to backlight the scene.

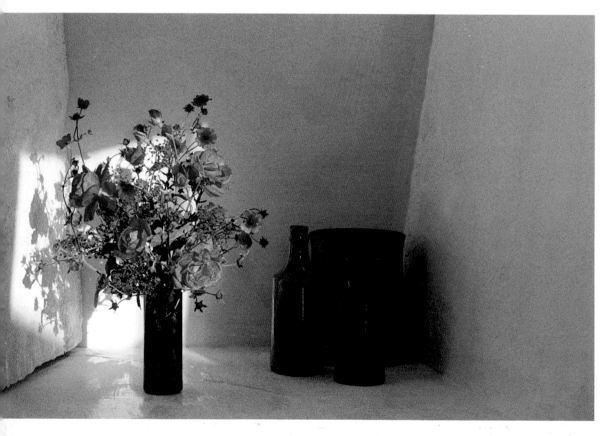

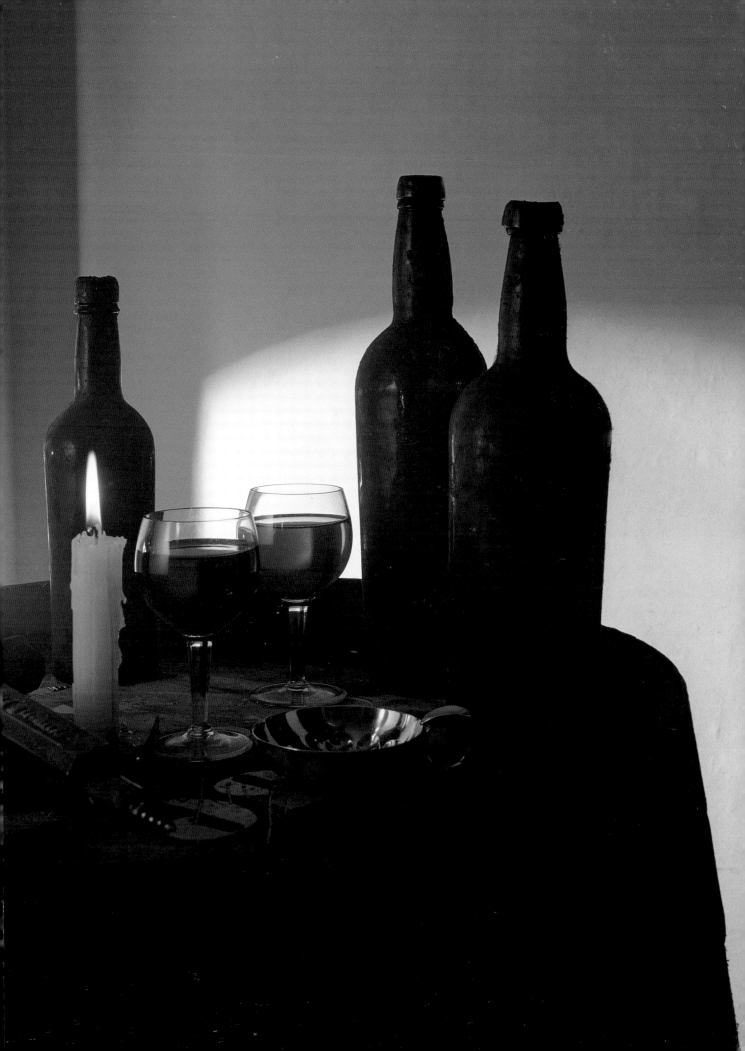

Shafts of light

Indoors, the light from a window can be 'controlled' in two separate ways. Firstly, you can mask the light so that it falls over a smaller area of the scene or creates a particular pattern. Curtains and blinds create a rough way of cutting back light, but thick material or black plastic can be stuck into position. The patterns that would be created by leaded windows or bars can also be mimicked with the creative use of cardboard and scissors.

Alternatively, you can move your subject into the pool of light. As the sun moves quickly, you do not have a lot of time. But a person or object can be positioned so that the pattern of light that has already been created falls across them. This technique also works well outdoors, where foliage can create dappled light that may be particularly useful and attractive for portraiture.

On a grander scale, for architectural or landscape shots it is a case of waiting for the spotlight – produced by breaks in the cloud – to highlight the area of the scene you are particularly interested in.

Patience is usually the key here, but an ability to spot changes in the weather can also be useful. In temperate climates, in particular, rain clouds may seem like a cue for you to put away the camera for the day. However, solid cloud cover does not necessarily last long. When it begins to break up, the gaps in the clouds allow the sun to break through. As the clouds are generally moving fast, it is just a matter of time before you get the lighting you want over your subject.

In these conditions, the contrast between strong lighting and dark clouds can be particularly appealing. An added benefit is that, if it has just rained, the air will have been washed clear of dust, reducing atmospheric haze and allowing you to see for miles.

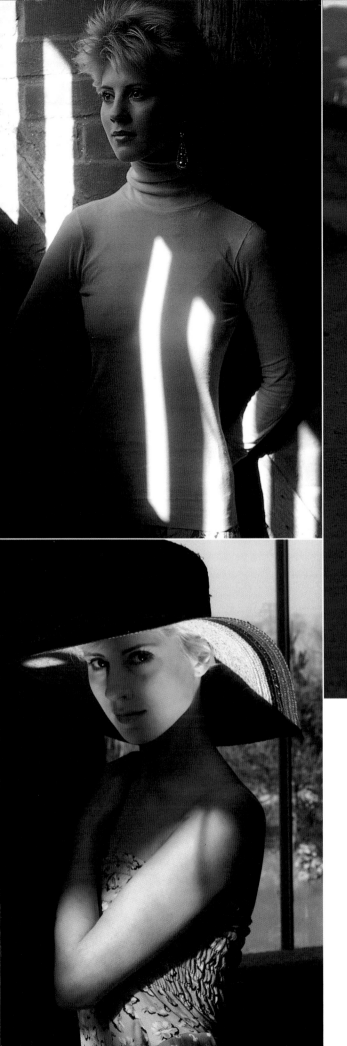

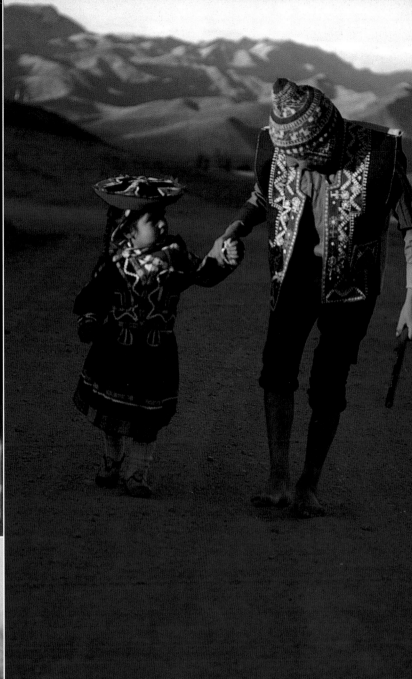

ABOVE LEFT: To make good use of this pattern of light across the wall, I moved the model so that the light fell across her body.

ABOVE: The setting sun in Peru created a complex pattern of light patches and dark shadows across the ground – and for this shot, all I had to do was to wait until the couple had walked into the light, highlighting the girl's face.

LEFT: With people, you can move your camera position and get them to move so that their faces are lit evenly. In this case, I liked the effect of the strip of shadow, caused by a window bar, dividing the woman's face in two.

Exploiting ambient light

The amount of light that you have to work with is not as important as its quality. With some sort of camera support, you can take pictures in the dingiest of conditions.

BELOW: A ceiling of a dance studio shows that pictures can be found by looking in the unlikeliest of places and directions. The shapes, created by the decorations, light and fan, make an interesting abstract arrangement.

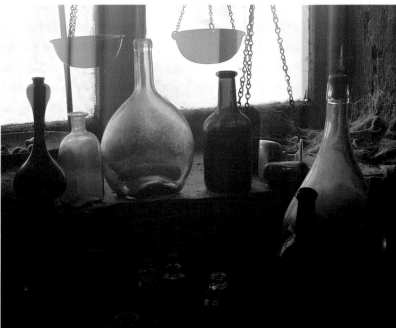

W̲E ARE SURROUNDED BY a world jam-packed with great photographs – though many pass us by because the light is too low, and it is inconvenient to use artificial illumination. But what many photographers forget is that the quantity of available light is far less important than its quality – the way its angle and softness reveals form, colour, and so on.

It is quite possible to take good pictures in the weakest of light. All we need is a slow enough shutter speed. The aperture can be left open for whole seconds to ensure that enough light reaches the film. The only pitfall is that you cannot hand-hold a camera at these speeds – a stable support ensures that long exposures are not ruined by camera shake.

A tripod is the best all-round choice, giving the fullest choice of slow shutter speeds and allowing you to use small apertures, when necessary, for maximum depth of field. ▷

ABOVE: A collection of dusty glassware in an old chemist's shop makes a fascinating backlit study, accentuating the different shapes. A tripod was essential for me to use a small aperture to retain depth of field.

RIGHT: Peeling paint might not be an obvious subject for a picture – particularly when there is no colour. However, the soft sidelight accentuates both the texture and form of the surface.

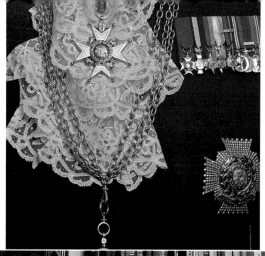

RIGHT: The Mayor of London's ornate regalia and medals create an obvious picture – but to capture the display on film required an exposure of 1/4sec, necessitating the use of a tripod.

BELOW RIGHT: The distinctive round lids and hobs of an Aga stove create a strong circular pattern, which is repeated by the saucepan in this simple study.

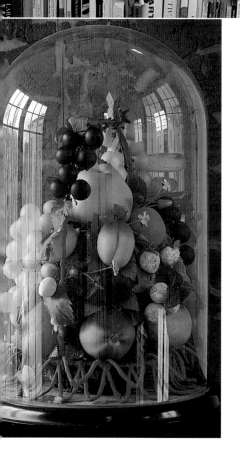

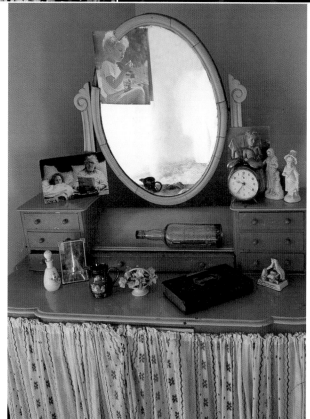

ABOVE: To shoot this assortment of ornaments spotted on a bookshelf, I rested my camera on a table, allowing the use of a slow shutter speed without camera shake.

LEFT: It was not the collection of Victorian wax fruit that interested me here, but the way the glass dome gives a wonderful reflection of the room and windows.

RIGHT: A dressing table tells you a lot about its owner – in this case, the poet Dylan Thomas.

Exploiting ambient light

Unfortunately, the heavier the tripod the better – and this does not make it an easy accessory to carry around all the time. A light-weight alternative is the monopod, which is less intrusive in crowded places and allows you to use a shutter speed that is around four to eight times as long as with a hand-held camera. Alternatively, you can often find a surface to rest the camera on – a table, car roof, and so on – which can used to support the camera. To minimize vibration when using these makeshift supports, the camera should be fired with the self-timer control.

RIGHT: Sunset shots look better when you can include a strong shape in the picture – such as a tree or cross – which can be used to form a silhouette. Take the exposure reading from the sky, rather than from the subject. With digital cameras, you can boost the colours of the sky by using a daylight white balance setting, as the automatic white balance will tend to try and 'correct' the orange colour of the sky.

ABOVE: Even discarded litter can create an interesting picture.

ABOVE: Piles of milk bottles used to be a common sight. But with home deliveries having become less common, the shot almost becomes nostalgic, as well as capturing an interesting monotone pattern.

BELOW: Farmyards are a great place to capture pictures of rusting machinery. Here, I used a monopod to shoot with a small aperture, despite a slow film and the dingy lighting conditions, I was able to use a shutter speed of 1/15sec.

LEFT: It was the contrast in tone and colour between the rusty, peeling pipe and the piece of string that first caught my eye. But I framed the shot to also accentuate the bendy shape of knot with the strong straight line of the metal.

RIGHT: Now most people have a mobile phone, call boxes are no longer found at every street corner. Such pictures, in time, become an interesting record of how the world around us changes.

LEFT: Everyday objects often have powerful shapes, which can be isolated if framed in the right way. A bike in the corner of a garage stands out well against the darker wall. Shot with a monopod.

BELOW: The spiralling coils of a hose show up well, as they are much lighter in tone than the backdrop.

RIGHT: An old, much loved teddy sits like an old man waiting to go on his holidays. This is one of those sights you see so often in people's homes and in shops, but which usually go by unphotographed.

Studio flash

Mains-powered electronic lamps allow you to experiment freely with the lighting in the home studio, without having to be dependent on daylight and windows.

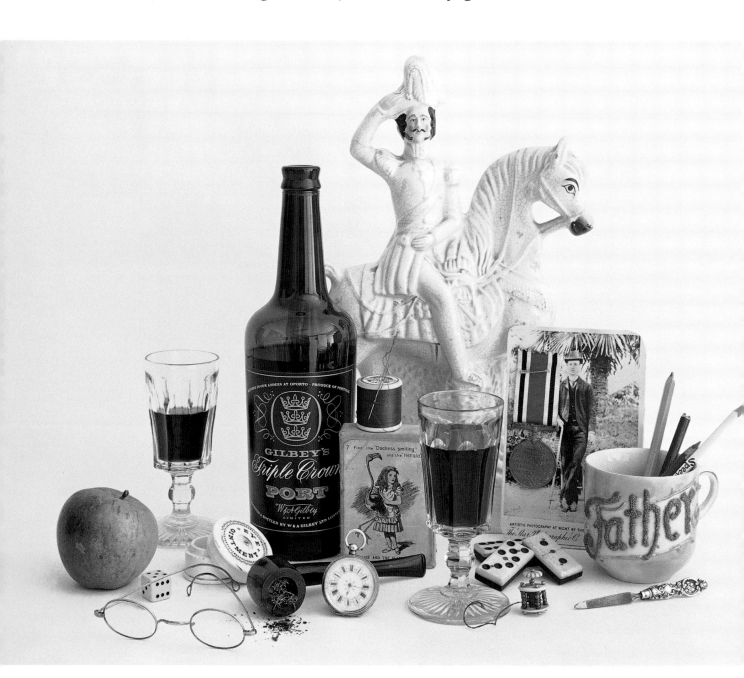

ABOVE: The main aim with studio lights is to recreate daylight, so they are usually placed higher than the subject. Their harshness and directionality must also usually be controlled. Here a single studio light is bounced off a white wall, weakening and softening its output. Fill-in is provided by the white backdrop; this has been dropped down under the set-up to create a 'cove', so you don't see a join between its vertical and horizontal planes.

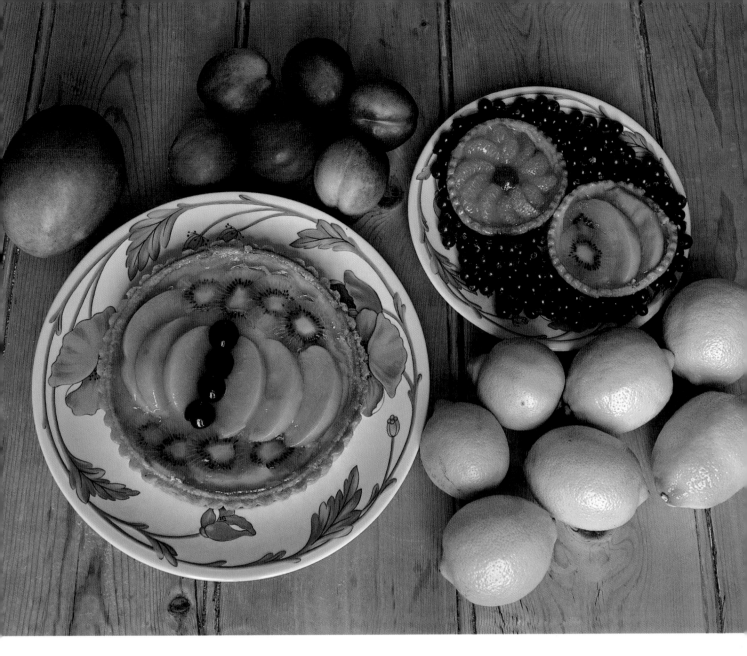

ALTHOUGH YOU CAN make do with natural light in a home studio, you are dependent on the weather and the time of day. Studio flash units need not be expensive, and provide more flexibility, letting you to place lights exactly where you want them and allowing you to continue shooting throughout the night should the urge take you.

A studio light is effectively a high-powered flashgun which, supported by its own stand, can be moved around the subject independently of the camera. It is mains-powered, so that it recharges quickly, and ideally should be able to be set to different brightness outputs, so that you have more control over aperture and shutter speed. One of the flash units needs to be connected directly to the camera –

via the 'PC' socket found on many models, or via an adaptor fitted to the hotshoe. Additional lights do not need to be wired up to synchronize with the camera's shutter in this way. Instead, these can be fitted with 'slave' units – sensor devices that trigger the flash when the main light is fired.

When buying a studio lighting system, start out with just one or two lights. With more units than this you maybe tempted to use them unnecessarily, and will waste a lot of time trying to get the balance right. As you will have seen already in this book, you can tackle a wide range of subjects with just a single light – using reflectors where necessary to provide fill-in for the darker areas. ▷

ABOVE: Soft sunshine has been recreated for this picture by bouncing electronic studio flash off a large white reflector placed above the arrangement of fruit. A modelling lamp on the light allows you to preview the effect.

LEFT: Part of a series of shots taken to illustrate children's nursery rhymes, Old King Cole was lit using a large softbox (which can be seen reflected in the golden orb) to give diffuse, even lighting.

BELOW: The background can be lit separately from the subject, as long they are far enough away from each other. This is particularly useful with white backdrops, as by varying the relative intensity of background lighting, the backdrop can appear any shade of grey, as well as white.

OPPOSITE: A large soft-box attached to the studio light creates an even, diffuse illumination which provides pictures that look as if they have been shot by soft window light.

Studio flash

Ideally, you should choose studio lights with modelling lamps, tungsten bulbs that allow you to get a feel for what the lighting will look like as you set up.

A flash meter is also handy for working out exposure – unless your camera is either a digital one with an LCD screen, or has a Polaroid back so that you can preview the results before committing them to film.

Rather than buying additional lights, it is worth purchasing a good range of the accessories designed for use with different lighting ranges. These allow you to angle the light and diffuse and reflect it, in a variety of ways.

A softbox, a large diffuser that fits over the head, producing a large window-like, soft light source, is a particularly good investment.

Other options include umbrellas, which can be used as diffusers and reflectors with changeable canvases. Barn doors and snoots, meanwhile, can be used to channel the light into a narrower beam.

RIGHT: Good reactions were needed to catch the tiny drop falling from the neck of the bottle in this shot. But if the wine is poured into a bowl, it can be funnelled back into the bottle to repeat the shot until you are sure that you have caught the moment – you can also experiment beforehand with water, if you don't want to ruin your favourite claret! The set-up here was lit with three lights: a main light, a backlight to pick out the colour of the wine, and a separate unit for the white background.

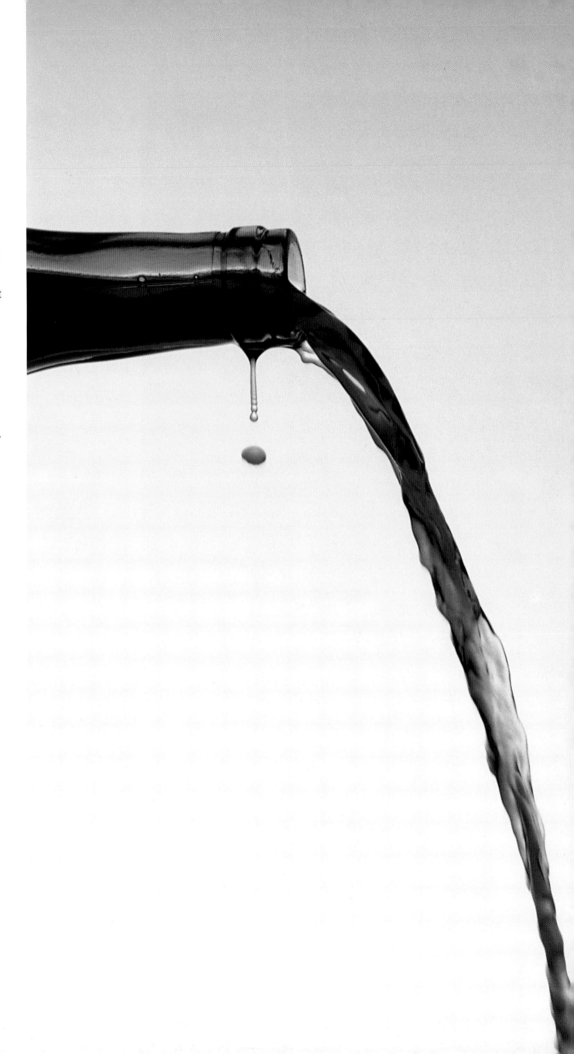

Freezing with flash

A burst of flash lasts just a fraction of a millisecond, which can be used to freeze a single moment of action that would otherwise be impossible to capture with a camera.

FLASH IS NOT JUST useful for providing a movable, controllable light source, which can come to your aid when the services of the sun are not available. It also has an extraordinary ability to freeze movement.

Flashguns work by charging a capacitor with electricity, drawn from batteries or the mains. It fills this reservoir with current, which, when the trigger is fired, is released through a gas-filled tube, producing an instantaneous burst of light. However, this flash of light is short-lived. With a portable or built-in flash this never lasts for more than 1/1000sec. But on automatic over short distances, or set to a lower power output, the duration can be as short as 1/40,000sec. ▷

BELOW: Here, daylight is combined with on-camera flash. The fill-in provided by the flash freezes the spray from a garden hose.

ABOVE: The secret of this shot was to pre-break the egg, so that the shutter and flash could be fired immediately the signal was given to the assistant to release the yolk. A studio flash unit gives a flash duration of around 1/500sec at full power (shorter at lower outputs). This is fast enough to freeze the egg in mid-air. The background was lit separately to ensure that it was shadowless and white.

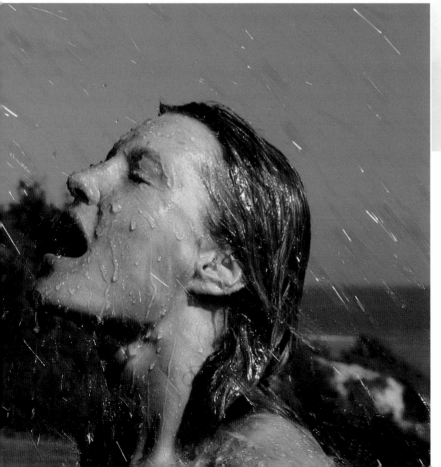

Freezing with flash

In low light, the duration of the flash effectively becomes the effective shutter speed for the picture you are taking (in a dark studio, the shutter speed set on the camera is largely irrelevant, as long as it is slow enough to synchronize fully with the flash). Because the duration of flash can be much shorter than that available with shutter speed, you can capture fast-moving events that are not visible to the human eye. The symmetrical spatters of a drop of milk hitting the ground, or the wings of an insect in flight, can be frozen.

Even in good light the technique can be used, as long as the subject is close to the camera; the power of the flashgun can be set so that it is more dominant than the daylight over short distances. This technique can be

used to capture runners in a cross-country race, or competitive cyclists, as they can be shot from close up with a wide-angle lens.

The main difficulty with high-speed photography in the studio is releasing the shutter at the right time. Human reactions are not fast enough for some subjects – such as a speeding bullet – and a specialist triggering device must be used. However, as the pictures on these pages show, you can still get impressive results without such equipment.

ABOVE: Caught on camera, a balloon full of water bursts in an extraordinary way. To take these four pictures, I filled a number of balloons with water, and suspended them one at a time with thread in front of a piece of softboard covered in black felt, with a large basin below to catch the water. To burst each balloon, I used an air pistol. This was fired with one hand as I released the shutter with the other. The lighting was provided by a single flash, with fill-in from a large mirror.

Index